Digital
Exposure

HANDBOOK

Revised edition

ROSS HODDINOTT

AMMONITE
PRESS

First published 2008
This edition published 2013 by
Ammonite Press
An imprint of AE Publications Ltd
166 High Street, Lewes,
East Sussex BN7 1XU

Text and photographs © Ross Hoddinott, 2013
Copyright in the Work © AE Publications Ltd, 2013

ISBN 978-1-90770-895-4

A catalogue record for this book is available from
the British Library.

Publisher: Jonathan Bailey
Production Manager: Jim Bulley
Managing Editor: Gerrie Purcell
Senior Project Editor: Dominique Page
Editor: Rob Yarham
Managing Art Editor: Gilda Pacitti
Designer: Chloë Alexander

Set in Bliss

Colour origination by GMC Reprographics
Printed and bound in in China

Picture credits

All photographs by Ross Hoddinott, except for
the following:

2020VISION/Ross Hoddinott: 77, 98, 173, 179
Ollie Blayney: 87, 88
Tom Collier: 64 (top)

Additional images by: Canon 24, 129; Datacolor
182; Epson 185 (top); Hoya 151 (far right), 160;
Lastolite 121, 144; Lee Filters 151, 155, 158; Lexar
168; Nikon 66, 67, 126, 130, 132; Permajet 184/185;
Sekonic 17; Wimberley 145.

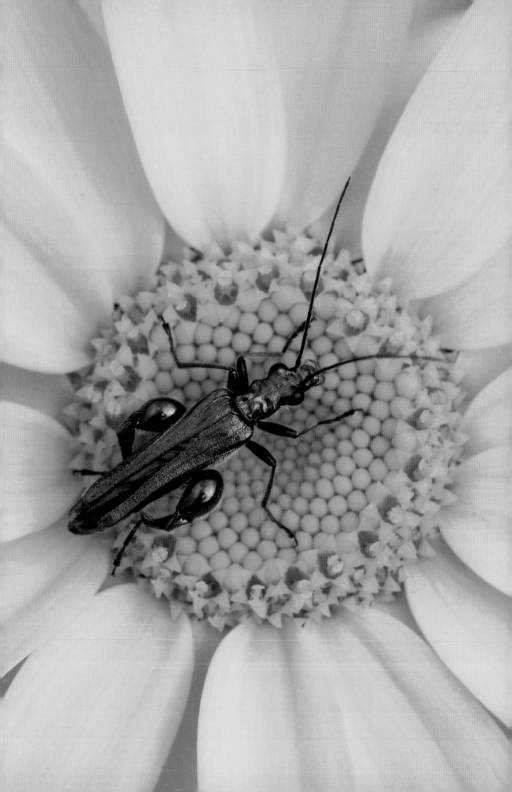

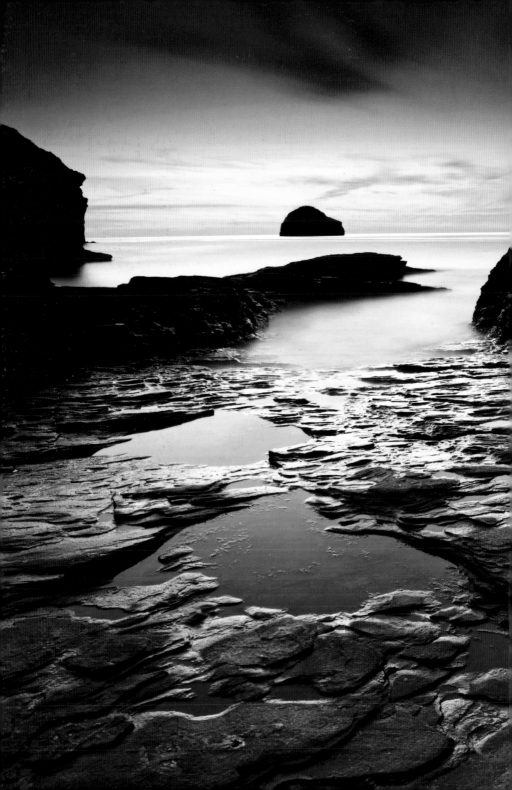

Contents

Introduction

exposure / *noun*.
The act, or an instance, of exposing a sensitized photographic material, or the product of the light intensity multiplied by the duration of such an exposure.

Exposure is the heartbeat of photography. Put simply, it is the process of light striking a photosensitive material, such as film, photographic paper or a digital camera's image sensor. Understanding and being able to control exposure is critical to successful photography. However, it is a subject that, at times, can appear complex and confusing – not only to beginners, but enthusiasts as well. So many things can influence exposure, including the time of day, focal length of the lens, subject movement, light source and any filters attached. Certainly, when I first began taking photography seriously as a teenager, I found the theory and technicalities of exposure tricky to understand. However, I quickly realized that if you try to overlook this key fundamental, your photography will suffer and never realize its full, creative potential.

Exposure is a combination of the length of time and the level of illumination received by a light-sensitive material. This is determined by three settings: shutter speed, lens aperture and ISO equivalency rating. The shutter speed is the duration of time that the camera's shutter remains open, allowing light to enter and expose the sensor. The aperture – or f-stop – is the size of the adjustable lens diaphragm, which dictates the amount of light entering the camera. The ISO speed indicates the sensor's sensitivity to light. At lower sensitivities, the sensor requires a longer exposure to get a good result, while at high sensitivities, less light is needed.

If the combination of shutter time, aperture and ISO sensitivity is incorrect, the picture will be wrongly exposed. Too much light falling on the sensor will result in an overexposed image with washed out highlights; too little light and the image will be underexposed, appearing too dark. Simply speaking, a good photograph relies on the photographer employing just the right combination of settings to form the correct level of exposure. However, while this might be logical in theory, I often ask myself: 'Is there really such a thing as the correct exposure?' While you could say that a correctly exposed image is one that records the scene or subject exactly as our eyes see it, photography is a subjective and creative art. There is no rule stating that a photographer must always capture images that are authentic – it is subject to individual interpretation. Therefore, arguably, a 'correct' exposure is simply one that is faithful to the vision of the photographer at the moment he or she triggers the shutter.

Today's breed of digital cameras boasts highly sophisticated and accurate internal metering systems, which are rarely fooled – even in awkward lighting conditions. They have simplified many of the technical aspects of exposure, for which we should be grateful. However, a camera is still only a machine; it cannot predict the effect and look the photographer is striving to achieve. It is for this reason that you shouldn't always rely on your camera's automated settings. Remember: you are the artist and, as such, you need to grasp control from your camera. Fail to do so, and your images will never truly convey your own individual interpretation of the subject you are shooting.

▶ *Damselfly*
Every time you take a photo, you are recording a unique moment that can never be repeated. A good understanding of exposure is vital to ensure your image is compelling to others and faithfully captures the light, essence and mood of that particular moment.

Nikon D800, 150mm, ISO 200, 1/3sec at f/22, tripod.

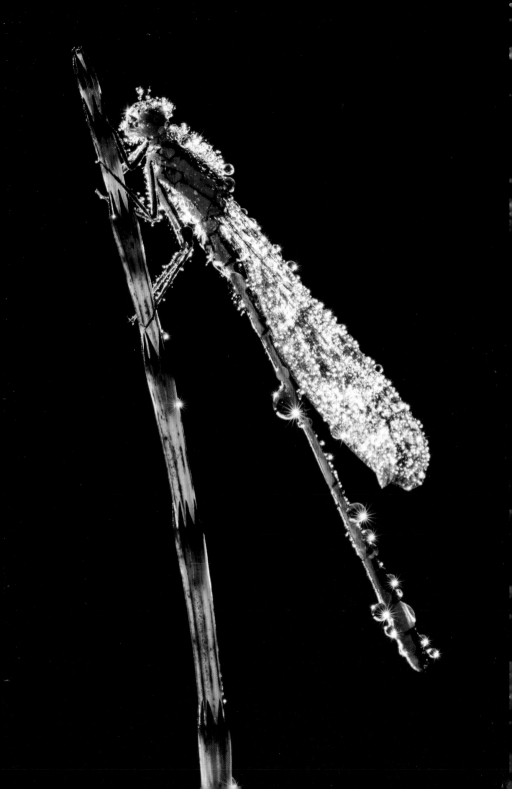

▶ *Church silhouette*

In many ways, there is no such thing as a 'correct exposure'. For example, technically speaking, a silhouette is the result of poor exposure – the subject being grossly underexposed. However, no one could deny that silhouettes create dramatic and striking imagery.

Nikon D300, 24–85mm (at 85mm), ISO 200, 2min at f/11, 10-stop ND, tripod.

Basically, without a good understanding of exposure, your images will never progress beyond the realm of pleasing snapshots.

Exposure can be manipulated for creative effect in so many different ways. For example, it can be used to create the impression of movement, or to freeze fast action that otherwise would be too quick for the human eye to register. However, the skill isn't just to know how to create such effects; you also need to be able to judge when to employ certain settings. This handbook will help you make the right choices. It is designed to be an exhaustive manual on the subject, covering every aspect of exposure as well as offering helpful and practical advice on ways to improve your photography in general.

My hope is that this guide will inspire you, helping to open your eyes to the skills and techniques required to manage and control exposure in order to create images that succeed in relaying your artistic vision. However, reading this book alone will not improve your photography; you have to adopt and implement the things you learn in your own picture taking. After all, photography is a skill and, if you wish to improve, it has to be practised.

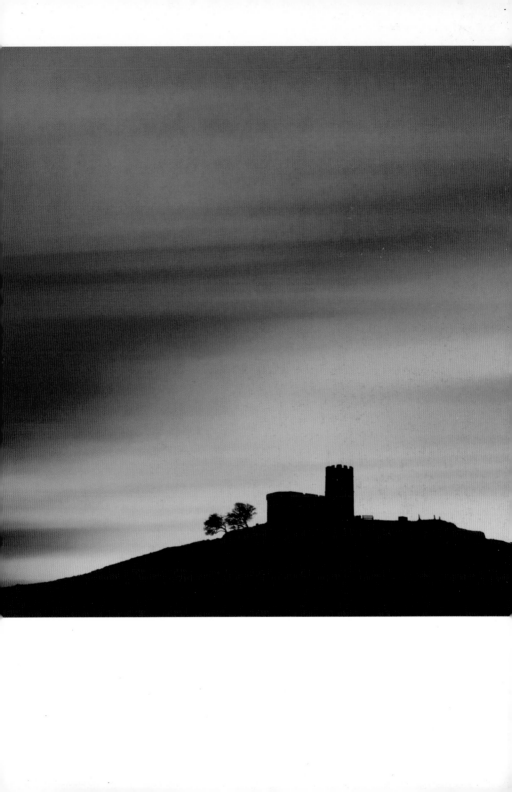

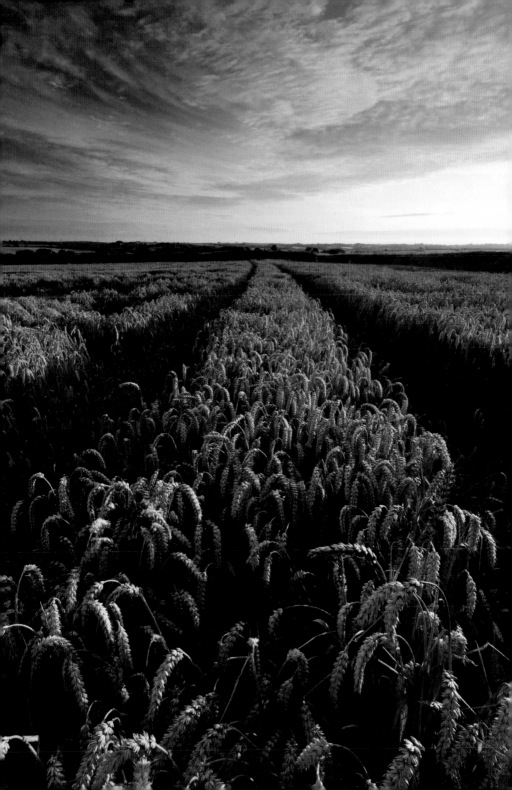

1 The basics of exposure

The basics of exposure

'Photography' is derived from the Greek *phos*, meaning 'light', and *graph*, meaning 'to draw'; therefore a photograph is a drawing made with light. Since the French lithographer Nicéphore Niépce created the first permanent photograph in 1826 by coating a pewter plate with asphaltum, controlling 'exposure' has been the key fundamental of photography. Even in this digital age, exposure is still determined by the same three variable settings that have been used since its advent: the sensitivity of the photo-sensitive material used to record the image, shutter speed and lens aperture.

ISO equivalency rating

ISO (International Standards Organization) equivalency refers to a sensor's sensitivity to light. It is a term that is adopted from film photography, when film was rated depending on the way it reacted to light. A low ISO rating – or number – is less sensitive to light, meaning it requires a longer exposure. In contrast, a high ISO equivalency is more sensitive to light, which in practical terms means it needs less exposure. Every doubling of the ISO speed halves the brightness of light, or the length of time required, to produce the correct exposure, or vice versa. The sensitivity of an image sensor is measured in much the same way as film. For example, an ISO equivalency of 200 would react to light in an almost identical way to a roll of film with the same rating. Digital cameras allow photographers the luxury of altering ISO sensitivity quickly and easily. Increasing ISO sensitivity is a useful way to generate a faster shutter speed in shooting situations where you wish to capture fast action or when working in low light.

Shutter speed

Also known as shutter time, shutter speed is the length of time the camera shutter remains open. It determines the amount of light entering the camera in order to expose the sensor. The duration of the shutter speed can be as brief as 1/8000sec or upwards of 30sec, depending on the light available

and also the effect the photographer desires. As with the lens aperture, one full stop change in shutter speed will either halve or double the amount of light reaching the sensor. For example, reducing the shutter time from 1/500sec to 1/250sec will double the length of time the shutter remains open and vice versa. The shutter speed greatly dictates how motion is depicted in the resulting photograph. A fast shutter time will freeze movement, while a slow speed can create subject blur (if the subject is moving), creating the feeling of motion and giving images added energy or interest.

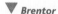

▼ *Brentor*

To ensure that sufficient light exposes the sensor to record the scene or subject faithfully, an appropriate combination of ISO sensitivity, lens aperture and shutter speed needs to be selected.

Nikon D300, 12–24mm (at 12mm), ISO 200, 3min at f/11, 10-stop ND, tripod.

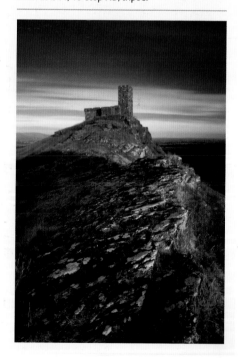

Lens aperture

The lens aperture is the size of the adjustable lens diaphragm, which dictates the amount of light allowed to reach the sensor. In isolation, its design can be compared to that of a human eye. Our pupils contract in bright conditions, needing less light to distinguish detail, while in low light our pupils require more light so grow larger. By altering the lens aperture, photographers are affecting the amount of light reaching the sensor.

Apertures are measured using f-stops and, while all camera lenses are calibrated to the same measurement scale, the range of f-numbers varies from one lens to another, typically ranging from f/1.4 and up to f/32. Larger apertures (denoted by small f-numbers) allow light to reach the sensor more quickly, meaning less exposure time is needed. At small apertures (large f-number), it takes longer for sufficient light to expose the sensor, so therefore a longer exposure is required. Each 1-stop increase in aperture doubles the amount of light reaching the image sensor, while each 1-stop reduction halves the amount of light. The aperture affects depth of field (see page 46), with a large aperture creating a narrow depth of field and a small aperture producing a wide depth of field.

Summary

To achieve consistently accurate and faithful exposures, it is essential to have a good understanding of the three variables and their relationship to each another. Once you have selected an appropriate combination of lens aperture and shutter speed – for a given ISO sensitivity – a change in one will necessitate an equal and opposite change in the other. Quite simply, it is these three exposure variables that form the basics of exposure and photography.

▼ *Blurred tide*

For this image, I prioritized a slow shutter speed to creatively blur the movement of the rising tide. I was able to do this by selecting a low ISO sensitivity, small aperture, and shoot in low light.

Nikon D700, 17–35mm (at 26mm), ISO 200, 30sec at f/14, tripod.

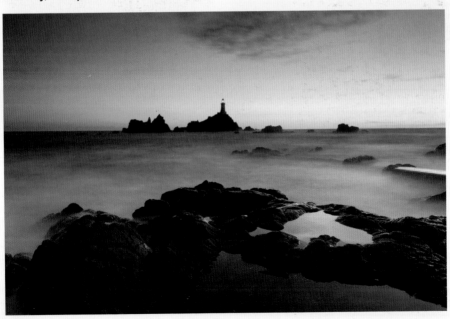

Metering

Metering is the way light is measured to determine the best exposure value for a particular scene or subject. There are two types of metering tool: the camera's built-in TTL (through the lens) metering system or a handheld device. The systems employed by today's digital cameras are highly sophisticated and accurate. However, they are not infallible and can be deceived in awkward lighting conditions – for example, by backlighting (see page 107).

▼ *Emerging leaves*
Modern metering may be highly accurate and reliable, but it cannot predict the effect you are striving to achieve artistically. Photographers need to be aware of how light is measured, to enable them to manipulate it creatively.

Nikon D200, 150mm, ISO 100, 1/100sec at f/9, tripod.

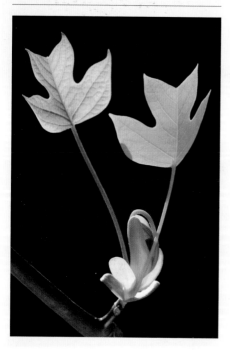

Reflected or incident light – what is the difference?

Light is calculated in one of two ways: either by measuring the light reflecting off the subject (reflected light) or the amount falling on it (incident light). Cameras – and some handheld devices – incorporate reflected light metering systems. They work by measuring the amount of light actually reaching the camera and, in the instance of TTL metering, entering the lens. They perceive the subject's visual brightness based on the amount of light reflecting off it, translating it into an exposure value.

The main drawback of using this type of measurement is that the level of reflectance varies greatly depending on the subject, so the metering system can only 'guess' at how much light is actually striking it. Also, it is affected by the tonality of the subject, being designed to give a reading for middle grey (see page 20), irrespective of its tone. This is fine when the subject's reflectance is sufficiently diverse throughout the image, which it tends to be in the vast majority of instances.

Problems can arise when the scene or the subject is excessively light or dark, as a reflected light reading will still attempt to record tone as middle grey. As a result, light subjects are typically recorded underexposed, while dark subjects will be overexposed. However, as long as the photographer is aware of the potential problem, they can compensate accordingly by selecting an appropriate metering evaluation mode or by adjusting exposure to correct any errors.

The biggest advantage of using a reflected light meter is its practicality. You don't need to be in the direct vicinity of the subject – something that is impractical with many subjects.

An incident light meter works by measuring the light actually falling on the subject and is commonly the type of metering employed in handheld devices. Therefore, they benefit from being not influenced by tonality and any light absorption properties of the subject. They are highly reliable, but meter readings need to be taken very near to the subject itself. While this is fine for studio work, weddings and portraiture, it is not practical when photographing distant subjects.

Handheld light meters

At first glance, handheld light meters may appear old fashioned and redundant. The built-in metering systems of digital SLRs (DSLRs) are so sophisticated today that they can be relied upon in the vast majority of situations. However, the versatility and accuracy of external meters mean they remain a popular accessory among enthusiast photographers, in particular those regularly working in a studio environment. There are two types of handheld meter; reflected and incident.

A reflected light meter – also known as spot – works in a similar way to TTL metering, measuring the light reflecting off the subject. The best handheld reflected light meters offer a 1-degree spot metering facility, allowing users to assess the light from very specific parts of the composition. Whilst some DSLRs can spot meter from a 3–4 degree area, none offer this high level of metering precision and creative control. However, on the downside, handheld devices do not calculate for external factors, such as filters. Therefore, if a filter is attached – for example, a polarizer with a 4x filter factor (see page 149) – the photographer must manually adjust the meter's recommended settings to compensate.

Incident light meters work by measuring the light actually falling on the subject, rather than reflecting off it, meaning they are unaffected by the tonality of the subject. They are designed with a white plastic dome, or invercone, which averages the light falling on it before the diffused level of light is measured by the meter's cell. While a handheld reflected light meter works by being pointed at the subject, an incident meter should be placed near to the subject itself, pointing back towards the camera – something that may not be practical for some subjects, such as wildlife photography. However, because of the way they work, they are not influenced by contrasting areas of light or dark, making them popular among wedding and portrait photographers.

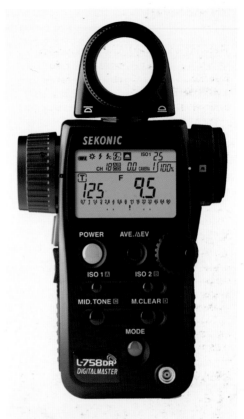

▲ *Handheld light meter*
Among the main manufacturers that produce handheld light meters are Gossen and Sekonic. Many are highly sophisticated. For instance, the Sekonic L-758DR boasts independent programming of flash, ambient, incident and reflected measuring modes – customized to your digital camera. It also alerts you when a measured value exceeds your digital camera's dynamic range. It has a rectangular 1-degree spot viewfinder with vivid display.

TTL metering

Through the lens (TTL) metering is the 'brains' behind how your camera determines the shutter speed and aperture combination, based on the available light and ISO rating. TTL metering systems measure the reflected light entering the lens. Therefore, unlike handheld devices, they automatically adjust for external factors, such as added filters or shooting at high magnifications. When TTL metering was first introduced, over 40 years ago, it was basic. Today, in-camera metering is highly sophisticated and reliable, producing accurate results in practically any lighting condition, meaning few photographers today require a separate handheld device.

How your camera calculates exposure is determined by the metering pattern it employs to measure the light reaching the metering sensor. Digital SLRs boast a choice of metering patterns – typically, multi-segment, centre weighted and spot – each of which are designed to evaluate light in different ways. The metering patterns of today's cameras aim to keep exposure error to a minimum. However, each system has lighting conditions for which they excel and also for which they can fail. Therefore, it is important to understand how each one works so you can select the system most appropriate for your subject and also the shooting conditions.

▼ **Castle ruins**

Digital cameras offer users a choice of metering method. It is important to be familiar with each, so that you can confidently select the form of metering that is best suited to what you are photographing. When I took this image, I used my camera's multi-segment metering, confident that it would produce an accurate reading in the conditions.

Nikon D800, 24–70mm (45mm) ISO 100, 1/8sec at f/11, tripod.

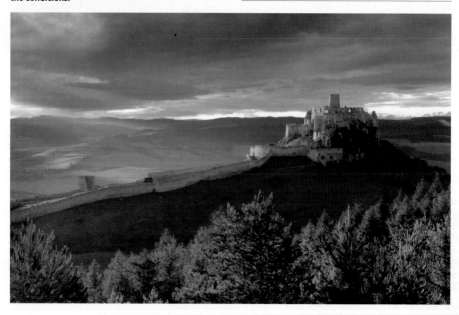

▲ *Bridge in autumn*
Multi-segment metering is most effective when the scene or subject is mid-tone, making it well suited to subjects like evenly lit landscapes and woodland scenes.

Nikon D700, 17–35mm (at 19mm), ISO 200, 4sec at f/16, polarizer, tripod.

Multi-segment metering

This form of metering offers photographers the highest ratio of success. Typically, this is a camera's default setting, being reliable in the vast majority of lighting conditions. As its name suggests, it works by taking multiple independent light readings from various areas of the frame. It then compares the measurements made from each individual area against a library of typical scenes before calculating a meter reading based on its findings.

Depending on the make of the camera, this form of metering pattern is named differently; for example, it is also known as 'Evaluative', 'Matrix' and 'Honeycomb' metering. However, regardless of the title it is given, the principle is the same. The viewfinder is divided into multiple segments from which the camera measures the level of light relative to that part of the image space. The camera's processor assesses this information, before assigning an exposure value via its viewfinder and LCD display.

Multi-segment metering is most effective when the scene or the subject is predominantly mid-tone, and the brightness range is within the camera's dynamic range. As the majority of photographs taken fall within this broad description, it is easy to understand why this particular form of measuring light is so popular and effective. However, the system is less useful when you wish to meter for a specific area within the frame, such as for a backlit or silhouetted subject, for example.

Due to its nature, multi-segment metering will provide an overall average setting, thus limiting the creative control you have over the image. In situations like this, it is worthwhile switching to the precision of spot or partial metering.

Centre-weighted metering

The oldest form of TTL metering is centre-weighted – or average-weighted – metering, but it is still found on most modern DSLRs. While it has been greatly superseded by sophisticated multi-zone metering systems, it remains a highly useful form of measuring light. The system works by averaging the light reading over the entire scene, but with emphasis placed on the central portion of the frame. Typically, around 75% of the reading is based on a centre circle, visible through the viewfinder. This is often $^3/_8$–1in (8–12mm) in diameter, although the size of the reference area that the camera uses to weight its light reading can be adjusted on some models.

Centre-weighted metering works using the theory that the main subject is normally central in the frame. Therefore, it is well suited to portraiture

photography or in situations where the subject fills a large portion of the image space. Also, this system is less influenced by areas of intense light or dark shadow at the edges, which would affect multi-zone readings. However, centre-weighted metering is less useful when taking photographs where the subject brightness range, between foreground and background, exceeds the camera's dynamic range (see page 28); for example, in landscape photography, where underexposure is likely in images boasting plenty of bright sky.

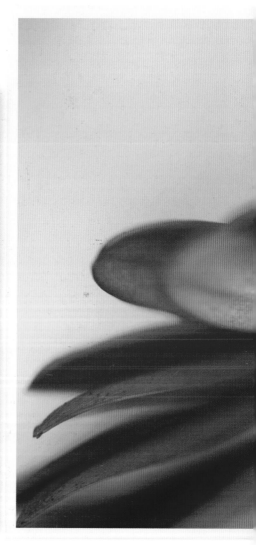

What is mid-tone?

Light meters – handheld and in-camera – are calibrated to always give a reading for a middle-tone subject that reflects 18% of the light falling on it. This is known as 18% grey or mid-tone and is the value of the mid-point of a photographic material's or sensor's ability to read detail in both an image's highlights and shadows. To help understand this, imagine a scale from pure white to pure black, with each progressive step reflecting half or double the amount of the light falling on its neighbour. While you might presume that 50% would be the mid-point, in reality this degree of reflectance would be substantially brighter than what would appear to be mid-tone. This middle point is therefore represented by 18% grey, although some would argue that the mid-tone is actually nearer to 12%. This is relevant, as light meters often work in greyscale.

Therefore, when photographing a medium-tone subject, such as the skin tone of a Caucasian, brickwork or grass, your light meter will be reliable, giving you a technically accurate exposure value. However, metering problems can arise when you photograph subjects that are darker or lighter than mid-tone; for example, snow or a black cat. Your metering will still set a value for mid-tone, whereas in reality you will normally want subjects that are lighter or darker than mid-tone to appear so, otherwise they won't be captured faithfully. This is why, despite the accuracy of modern metering, it is necessary to employ a degree of exposure compensation (see page 58) in some instances.

▼ *Gerbera*

Centre- or average-weighted metering systems assign greater emphasis to the light falling in the middle of the frame. This makes it a reliable system for photographing subjects that fill the frame, such as this close-up of a gerbera.

Centre weighted

Using this form of metering, about 75% of the sensitivity is directed towards the central part of the frame. As a result, it is less influenced by any areas of varying brightness at the edges of the frame that would otherwise trick the metering system.

Canon EOS 50D, 60mm, ISO 100, 1/200sec at f/2.8, tripod.

Spot and partial metering

These are the most precise forms of TTL metering available to photographers. Both systems calculate the overall exposure from just a small portion of the image space, without being influenced by the light in other areas. Typically, spot metering employs a reading from a central circle covering just 2–4% of the frame; partial metering works by measuring light from a larger area – usually 10–14%. Spot is a common metering system, found on the majority of DSLRs, while partial metering is found on only a few models, mostly Canon-made.

Spot and partial metering allow far more control over the accuracy of exposure than any other metering system. However, they also rely on greater input from the photographer, requiring them to point the metering spot directly towards the area of the scene they wish to meter from. By measuring the light from just a small percentage of the image space, it is possible to achieve a correct reading for relatively small, specific subjects within the frame. This is useful in a number of situations, but particularly when dealing with awkward, changeable light and high-contrast scenes – for example, when the background is much brighter than the subject due to backlighting (see page 107).

Although the metering circle is central in the viewfinder, most cameras allow the user to select an off-centre spot – for when the subject is not central. If your camera does not have this option, take a spot meter reading from the desired area and then employ autoexposure lock (AE-L) before recomposing the shot. Some cameras have a multi-spot option, which allows you to take several spot meter readings and then employ an average.

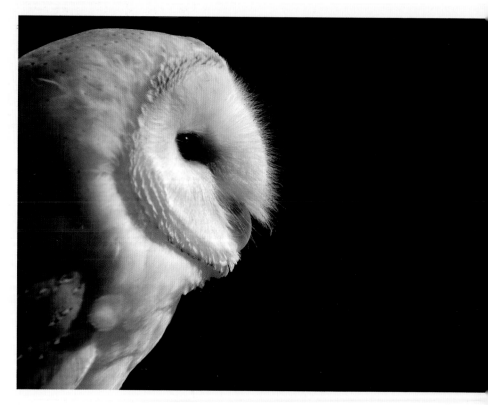

Spot and partial metering are highly useful tools, which, when used correctly, will help to ensure you achieve the exposure you desire. However, remember to switch your metering mode back to multi-segment metering when you have finished, as this is best suited to day-to-day photography.

Exposure tip

Exposure lock

The autoexposure lock (AE-L) button is a common feature on practically all DSLRs, permitting photographers to 'lock' the current exposure settings – regardless of changes to the incoming light levels through the viewfinder. In practice, this means you can take a meter reading from a small, specific area – typically using spot or partial TTL metering – and then lock the settings before recomposing the image and releasing the shutter.

As a result, your original reading will be unaffected by light or shadow in other parts of the frame and the region you metered from will be correctly exposed. Fail to lock exposure and your camera will automatically readjust the settings when the composition is rearranged. If shooting in manual exposure mode, autoexposure lock isn't required as settings are altered by the photographer, not the camera.

◀ *Barn owl*

The owl's white plumage strongly contrasts with the inky black background, creating a difficult scene to meter correctly. I feared my camera's multi-segment metering would be fooled, so instead I selected spot metering mode, and metered from the plumage on its head. I then locked the settings before taking the picture.

Nikon D200, 200mm, ISO 100, 1/1000sec at f/5, tripod.

Partial metering

Spot metering

Spot and partial metering base their light readings on a small percentage of the frame, making them the most accurate form of TTL metering. However, as a result, they also require the most input and care from the photographer.

Sensor technology

At the hub of a digital camera is its image sensor. Sensors are silicon chips. The most common types found in DSLRs are charge-coupled device (CCD) and complementary metal oxide semiconductor (CMOS). While they have differing characteristics, both types work in a similar way, with each capable of excellent results.

■ ■

Image sensors

Image sensors have millions of photosensitive diodes, called photosites, on their surface, each of which captures a single pixel. They are usually arranged in rows on the chip and are only sensitive to monochromatic light. Therefore, to create colour, the majority of image sensors are overlaid with a Bayer mosaic, which filters light into red, green and blue. Each individual diode reads the quantity of light striking it during exposure, which is then counted and converted into a digital number. This number represents the brightness and colour of a single pixel. The information is then converted into an electrical signal and the charges are processed row by row to reconstruct the image. (Charge-coupled devices get their name from how the information from the rows of pixels is joined together, or coupled.)

Finally, the picture information is passed to the storage media. It is remarkable to think that each time you take a picture your digital camera quite literally makes millions of calculations in order to capture, filter, interpolate, compress, store, transfer and display the shot. All of these calculations are performed in-camera by a processor – similar to the one employed in your desktop computer, but dedicated to this task.

Resolution

The number of pixels used to capture a photograph is known as the pixel count or resolution. So, for example, if a digital camera produces an image size of 5,760 x 3,840 pixels, its maximum resolution is 22.3 million pixels (5,760 multiplied by 3,840). The term 'mega-pixel' is commonly used to express 1 million pixels. Digital cameras are often referred to by their maximum resolution; so, for example, a 22-megapixel camera is one that is capable of recording upwards of 22 million pixels.

The number of pixels used to capture an image is important as it dictates how large the resulting photograph can be displayed or printed before image quality degrades. More pixels should equate to added detail and sharpness. Therefore, it is always best to employ your camera's highest resolution, for the simple reason that you can make an image smaller using photo-editing software, but you cannot make it larger while still retaining the original quality. Regardless of the number of megapixels used to capture an image, the square pixels will always begin to show if they are enlarged enough. This is known as pixellation. However, with many digital cameras now boasting a resolution of 18 million pixels or more, image quality remains outstandingly high even when images are printed or enlarged to A2 or bigger.

▶ *Sensor unit*
This image shows the sensor unit found in the EOS 5D Mark III. It is typical of the units incorporated in today's DSLRs. This particular CMOS sensor has an effective resolution of 22.3 megapixels; others boast upwards of 36 megapixels.

Image sensors

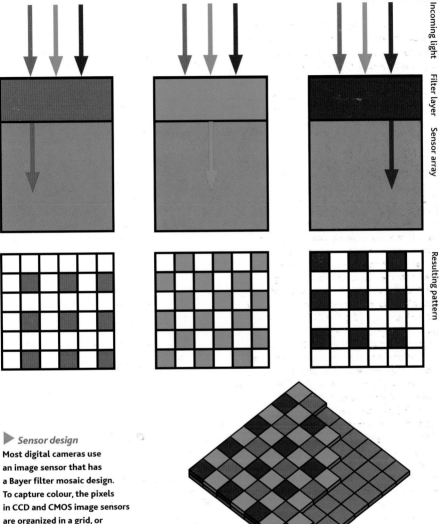

Incoming light

Filter layer

Sensor array

Resulting pattern

▶ *Sensor design*

Most digital cameras use an image sensor that has a Bayer filter mosaic design. To capture colour, the pixels in CCD and CMOS image sensors are organized in a grid, or mosaic, resembling a tri-colour chequerboard (see right). Each pixel is covered with a filter that only allows one wavelength of light – red, green or blue – to pass through to any given pixel location. The filter pattern has twice as many green 'pixels' as red or blue to mimic the human eye's greater resolving power for green light.

An alternative sensor design is the Foveon. This type employs three layers of pixels embedded in silicon. The layers are positioned to take advantage of the fact that silicon absorbs different wavelengths of light to different depths. The bottom layer records red, the middle records green and the layer at the top records blue. Each pixel stack directly captures all of the light at each point in the image to ensure it records colour other designs may miss.

Sensor size

Image sensors are produced in a variety of sizes: so-called 'point and shoot' compacts employ the smallest; large-format digital cameras boast the largest. While an increasing number of high-end DSLRs employ a 'full-frame' sensor – the same size of a traditional 35mm film frame – most consumer models use a smaller APS-C-size sensor. This is equivalent to the 'Advanced Photo System' size images, approximately 25.1 x 16.7mm. This is commonly regarded as a cropped-type image sensor and effectively multiplies the focal length of the lens attached, known as its multiplication factor. The degree of multiplication depends on the size of the sensor, but typically it is 1.5x. Therefore, a 50mm lens will effectively be 75mm when attached to a camera with this cropped-type design. This can be a disadvantage. For example, traditional wide-angle lenses lose their characteristic effect, meaning an even shorter focal length has to be employed to retain the same field of view. However, when photographing distant subjects, such as wildlife and action, the multiplication factor can be hugely beneficial.

Generally speaking, the larger the sensor the better quality the resulting picture will be. Bigger sensors have larger photosites, capturing more light with less noise, so images are smoother, more detailed and sharper. For this reason, it is actually possible for a larger sensor, with fewer pixels, to capture better quality images than a physically smaller sensor with a higher resolution.

▼ *Multiplication factor*
The effect of using a cropped-type sensor (2), compared to a full frame model (1), is obvious from these two images.

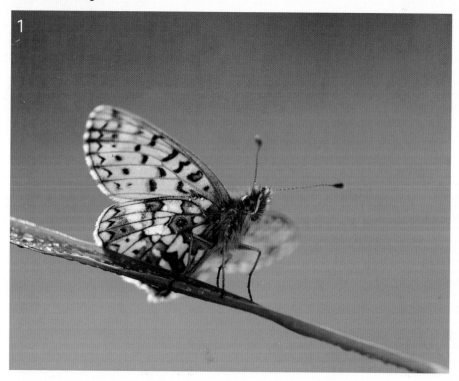

Four Thirds system

The Four Thirds system gets its name from the CCD image sensor it employs. The size of the sensor is 18 x 13.5mm (22.5mm diagonal). Therefore, its area is 30–40% less than the APS-C-size image sensors found in the majority of other DSLRs and its aspect ratio is 4:3 – squarer than a conventional frame, which has an aspect ratio of 3:2. It was devised by Olympus and Kodak with the intention of freeing manufacturers from the onus of providing compatibility with traditional camera and lens formats. The system has subsequently been supported by Panasonic and Sigma. The diameter of its lens mount is approximately twice as big as the image circle, allowing more light to strike the sensor from straight ahead, thus ensuring sharp detail and accurate colour even at the periphery of the frame. The small sensor effectively multiplies the focal length by a factor of 2x, enabling manufacturers to produce more compact, lighter lenses. The Four Thirds system is providing a growing challenge to more conventional systems.

Compact System Cameras (CSC)

More recently, a Micro Four Thirds system (MFT) was developed by Olympus and Panasonic. This is a mirrorless interchangeable lens digital camera. Unlike the preceding Four Thirds system, it is not an open standard, but it shares the image sensor size and specification with the original Four Thirds system. The Micro Four Thirds design, and other compact system cameras, does not provide space for a traditional mirror box and a pentaprism. In other words, they lack an optical viewfinder. Instead, users of micro system cameras use either the rear LCD screen or an electronic viewfinder to compose their images.

The main benefit of micro system cameras over DSLRs is that both cameras and optics can be produced smaller and lighter, making them ideal for travel. Also, because they house a significantly larger sensor than most compacts, image quality is far above that of a normal point-and-shoot or camera phone. Quite simply, they are designed to offer high image quality in a convenient, compact form.

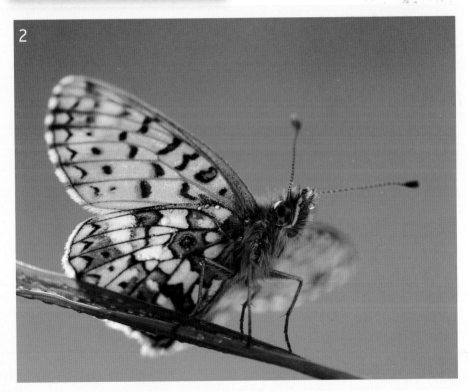

2

Dynamic range

This term is used to describe the ratio between the smallest and largest possible values of a changeable quantity. Within the realms of digital photography, it relates to the range of intensities that the camera's sensor can record in both shadow and highlight areas. Also referred to as contrast range or latitude, dynamic range is a term that was originally used in audio recording.

Our eyes have a remarkably wide dynamic range (up to 24 stops of light) and can distinguish between dark shadows and brightly lit areas with great speed and accuracy. However, a digital chip has a much narrower perception and can struggle to simultaneously record detail in the darkest and lightest areas. Therefore, if there is a large degree of contrast within your photo, the camera – unaided – will not be able to record all areas faithfully.

To simplify how a sensor records light, it can be useful to think of each of the sensor's millions of pixels as tiny, photon-collecting 'buckets'. The brighter the captured area, the more photons they collect. The level of each 'bucket' is assigned a discrete value: an empty bucket (pure black) is assigned a value of '0' while a full one is '255' (pure white). Once a 'bucket'

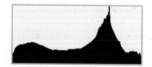

Exposure tip

It is possible to merge several bracketed images of an identical composition to create a high dynamic range (HDR) image (see page 180).

▶ *Coastal cliff top*
This image just remains within the sensor's dynamic range, with detail being retained in both the picture's highlights and shadow areas.

Nikon D700, 17–35mm (at 19mm), ISO 200, 10sec at f/22, polarizer, tripod.

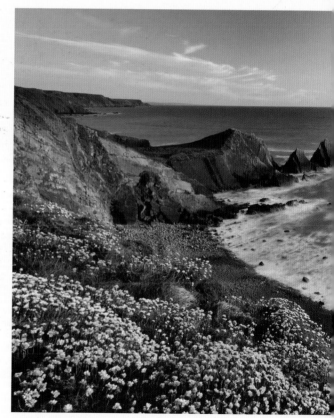

is full, it overflows. Anything that overflows gets lost; the value is recorded as 255, even though it actually should have been recorded as greater. In other words, highlight detail is lost or 'clipped'. To prevent this, you can reduce the length of exposure. However, then the pixels that correspond to the darker areas of the scene may not have enough time to capture a sufficient amount of photons and, as a result, might still have a zero or lower value, resulting in clipped or underexposed shadow areas.

As a result of a sensor's far more limited dynamic range compared to that of our eyesight, photographing high-contrast scenes can prove

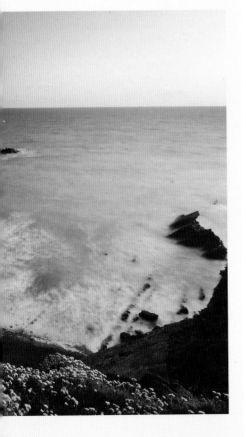

challenging. It can be difficult, if not impossible, to achieve a correct exposure in-camera – filtration or combining exposures (using photo editing software) may be the only practical solution, effectively extending the sensor's dynamic range.

In photography, dynamic range is often measured in stops of light. The latitude of a digital sensor is defined by the largest possible signal divided by the smallest possible signal it can generate. The largest signal is proportional to the full capacity of the pixel, while the lowest signal is the noise level when the sensor is not exposed to any light. Therefore, a digital camera's dynamic range will differ depending on the design of the chip and the manufacturer. The precision at which light measurements are translated into digital values is dictated by bit depth. The workhorse that converts these continuous measurements into numerical values is called the analog to digital (A/D) converter. Most modern DSLRs have a 12- or 14-bit A/D converter, resulting in a theoretical maximum dynamic range of 12–14 stops, although, in practice, most cameras have a more limited dynamic range than this. When this range isn't sufficient, photographers need to look at ways to extend their sensor's capabilities. If shooting scenics – when the contrast range between bright sky and dark foreground often extends beyond that of the sensor – it is possible to attach a graduated neutral-density filter (see page 156) to help balance exposure. Another effective way to retain detail throughout contrasty scenes is to shoot two or more photographs of the same scene using different lengths of exposure and then combine them during post processing (see page 178).

As technology advances, dynamic range is being extended. Full-frame models in particular benefit from increased dynamic range due to their larger photosites and ultimately the need for filtration or combining exposures may well become a thing of the past.

Histograms

The histogram is without doubt the most useful of all the tools available to digital photographers. It allows you to assess exposure, and quickly and easily identify if an image is correctly exposed or whether it needs to be re-shot with a degree of compensation applied. Basically, it will help ensure you never make large exposure errors ever again.

A histogram is a two-dimensional graph, often resembling a range of mountain peaks, which represents an image's tonal extent. The horizontal axis of a histogram represents the picture's range from pure black (0, far left) to pure white (255, far right); whilst the vertical axis illustrates how many pixels have that particular value. If a histogram shows a large number of pixels grouped at either edge, it is often an indication of a poorly exposed image, with either lost shadow or highlight detail. A graph showing a narrow peak in the middle with no black or white pixels indicates a low contrast image.

Generally speaking, a histogram should show a good spread of tones across the horizontal axis, with the majority of pixels positioned close to the middle (128, mid-point). Usually, it is best to avoid peaks to the far right of the graph, as this tends to be an indication of 'clipped' (overexposed) highlights, resulting in lost data. However, when assessing a histogram, it is important to consider the brightness of the subject itself. For example, a scene or subject boasting a large percentage of light or dark tones, such as snow or a silhouette, will naturally affect the overall look of the resulting graph. Therefore, it is impossible to make generalizations about what is and isn't a good histogram. While an even spread of pixels throughout the greyscale is often considered to be desirable you will need to employ your own judgement and discretion.

Digital cameras allow you to view, or overlay, a picture's histogram in the camera's LCD monitor via playback, making it easy to assess exposure immediately after taking the photo. Some models will even display a 'live' histogram in a 'Live View' mode (see page 66). The histogram is a far better method of assessing exposure than looking at the LCD picture display. This is because it can be difficult – if not impossible – to make an accurate assessment of a replayed photo when there is light reflecting from the monitor. This is particularly true when outdoors.

▼ *Histograms*

A histogram with pixels predominantly skewed to the left or right is often (although not always) an indication of poor exposure, while one showing the pixels evenly distributed throughout the graph is normally an indicator of good exposure. However, a histogram simply tells us how a picture is exposed, allowing photographers to decide whether – and how – to adjust exposure settings.

▼ dark histogram

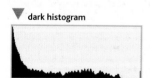

▼ correct histogram

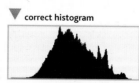

▼ light histogram

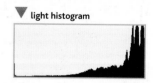

It is worth noting that when shooting in Raw (see page 68), the corresponding histogram displayed on the camera's LCD is actually based on a simulated Jpeg created simultaneously. The actual Raw file itself tends to have a greater latitude then indicated. Therefore, even if the histogram suggests that a photo is slightly overexposed, in reality it may not be and detail is often easily recovered when processing the file in your Raw converter.

▼ *Mute swan*

Studying an image's histogram will quickly help you to identify exposure errors and allow you to correct them there and then. Predominantly light and dark subjects usually prove the most challenging for metering systems. For example, when I photographed this swan, its light white plumage initially fooled my camera into underexposure.

However, by looking at the corresponding histogram, I recognized the problem immediately, as the graph was skewed to the left. I applied positive exposure compensation to lighten the image and re-shot, before checking the histogram again to ensure that the highlights weren't clipped.

Nikon D300, 70–200mm (at 200mm), ISO 400, 1/1600sec at f/8, handheld.

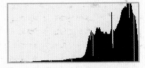

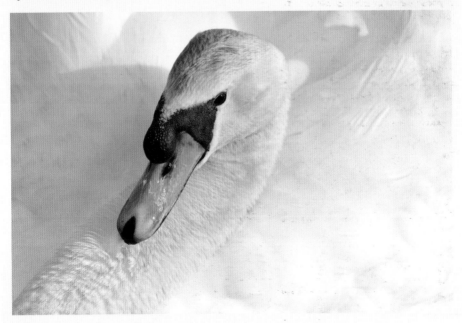

Histograms in practice

The general rule when interpreting histograms is to strive to achieve a reasonable spread of tones, covering at least two thirds of the graph, with its average slightly left of the mid-tone point. But, while this might be fine in theory, in practice it isn't that straightforward, or even desirable. Deliberately under- or overexposed images, such as silhouettes (see page 108) and high- and low-key images (see page 38), will produce histograms with peaks either towards the far left (black) or far right (white). Equally, photographs taken of a scene or subject possessing a large percentage of light or dark tones will have a corresponding histogram weighted to one edge of the graph. This doesn't mean the photograph is incorrectly exposed; the histogram is simply representative of the subject.

The following three images are all 'correctly' exposed, yet their histograms appear vastly different. See how the subject matter affects the resulting graph. The images help to illustrate that whilst histograms are an essential aid to exposure, they come in all shapes and sizes and photographers need to learn how to interpret them depending on the subject matter.

► *Knife and fork silhouette*

Nikon D200, 150mm, ISO 100,
1/80sec at f/11, tripod.

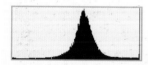

► *Backlit leaf*

Nikon D3x, 150mm, ISO 200,
1/30sec at f/11, tripod.

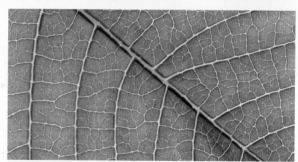

► *Snowdrop in snow*

Nikon D300, 150mm, ISO 200,
1/200sec at f/4, handheld.

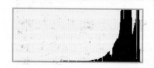

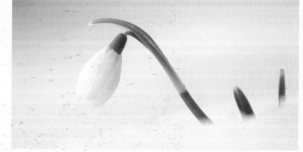

Exposure warnings – the highlights screen

Most digital cameras are designed with a playback function known as the 'highlights screen'. This useful function provides photographers with a graphic indication of when areas of the image are overexposed. This 'exposure warning' can prove a valuable and highly useful in-camera tool to help prevent you clipping highlights.

While histograms provide a graphic illustration of an image's tonal extent, helping you assess exposure overall, the highlights screen – or highlights alert – is aimed specifically at helping photographers to avoid highlights burning out. White or very light subjects in direct sunlight are especially prone to this. A histogram with a sharp peak to the far right

will normally indicate that an image is suffering from areas of overexposure. However, the highlights alert actually identifies the pixels that exceed the value for pure white (255). Pixels that do so are not given a value, meaning they cannot be processed and are effectively discarded – having no detail or information recorded. When the image is replayed on the camera's LCD monitor the pixels falling outside the camera's dynamic range flash or blink, providing a quick and graphic illustration of where picture detail is 'burned out' and devoid of detail. To rectify this, set a degree of negative exposure compensation (see page 58) so that the subsequent frame is recorded darker.

A digital camera's highlights alert is not always switched on by default. Therefore, consult your user's manual and switch it on when you feel this type of exposure warning would prove useful. Normally this is done via the camera's Playback Menu.

▼ *Highlights screen*
The highlights alert causes groups of pixels that have exceeded the sensor's dynamic range – and are therefore recorded without detail – to flash as a warning. In this instance, the areas of the sky close to the bright, rising sun are 'burnt out'.

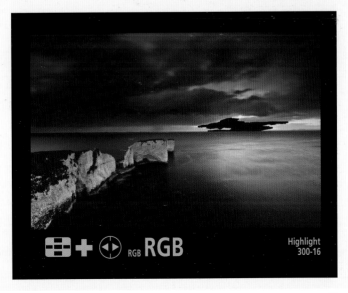

Exposing to the right

Exposing to the right (ETTR) is a technique designed to help photographers maximize image quality. It is only applicable to photographers capturing their images in Raw, where the photographer 'pushes' their exposure as close to overexposure as possible, but without actually clipping the highlight areas. The result is a histogram with the majority of pixels grouped to the right of mid-point – hence why it is known as 'exposing to the right'.

The argument for exposing to the right is best understood once you appreciate that camera sensors count light photons in a linear fashion. Linear capture has important implications for exposure. For example, typically, a digital camera is able to capture around six stops of usable dynamic range (see page 28). Most DSLRs record a 12-bit image capable of recording 4,096 tonal values. However, while you might presume that each stop of the six-stop range would record an equal amount of the tonal value total, this isn't so. The level corresponds exactly to the number of photons captured so, in reality, each stop records half the light of the previous one.

Linear distribution

At first, this may seem a little confusing and irrelevant. However, in simple terms, what this signifies is that if you do not properly use the right of the histogram, which represents the majority of the tonal values, then you are wasting the majority of your camera's available encoding levels. If an image is badly underexposed, you are wasting a large percentage of the data the camera is capable of capturing. Also, if you then attempt to brighten it during processing, the tonal transitions will not be so smooth and the risk of 'posterization' (abrupt changes in tone and shading) is greatly enhanced. However, if you do the opposite so that more data is recorded in the sensor's brighter stops, you will capture far more tonal information. This is easy to illustrate by simply taking two images – one at a 'normal' exposure and the other successfully exposed to the right. Now compare the file size; the difference can be several megabytes, with the ETTR image being larger with far more data recorded.

To get the most out of an ETTR file, good processing technique is essential (see page 166). The unprocessed Raw file will look too bright and washed out. In fact, ETTR images can look quite awful when reviewed on the camera's monitor, which can deter photographers from using the technique. However, once the image is downloaded onto your computer and exposure, brightness and contrast are adjusted in Raw processing software, the final image will look correct.

Admittedly, ETTR requires more time, thought and effort, but the final result is an image with more tonal information and boasting smoother tonal transitions. Another key benefit of ETTR is cleaner, less noisy images. To some degree, noise is present in all digital images, even pictures taken at low ISOs. However, it is most obvious in the shadow areas. By biasing the exposure towards the highlights, noise is kept to a minimum.

So, while it remains important not to actually overexpose images to the degree where the value for pure white is blown, when practical to do so, it is always good practice to 'expose to the right'. While the method needs applying with care, and relies heavily on using the histogram to avoid clipping, image quality is maximized.

Exposure tip

'Exposing to the right' means biasing your exposures so that the histogram graph is pushed up to the right edge, but not to the point where the highlights are blown. It is a fine line between getting this correct and overexposing the image. Apply positive exposure compensation to brighten the image, in small 1/3-stop increments, until the graph is nuzzling the right edge.

64 128 256 512 1,024 2,048 levels (half of total)

While the look of your histogram will vary depending on what you are photographing, when adopting the 'expose to the right' approach, the majority of the pixels should be right of mid-point. Try to push exposure as close to the right of the graph as possible without 'clipping' the value for pure white. The resulting histogram may look similar to this one.

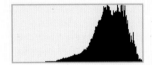

▲ *Dynamic range*
This illustration represents six stops of dynamic range – the typical latitude of a digital camera. The majority of DSLRs are capable of capturing at least a 12-bit image capable of recording 4,096 tonal levels. Half of these (2,048 levels) are devoted to the brightest stop, half of the remainder (1,024 levels) are devoted to the next stop and so on. The last and darkest stop – on the far left of the graphic and representing the shadow areas – has only 64 levels, so is able to record less detail as a result.

▼ *Restoring colour and contrast*
When exposing to the right, the unprocessed Raw file may look washed out on the camera's monitor and when first downloaded onto your computer (1). However, as long as you have used your camera's histogram screen to ensure the highlights aren't actually clipped, colour and contrast can be quickly restored during conversion (2).

Nikon D700, 17–35mm (at 17mm), ISO 200, 2sec at f/16, polarizer, tripod.

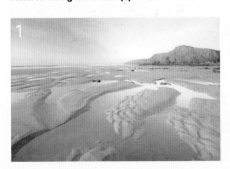

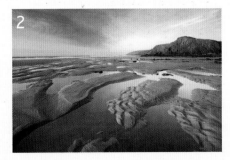

Overall exposure brightness

Contrast is a regularly used term, describing the subjective difference in brightness between the light (highlights) and dark (shadows) areas of an image. Photographs with a wide tonal range – with dark shadows and light highlights – are said to be high contrast, while photographs possessing lots of similar shades are regarded as being low contrast.

High

Low

Contrast is the difference in visual properties that makes a subject distinguishable from other objects and its background. In visual perception, contrast is determined by the difference in the colour and brightness of the subject and other objects within the same field of view. It can have a significant visual impact on our images. High-contrast images have deeper shadows and more pronounced highlights, helping to accentuate texture, shape and a subject's three-dimensional form. A low-contrast image can appear quite flat, with little difference in the density of its colours or tones, but appear atmospheric and subtle. Both high- and low-contrast images can work well combined with the right scene or subject.

Contrast is greatly influenced by the direction and intensity of light. It is greater under direct lighting conditions; for example, point light sources, such as the sun, or when light is positioned to the side or directly above the subject. If lighting is diffused, or the light source is in front of the subject, the degree of contrast is reduced. A low-contrast image may also result because of the subject matter or conditions; for example, photographs taken in fog, mist or smoke will have little contrast.

An image's histogram (see page 30) can be used to evaluate its contrast. A broad histogram, demonstrating a wide tonal range from dark to light, reflects a scene with good contrast. However, a narrow histogram signifies low contrast and the resulting picture may look flat. Contrast can be remapped post capture using tools like levels or curves (see page 172). This is useful

▲ **High- and low-contrast**
These two illustrative histograms demonstrate how the tonal extent of both a high- and low-contrast image differs.

▶ **Misty morning**
This photo of autumnal trees, taken early one misty morning, is a good example of a low-contrast image. In this instance, the narrow contrast is caused by the weather conditions and while – due to the lack of contrast – the image may look quite flat and one-dimensional, the result is atmospheric and faithful to the original scene.

Nikon D200, 100–300mm (at 270mm), ISO 100, 1/20sec at f/11, tripod.

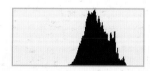

in situations where, due to a sensor's limited latitude, a picture is recorded with less contrast than is faithful to the original scene. Alternatively, you may simply wish to alter an image's contrast to enhance its impact.

Exposure tip

Low-contrast images, particular those caused through atmospheric conditions such as mist or fog, can look very striking. Therefore, don't enhance contrast artificially post capture – doing so will destroy your images' authenticity.

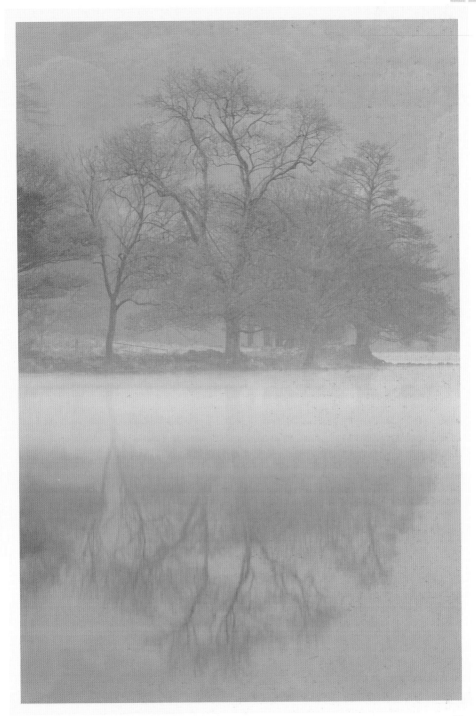

High- and low-key images

'High key' and 'low key' are terms used to describe exposures that are predominantly light or dark. High key refers to an image that is light in tone overall. An image that is dark, with the majority of the tones occurring in the shadows, is deemed low key. While you might imagine that due to their nature, high- and low-key images would lack impact, in reality this approach can create striking results.

High key is a photographic style where the image is predominantly white or brightly lit; in other words, there is little mid-range tonality. Low key is where the subject is surrounded by dark tones and in which there are few highlights. Both styles intensively use contrast and can be used to convey differing moods. High-key images are light, bright and often considered positive, while low-key images are often dramatic and atmospheric.

High-key images have little or no shadow and lack contrast, with the subject rendered in a light tone similar to that of the background. There are few middle tones and, in addition to the tone being bright, it will often be quite even across the image. One of the best high-key subjects is people,

▼ *Swan*

High-key images are mostly light in tone, often with both the subject and background brightly lit. Photographing a swan against a light, misty background created a simple, high-key result.

Nikon D300, 70–200mm
(at 200mm), ISO 200,
1/200sec at f/7.1, handheld.

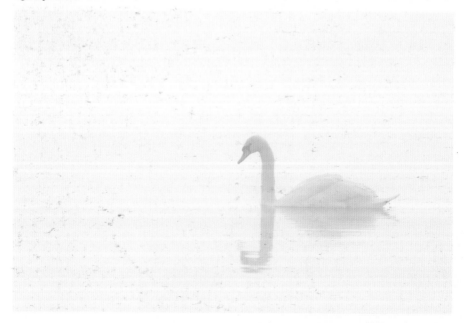

Histograms for high-key images will often show peaks to the far right, while low-key images will show peaks grouped left of the mid-tone point.

with the sitter being photographed against a white background, often dressed in white or light clothing. Exposure levels generally need to be high, but images shouldn't be overexposed. With low-key photographs the tone is dark, and the controlling colour is usually black. Special attention will usually be given to the subject's shape, form and curves – often emphasizing them with highlights – to provide the picture's interest and impact. Low-key images tend to have a reasonably high level of contrast.

Before you take a picture, it is useful to identify whether or not your subject qualifies as high or low key. Cameras measure reflected light, opposed to incident light (see page 16), so they are unable

to evaluate the absolute brightness of the subject. Cameras employ sophisticated algorithms to try to circumvent this limitation, which estimates the image's brightness. This estimate will often place brightness in the mid-tones and, while this is acceptable for most subjects, it will often result in high- and low-key images being incorrectly exposed. Therefore, high- and low-key images often require a degree of manual exposure adjustment relative to what the camera would do automatically. For example, high-key images often require longer exposure than recommended, with low-key images needing less exposure time.

▼ *Uncurling fern*

Low-key images are dark in tone and rely on either highlights or colour to highlight the subject's shape and form.

Nikon D300, 150mm, ISO 200, 1/15sec at f/16, tripod.

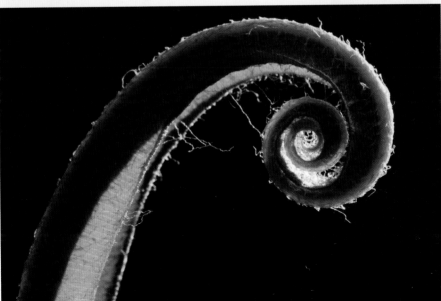

Exposure value (EV)

The 'law of reciprocity' (see page 56) states that the relationship between aperture and shutter speed is proportional. As a result, a 'technically' correct exposure can be made by using a variety of lens aperture and shutter speed combinations. For example, if an exposure of 1/125sec at f/5.6 is correct, then it is also possible to employ settings of 1/250sec at f/4 or 1/60sec at f/8 and maintain the same amount of light reaching the sensor. The exposure value (EV) number represents all combinations of aperture and relative shutter speed that can be selected to produce the same level of exposure.

The EV concept was developed in Germany during the 1950s in an attempt to simplify choosing among combinations of equivalent camera settings. Every combination of lens aperture, shutter speed and sensitivity refers to an exposure value for a given ISO. The EV is a number that – when used in

▼ *Oilseed rape*

While all camera settings with the same EV number will create the same level of exposure, the resulting pictures can differ greatly. These images were both taken using the same EV. However, due to the different aperture and shutter speed combinations employed, motion is recorded very differently. Remember that the shutter speed dictates the amount of motion blur and the relative aperture determines the level of depth of field.

Nikon D300 12–24mm (at 12mm), EV 10, ISO 100, polarizing filter, tripod. (1) 1/15sec at f/8 and (2) 1sec at f/32.

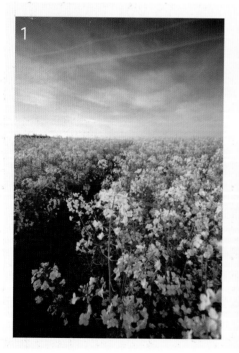

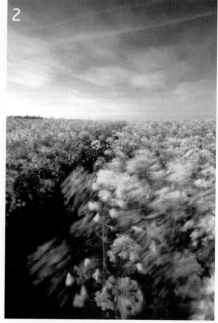

The numbers stated in an EV chart relate to a specific ISO rating, typically 100. If the ISO sensitivity is different, then you will need to adjust exposure accordingly. For example, if you are using 200 ISO, then you need to adjust the above settings by -1 stop.

	f/1.0	1.4	2.0	2.8	4.0	5.6	8.0	11	16	22	32
1 sec	0	1	2	3	4	5	6	7	8	9	10
1/2	1	2	3	4	5	6	7	8	9	10	11
1/4	2	3	4	5	6	7	8	9	10	11	12
1/8	3	4	5	6	7	8	9	10	11	12	13
1/15	4	5	6	7	8	9	10	11	12	13	14
1/30	5	6	7	8	9	10	11	12	13	14	15
1/60	6	7	8	9	10	11	12	13	14	15	16
1/125	7	8	9	10	11	12	13	14	15	16	17
1/250	8	9	10	11	12	13	14	15	16	17	18
1/500	9	10	11	12	13	14	15	16	17	18	19
1/1000	10	11	12	13	14	15	16	17	18	19	20
1/2000	11	12	13	14	15	16	17	18	19	20	21
1/4000	12	13	14	15	16	17	18	19	20	21	22

conjunction with an exposure value chart – gives the appropriate combinations of exposure settings that maintain the same amount of light reaching the sensor. For example, 0 EV is equivalent to an exposure setting of f/1 at 1sec at an ISO sensitivity of 100. Each time you halve the amount of light collected by the image sensor – for example, by doubling the shutter speed or by halving the aperture – the EV will increase by one. Basically, each one-unit change in EV is equal to a 1-stop adjustment in exposure. High EV numbers will be used in bright conditions requiring a low amount of light to be collected by the camera's sensor to avoid overexposure, while low EVs will be employed when there is less available light and a greater degree of exposure is needed to avoid underexposure.

EV charts

The relationship between shutter speed and lens aperture is proportional – make an increase in one value, and you must make a proportional reduction in the other to maintain the same level of exposure and vice versa. Therefore, simple tables of exposure values can be calculated relatively easily for any given aperture.

Exposure value charts like this may look quite daunting at first, but they are actually quite straightforward to interpret. The value on the left relates to the shutter speed in seconds and the value along the top refers to lens aperture. Typically, an EV chart will include an aperture range from f/1 to f/32 – it is unusual for a camera lens to have a range exceeding this. While the concept of EV may not prove quite so useful or relevant to photographers today, they do allow you to take photographs fairly reliably under certain lighting conditions without a light meter.

ISO sensitivity

ISO (International Standards Organization) is a numeric indication of a photographic material's sensitivity to light. This standard measurement was originally used to show the speed of film. However, since digital cameras use an image sensor instead, the term is now used to refer to the ISO equivalent. Therefore, ISO signifies how sensitive a digital camera's sensor is to the amount of light present. When using film, photographers had to change film to alter ISO speed. In contrast, digital photographers can quickly and conveniently alter the ISO rating for individual images.

A digital camera's ISO range varies from camera to camera, but many today have a large and useful sensitivity range, typically ranging from either ISO 50 or 100, up to a staggeringly high 204,800 on some DSLRs. The ISO setting you employ has a huge bearing on exposure, being directly related to the combination of shutter speed and aperture needed to obtain a correct result. For example, at low sensitivities, more light is required to enter the camera in order to expose the image. Therefore, either a longer shutter speed or larger aperture

is required. At higher ISO sensitivities – for example, 1600 or 3200 – the sensor is more sensitive and therefore requires less light to obtain the correct exposure. As a result, a faster shutter speed or a smaller aperture is needed. Photographers will usually increase the ISO in order to generate a faster shutter speed, which is desirable when shooting action or in low light. However, by increasing the ISO, digital noise will also be enhanced. Noise appears like grain, obscuring fine detail and degrading overall image quality. It is for this reason that it is best to employ your camera's lowest ISO setting whenever practical. For example, when using a tripod or shooting static subjects, it is usually best to keep ISO at its base setting. However, the high ISO performance of most modern DSLR cameras is so good today that photographers can confidently work at speeds of ISO 800 or more without seeing any great reduction in image quality. Advances in high ISO performance – particularly in full-frame models – are hugely beneficial to sports, action and wildlife photographers who often require rapid shutter speeds to freeze their subject's movement.

Changes to ISO ratings are measured in stops – just as they are for adjustments to aperture and shutter speed. This helps to simplify exposure calculations. Each time the ISO rating is doubled it is the equivalent to one stop. For instance, adjusting sensitivity from ISO 100 to 200 will generate 1 stop of light, ISO 400 will generate 2 stops, and so on.

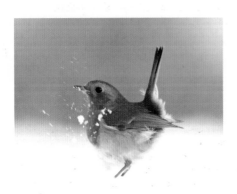

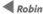 *Robin*

To generate a shutter speed fast enough to freeze this robin's movement, I selected a setting of ISO 400. This gave me an extra two stops of light, compared to the camera's lowest rate. While this caused a slight increase in noise, it enabled me to take pin-sharp images that didn't suffer from subject blur.

Nikon D300, 120–400mm (400mm), ISO 400, 1/500sec at f/5.6, handheld.

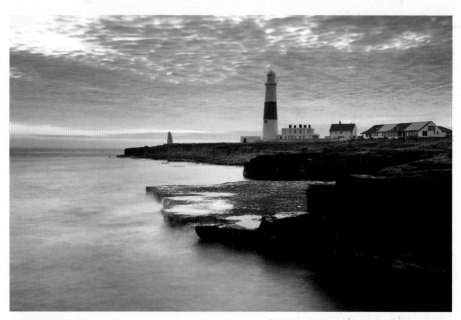

▲ *Lighthouse sunset*

Noise is almost invisible at low ISOs on modern DSLRs. When shooting static subjects, such as landscapes, always select your camera's base ISO setting in order to maximize image quality.

Nikon D800, 17–35mm (at 20mm), ISO 100, 10sec at f/16, tripod.

Noise

In conventional photography, high ISO films are more responsive to light due to the fact that the silver halide crystals are larger. As a result, the film and the image produced is grainier, which degrades image quality. In digital photography, employing a high ISO rating creates a similar effect, known as 'noise'. This refers to unrelated, brightly coloured pixels that appear randomly throughout the image, and is a result of electrical interference between the photodiodes that form a digital camera's sensor. While noise will hardly be noticeable at a camera's lowest ISO rating, when light sensitivity is increased, the interference – or signal noise – is also amplified. In principle, the effect can be compared to turning up the volume of a radio with poor reception. Doing so

not only amplifies the (desired) music, but also the (undesired) interference. Noise can also grow more obvious in pictures taken using a shutter speed longer than 1sec, as it can amplify while the sensor is active. For this reason, many DSLR cameras have a noise-reduction (NR) facility. This works by taking a dark frame and then subtracting the background noise from the final image.

Advances in sensor technology are steadily reducing the effects of noise, to the point that even at relatively high ratings, upwards of ISO 800, image quality remains excellent. However, it is still advisable to always select the lowest ISO practical in any given situation.

Lens apertures

Aperture is the common term relating to the iris diaphragm of a lens. It consists of thin blades that can be adjusted inward or outward to alter the size of the almost-circular hole – the lens aperture – through which light passes. Like the pupil of an eye, controlling the size of the lens iris determines the amount of light that enters the lens to expose the sensor. Varying the aperture alters the level of depth of field.

Lens apertures are stated in numbers – or f-stops. Typically, this scale ranges from f/2–f/32. However, it will depend on the lens itself, with some having more or fewer settings. The f-numbers stated below relate to whole-stop adjustments in aperture:

f/2.8	f/4	f/5.6	f/8	f/11	f/16	f/22	f/32

What is a stop?

In photography magazines and books – including this handbook – the term 'stop' is regularly used. One of the keys to controlling exposure is understanding the significance of the 'stop'. In the context of photography, a stop is a unit of measurement relating to light. A stop is equivalent to doubling or halving the quantity of light entering the camera – either via the lens aperture, ISO sensitivity, or the duration of the shutter speed (see page 50). For example, if you increase the size of the aperture from f/11 to f/8 you are effectively doubling the amount of light reaching the sensor by 1 stop. If you increase the shutter speed from 1/250sec to 1/500sec you are halving the length of time the shutter remains open by 1 stop.

Most modern DSLRs also allow photographers to alter aperture size in 1/2- and 1/3-stop increments, for greater exposure precision.

The f-number corresponds to a fraction of the focal length. For example, f/2 indicates that the diameter of the aperture is half the focal length; f/4 is a quarter; f/8 is an eighth, and so on. With a 50mm lens, the diameter at f/2 would be 25mm; at f/4 it is 12.5mm, and so forth.

A lens's aperture range is often referred to by its maximum and minimum settings. The maximum – or fastest – aperture relates to the widest setting of the lens iris; while closing it down to its smallest setting – allowing the least amount of light through – is the minimum aperture. Many zooms have two maximum apertures listed, for example 70–300mm, f/4–5.6. This indicates that the lens's maximum aperture changes as you alter focal length.

F-numbers often cause confusion, particularly among new photographers. This is because of the way a large (wide) aperture is represented by a low number, for example f/2.8 or f/4; and a small f-stop – when the aperture is closed down – is indicated by a large figure, like f/22 or f/32. At first this might seem to be the opposite way round to what you would imagine. Therefore, to help you remember

which value is bigger or smaller, it can be helpful to think of f-numbers in terms of fractions; for example, 1/8 (f/8) is smaller than 1/4 (f/4).

Lens aperture is determined by the size of the hole in the iris diaphragm through which light passes. Small apertures create the greatest depth of field and are denoted by larger f-numbers; large apertures produce a more limited depth of field and are indicated by smaller f-numbers. Apertures are one of the key variables controlling exposure.

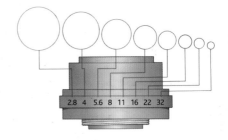

2.8 4 5.6 8 11 16 22 32

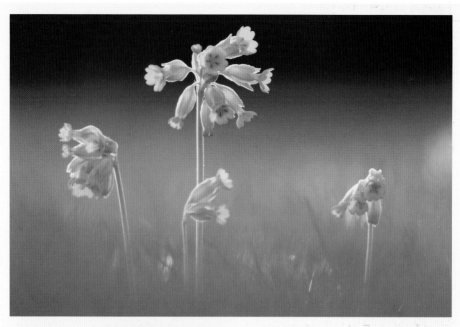

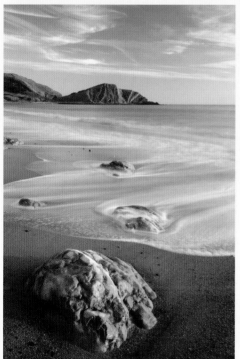

▲ *Cowslip*
The aperture affects the depth of field recorded. A large aperture (lower number) will create a shallow depth of field, ideal for isolating a subject from its surroundings.

Nikon D300, 100–200mm (at 200mm), ISO 200, 1/100sec at f/4, tripod.

◀ *Dorset coastline*
By selecting a small aperture (higher number), depth of field will be extensive – ideal for scenic images. In this instance, I prioritized a small f-stop to ensure both the boulders in the foreground and distant coastline were recorded acceptably sharp.

Nikon D300, 10–20mm (at 20mm), ISO 100, 4sec at f/20, 2-stop ND grad, polarizer, tripod.

Depth of field

Adjusting the size of the aperture alters the speed at which sufficient light can pass through the lens to expose the image sensor. Select a large aperture (small number) and light can pass quickly, so the corresponding shutter speed is faster; select a small aperture (large number) and the exposure will take longer, resulting in a slower shutter speed. This has a visual effect, with the aperture determining the area in your image that is recorded in sharp focus. This zone is known as depth of field.

Depth of field is a crucial creative tool. At large apertures, like f/2.8 or f/4, depth of field is narrow. This will throw background and foreground detail quickly out of focus, reducing the impact of any distracting elements within the frame and helping to place emphasis on your subject or point of focus

– ideal for action, portrait and close-up photography. Select a small aperture, such as f/16 or f/22, and depth of field will be extensive. This will help capture good detail throughout the shot and is particularly well suited to landscape photography, when you will often want everything – from your foreground to infinity – to appear acceptably sharp.

While the lens aperture is the overriding control dictating the level of depth of field achieved, it is also affected by the focal length of the lens, the subject-to-camera distance and the point of focus. This is useful to know in situations where you want to maximize the zone of sharpness without altering the f-number. For example, longer focal length lenses produce a more restricted depth of field than those with a shorter range. Wide-angle lenses can produce extensive depth of field, even at relatively large apertures. The distance between the camera and the object being photographed also has a bearing on depth of field – the closer you are to the subject, the less depth of field you will obtain in the final image. This is one of the reasons why it can prove so challenging to achieve sufficient focus when shooting at high magnifications.

Finally, the exact point at which you focus the lens will affect where depth of field falls in the final image. Depth of field extends from approximately one third in front of the point of focus to roughly two thirds behind it, so it can be maximized by focusing on the hyperfocal distance (see page 48).

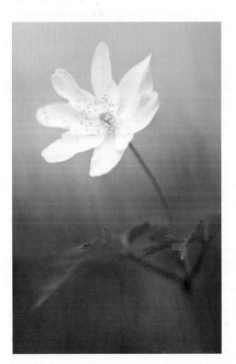

◀ *Wood anemone*
It is important to achieve just the right amount of depth of field. Too little, and your subject may not be recorded sharp throughout; too much, and distracting back- and foreground objects may become too prominent and conflict with your main subject. To help achieve the right balance, use your camera's depth of field preview button if it has one.

Nikon D300, 150mm, ISO 200, 1/125sec at f/5.6, tripod.

Depth-of-field preview button

To ensure the viewfinder is always at its brightest (so as to assist viewing and focusing), cameras are designed to automatically set the lens's fastest (maximum) aperture. As a result, what you see through the viewfinder isn't always a fair representation of the level of depth of field that will be achieved in the final shot. A depth of field preview button allows photographers to properly assess how the final image will appear at the aperture selected.

It works by stopping the lens down to the chosen f-stop. When you do this, the scene will darken in the viewfinder – the smaller the aperture, the darker the preview – but you will be able to assess whether the aperture selected provides sufficient depth of field. If not, simply adjust the aperture accordingly. While this function can take a while to get used to, it can prove highly useful. However, it may be helpful to reduce the aperture gradually, stop by stop, so that changes in depth of field are more obvious. The button is usually located close to the lens mount. Not all cameras have this facility, though. If yours doesn't, assess depth of field by shooting a test shot and then review it via image playback.

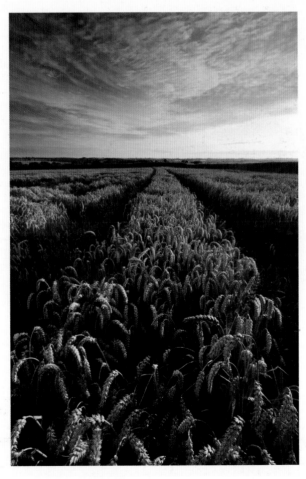

▶ *Cornfield*

When you require front-to-back sharpness – for example, when shooting scenic images – prioritize a small aperture to achieve a large depth of field. In this instance, f/16 allowed me to keep everything within the frame sharp.

Nikon D700, 17–35mm
(at 17mm), 1/10sec at f/16,
3-stop ND grad, tripod.

Hyperfocal distance

A lens can only focus precisely at one given point: sharpness gradually decreases on either side of this distance. However, the reduction in sharpness within the available depth of field is imperceptible under normal viewing conditions. Depth of field extends about one third in front of the point of focus and two thirds beyond it. The hyperfocal distance is the focal point where the photographer is able to maximize depth of field for any given aperture. Calculating and focusing on this point is important if you require extensive depth of field, so the principal is particularly relevant to landscape photography. When a lens is correctly focused on the hyperfocal point, depth of field will extend from half this distance to infinity.

Due to the way depth of field falls one third in front of the point of focus and two thirds beyond it, photographers are often advised to simply focus approximately one third of the way into the scene in order to maximize depth of field. While this is a fairly rough and imprecise method, it is a good tip and works is many shooting situations. It is certainly preferable to simply focusing on infinity, when the depth of field falling beyond your point of focus is effectively wasted. However, when you require a large depth of field to keep both your foreground and distant subjects acceptably sharp, you should opt for the precision of focusing on the hyperfocal distance. While this is a technique that can cause confusion among photographers, it is not as complex as it might first seem. In fact, if you are using a prime lens with good distance and depth of field scales on the lens barrel, it could hardly be easier: switch to manual focus and align the infinity mark against the selected

aperture. However, few modern lenses – particularly zooms – are designed with adequate scales, meaning photographers normally have to calculate and estimate distance themselves. Thankfully, there is a variety of depth of field calculators and hyperfocal charts available to download online that are designed to make this far easier. Conveniently, you can even get 'hyperfocal distance' applications for smart phones – simply enter the f/number and focal length in use, and it will calculate the distance for you. For more information, see the list of useful websites on page 190. Alternatively, below are two hyperfocal distance charts that cover a range of the most popular focal lengths, at various apertures, for both full-frame and APS-C size sensors. Copy the chart for your camera type, laminate it and keep it handy when composing and focusing your shots. Again, switch to manual focus when focusing on the hyperfocal distance for accuracy.

Frustratingly, even when you have calculated the hyperfocal distance, it can prove quite difficult focusing your lens to a specific distance as many modern lenses have rather perfunctory distance scales; for example, a lens may only have 1.5ft, 2ft, 3ft, 5ft and infinity marked on their distance scale. This is inadequate and, as a result, photographers often have to employ a degree of guesswork when adjusting focus. However, often the hyperfocal point is less than 12ft (3.6m) away, and most people can judge distance fairly accurately within this range. Therefore, if you know the hyperfocal point is, say, 6.4ft (2m), look for an object that is approximately this distance away, focus on it, and then don't adjust your focusing until after you've finished taking the shot. While this method isn't quite exact, it is near enough. When selecting the hyperfocal distance, it is worth allowing a little margin for error, by focusing slightly beyond the exact hyperfocal point.

It is a good habit to employ hyperfocal focusing whenever practical. It is particularly important when shooting images with nearby foreground interest.

Exposure tip

When you set the hyperfocal distance, you may notice the viewfinder image appears unsharp. This is because your lens is set to its widest aperture to provide a bright viewfinder image, so depth of field appears limited. Trust in the technique, though. To get a true representation of how depth of field is distributed at the selected f/stop, press your camera's preview button.

The charts below give the approximate value for the hyperfocal distance, depending on sensor type, focal length and aperture. Once you have focused on the pre-determined distance, do not adjust focal length or aperture. If you do, you will need to recalculate. Remember, using this technique, everything from half the hyperfocal distance to infinity will be recorded acceptably sharp.

Hyperfocal distance – APS-C-size sensors

Focal length	12	15	17	20	24	28	35	50
Aperture f/8	3¹/₄ft (1m)	5ft (1.5m)	6¹/₂ft (2.0m)	9ft (2.7m)	12¹/₂ft (3.8m)	17ft (5.2m)	27ft (8.2m)	55ft (16.8m)
f/11	2¹/₄ft (0.7m)	3¹/₂ft (1.1m)	4¹/₂ft (1.4m)	6¹/₄ft (1.9m)	9ft (2.7m)	12ft (3.66m)	19ft (5.8m)	39ft (11.9m)
f/16	1³/₄ft (0.5m)	2¹/₂ft (0.8m)	3¹/₄ft (1.0m)	4¹/₂ft (1.3m)	6¹/₂ft (2m)	8¹/₂ft (2.6m)	14¹/₂ft (4.4m)	27ft (8.2m)
f/22	1¹/₄ft (0.4m)	2ft (0.6m)	2¹/₄ft (0.7m)	3¹/₄ft (1m)	4¹/₂ft (1.4m)	6ft (1.8m)	9¹/₂ft (2.9m)	19¹/₄ft (5.9m)

Hyperfocal distance – full-frame sensors

Focal length	16	20	24	28	35	50
Aperture f/8	3³/₄ft (1.1m)	5¹/₂ft (1.7m)	8ft (2.4m)	11ft (3.4m)	17ft (5.2m)	35ft (10.7m)
f/11	2¹/₂ft (0.8m)	4ft (1.2m)	5³/₄ft (1.8m)	7³/₄ft (2.4m)	12ft (3.7m)	25ft (7.6m)
f/16	2ft (0.6m)	3ft (0.9m)	4ft (1.2m)	5¹/₂ft (1.7m)	8¹/₂ft (2.6m)	17¹/₂ft (5.3m)
f/22	1¹/₂ft (0.4m)	2ft (0.6m)	3ft (0.9m)	4ft (1.2m)	6ft (1.8m)	12¹/₂ft (3.8m)

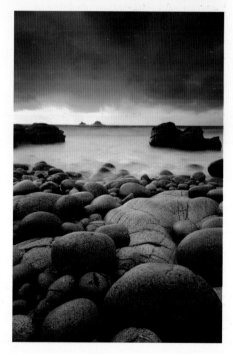

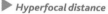 **Hyperfocal distance**

I took this image using a 12–24mm zoom at 12mm, on a camera with an APS-C size sensor, using an f/stop of f/16. Using the accompanying chart, I knew the hyperfocal distance for this combination was 1³/₄ft (0.5m). I manually focused the lens to this distance and took the shot, confident that everything from half this distance to infinity would be recorded acceptably in focus.

Nikon D300, 12–24mm (at 12mm), ISO 200, 10sec at f/16, 3-stop ND grad, 3-stop ND, tripod.

Shutter speed

This is the precisely calibrated length of time that the shutter remains open to expose the image sensor. It is one of the principal controls of exposure, along with the ISO sensitivity (see page 42) and lens aperture (see page 44). Generally speaking, the way shutter speeds work – and their role – is easier to understand than apertures. The majority of images taken require shutter speeds of just a fraction of a second, although exposure can take seconds, minutes or, for a few specialized forms of photography, even hours.

Bulb setting

A DSLR normally boasts a maximum automatic exposure of 30sec, although it is 1min on some models. For exposures longer than this, the camera needs to be set to 'bulb' or 'B'. Using this setting, the shutter will remain open for as long as the shutter-release button is depressed, either via a wireless device or remote cord. The term 'bulb' refers to old-style pneumatically actuated shutters – squeezing an air bulb would open the shutter, while releasing it would close it again. When using the bulb setting, exposure has to be timed manually. Some cameras have an automatic counter on their LCD to aid precise timing; otherwise, you will need to time exposures yourself using a watch or the clock/stopwatch on your mobile phone. When using shutter speeds of this length, a sturdy tripod is essential to ensure sharp results.

The shutter speed dictates how motion will appear in the resulting picture. Basically, a fast shutter speed will freeze subject movement, suspending action and recording fine detail, while a slow shutter time will blur its appearance, creating a visual feeling of motion and energy. DSLR cameras have a wide range of shutter speeds, typically from 30sec to speeds up to 1/8000sec. Most DSLRs also have a 'bulb' setting that allows the shutter to be opened for an infinitive length of time. Shutter speeds are generally quoted in stops (see page 44) and the scale of measurement employed is roughly half or double the length of time of its immediate neighbour. The agreed standards for shutter speeds are as follows:

30	15	8	4	2	1	1/2	1/4	1/8	1/16	1/30	1/60	1/125	1/250	1/500	1/1000 sec

To provide a greater level of precision over shutter times, DSLRs allow photographers to adjust shutter speeds in increments smaller than stops; for example 1/2- and 1/3-stop adjustments. This allows photographers to make very fine alterations to exposure, helping to ensure they achieve exactly the exposure and result they desire. In order to have full creative control over the shutter speed employed, it is best to either select shutter-priority (see page 61) or manual (see page 63) exposure mode.

▶ *Southerndown*

The shutter speed greatly influences the subject's appearance in the final image. A fast shutter speed will suspend fast movement, capturing the finest detail, while a slow exposure will blur subject movement. In this instance, I selected a slow shutter to deliberately blur the movement of the rising tide and water rushing over the foreground rocks.

Nikon D700, 17–35mm (at 19mm), ISO 200, 2sec at f/16, 3-stop ND grad, 3-stop ND, tripod.

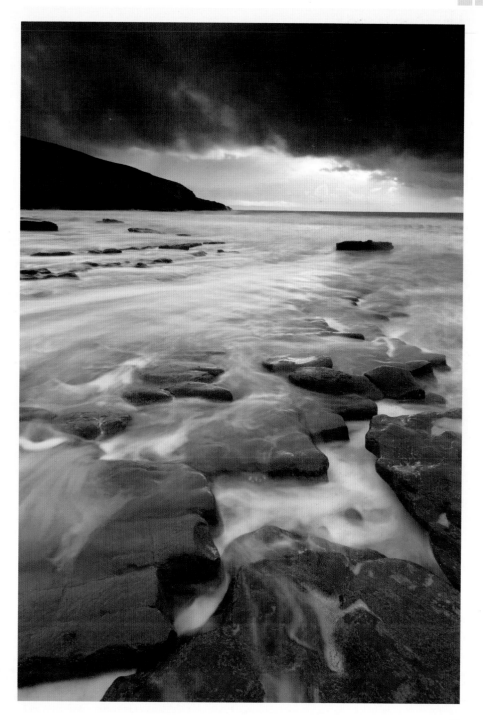

Camera shake

Camera shake is a common problem that occurs when the selected shutter speed isn't fast enough to eliminate the photographer's natural movement. The result is a blurred image, effectively ruining the shot. The problem can be further exaggerated if using a long focal length lens or shooting at a high degree of magnification. There are two ways to rectify camera shake: select a faster shutter speed or use a camera support, such as a monopod, beanbag or tripod. A tripod is the best solution, providing good stability while allowing you to retain your original exposure settings. However, it is not always practical to use a support. In situations like this, where you have no other choice but to shoot handheld, it will be necessary to select a faster shutter time.

It is easy to overestimate how steady you can hold a camera, but a good basic rule is to always employ a shutter speed equivalent to the focal

◀ *Avoiding shake*
Camera shake is a common problem, usually caused by photographers overestimating how still they can hold the camera. When I took the first image, the shutter speed of 1/30sec proved too slow to freeze my natural movement. I used a tripod to take the subsequent shot, and the result is razor sharp.

length of the lens you are using. For example, if you are using the long end of a 70–200mm zoom, select a minimum shutter time of 1/200sec. If your lens is designed with image stabilizing technology, use it – sharp images can be produced at speeds two or three stops slower than normal. You can also employ a larger aperture, or increase the camera's ISO sensitivity, to help generate a faster shutter speed. However, this will reduce depth of field, or increase noise levels, respectively.

It is also possible to limit the effects of shake through the way you support your camera. For example, kneeling is more stable than standing. Hold your elbows in towards your chest and hold the camera firmly to your face. Hold it with both hands and squeeze the shutter-release button smoothly.

Freezing

When shooting popular subjects like sports, action, birds and mammals, you will often want to suspend movement – capturing it in sharp detail. Selecting a fast shutter speed will do this, freezing the motion of moving subjects. However, the speed required to do this will be relative to that of the subject's movements; the direction in which it is moving; and also the focal length of the lens being used. For example, a man running parallel with the viewfinder will be moving more slowly across the frame than, say, a travelling car. Therefore, the minimum shutter speed needed to 'freeze' the runner will be slower than that for the car, but faster than if the man were simply walking. If the runner is jogging directly towards the camera he will be crossing less of the sensor plane and therefore will require a slower minimum shutter speed to be rendered sharp than if he were running parallel across the frame. Using a longer focal length will mean the subject is larger within the image space, therefore moving proportionally faster within the frame than if you were using a shorter focal length.

The exact shutter speed needed to suspend the movement of the subject you are photographing will be dictated by the factors mentioned above.

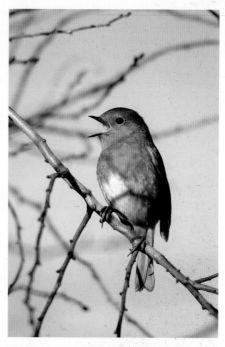

▲ *Robin*

Prioritize a fast shutter speed if you wish to freeze movement. In this instance, a shutter speed of 1/640sec suspended the movement of the singing robin.

Nikon D70, 400mm, ISO 200, 1/640sec at f/4, handheld.

A degree of 'trial and error' is often required to achieve the speed desired. While many DSLRs are capable of shutter speeds exceeding 1/4000sec, in practice, shutter times of 1/500–1/2000sec will often prove more than sufficient.

Using a fast shutter speed will often result in a wide aperture. Therefore, bear in mind depth of field will be shallow. While this will help your subject stand out from its background, your focusing will need to be pinpoint accurate.

Exposure tip

Blurring motion

Employing a slow shutter speed will blur the appearance of motion. While this might not always be desirable, combined with the right subject the results can be striking, implying a sense of motion. This type of intentional blur is commonly used in scenic photography to record flowing water as a milky wash to emphasize its movement. However, blur can suit all types of subjects, for example a bustling crowd, crops or flowers swaying in the breeze, cloud motion or a flock of birds in flight. When you adopt this approach, a tripod is an essential tool. Blur is achieved using slow shutter speeds, so without a support, you will add your own movement to

▼ *Record in motion*
The shutter speed can have a dramatic effect on a subject's appearance. I shot two images of this photograph of water cascading onto pebbles: the first using a fast shutter speed of 1/500sec (1); the second using a slow shutter speed of 1/2sec (2). The contrasting way in which the water's movement is recorded creates two very different shots.

that of the subject's (see camera shake on page 52) and the whole scene will be blurred – not just the subject's movement.

The shutter speed required to create blur is, again, relative to the subject's movement, but a good starting point is 1/4sec or less. For more dramatic, pronounced effects, a shutter speed of 1sec or longer may be required. Subject blur is a subjective effect – some love it while others despise it. Personally, I love the implied energy and life it can give to images. Therefore, I regularly employ a lengthy shutter speed of several seconds or more in order to blur water, foliage or clouds. This can create atmospheric, ethereal-looking results. However, normally an exposure of this length is only possible in low light or through the use of neutral-density filters. When taking this type of image, experimentation is key to achieve just the right result. Too little blur, and the effect won't look intentional; too much, and the subject may become unrecognizable. I strongly recommend that you try doing your own tests and shutter speed comparisons – it will prove helpful in the long term.

Panning

Shooting a subject while moving the camera in tandem with the subject's movement during exposure is known as panning. The result is a sharp subject with a blurred background, suggesting a feeling of motion and action. It is a well-used technique among sports and wildlife photographers, creating dynamic action shots. To pan successfully requires quite a slow shutter speed – typically in the region of 1/30sec. Then, track the subject's movement through the viewfinder and continue to smoothly pan the camera after you depress the shutter-release button. For best results, try to position yourself so that you are parallel to the path of your subject – this will also simplify focusing – and keep your movement constant from start to finish to ensure the motion blur in the image's background remains smooth. A steady hand and practice are required, but the results will make your patience worthwhile.

To generate long exposures, opt for a small f-stop and select your camera's lowest ISO rating. If the resulting shutter speed is still not long enough, attach a solid neutral-density filter (see page 152).

Exposure tip

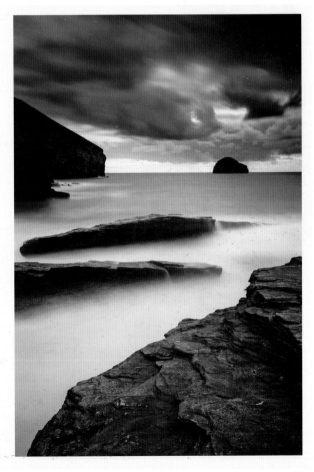

▶ *Trebarwith Strand*
Extreme exposures of 1min or longer are possible using filtration. A shutter speed of this length will render sea water smooth and glassy in appearance and record moving cloud like artistic brushstrokes. The technique is subjective, but one that I like and regularly employ in my photography.

Nikon D800, 17–35mm at
(25mm), ISO 100, 1min
at f/11, 2-stop ND grad,
10-stop ND, tripod.

Reciprocity

In photography a reciprocal value is used to explain the relationship of aperture and shutter speed. The 'law of reciprocity' refers to the inverse relationship between the intensity and duration of light that determines the exposure of a light-sensitive material, such as an image sensor, for example.

The law of reciprocity states that exposure = intensity x time. Therefore, the correct exposure can be retained by increasing duration and reducing light intensity, or vice versa. Put simply, if you adjust aperture or shutter time, it must be accompanied by an equal and opposite change in the other to maintain parity. Therefore, if you double the amount of light reaching the sensor, by selecting a larger aperture, you also need to halve the length of time the sensor is exposed in order to maintain a correct exposure, or vice versa.

To give you an example, the following list of aperture/shutter speed combinations all let in the same light – despite appearing vastly different – and are, therefore, reciprocal: f/1.4 at 1/2000sec, f/2 at 1/1000sec, f/2.8 at 1/500sec, f/4 at 1/250sec, f/5.6 at 1/125sec, f/8 at 1/60sec, f/11 at 1/30sec, f/16 at 1/15sec, f/22 at 1/8sec and f/32 at 1/4sec.

However, it is worth noting that, while the above settings would all retain the same overall level of exposure, the resulting images would actually look radically different. This is due to the shift in depth of field (see page 46) created by adjusting aperture, and also the way different shutter speeds record motion (see page 54).

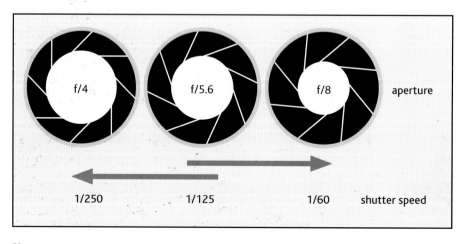

| f/4 | f/5.6 | f/8 | aperture |

| 1/250 | 1/125 | 1/60 | shutter speed |

▲ **Common frog**

When I photographed this frog, I took two frames. For the first image (1), I employed an exposure of f/2.8 at 1/500sec, while for the subsequent frame (2) I adjusted the settings to f/16 at 1/15sec. Although the exposure value for both images is, in fact, identical, the two images appear radically different due to the shift in depth of field created by the contrasting apertures.

Nikon D300, 150mm, ISO 200, handheld.

▼ **St Michael's Mount**

I took this photograph using a lengthy 30sec exposure to intentionally blur the rising tide. For film users, an exposure of this length would likely cause the failure of the law of reciprocity – requiring extra exposure and a large degree of guesswork. However, digital sensors are greatly unaffected by this problem and, in this instance, I didn't have to make any alterations to the camera's recommended settings.

Nikon D300, 12–24mm (at 12mm), ISO 200, 30sec at f/22, polarizer, 3-stop ND filter, tripod.

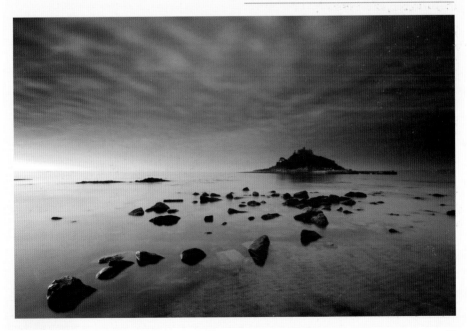

Exposure compensation

Despite their sophistication and accuracy, metering systems are not infallible. If we always relied on our camera's recommended exposure settings, there would be times when our results were either under- or overexposed. Photographers need to be aware of this and be able to compensate when required.

▪ ▪

Light meters work on the assumption that the subject being photographed is mid-tone. While this is normally fine, they can incorrectly expose subjects that are considerably lighter or darker. For example, very dark subjects will often be recorded overexposed, as the meter will take a reading designed to render them mid-tone. Conversely, very light subjects may fool the camera into underexposing them, making them appear darker than reality.

Thankfully, once you know this – and with a little experience – the errors your metering system is likely to make are easy to predict and compensate for. For instance, a subject that is significantly lighter than mid-tone, like a wintry scene or a pale flower, is likely to be underexposed by your camera, so select positive (+) compensation

(longer exposure). In contrast, if the subject is much darker than mid-tone, it is likely to be rendered overexposed by your camera's metering. Therefore, apply negative (-) compensation (shorter exposure). The exact amount of positive or negative compensation required will depend on the subject and lighting. This is not always easy to judge, but by regularly reviewing your photograph's histogram (see page 30), you will be able to make the appropriate adjustments relatively easily. Alternatively, you could 'bracket' exposures to help guarantee a correct result. You may also want to apply exposure compensation to creatively make your images lighter or darker, or in order to expose to the right (see page 34). It is a highly useful camera function that you must feel comfortable and confident using.

When required, applying exposure compensation is quite straightforward. If you are using manual exposure mode (see page 63), simply manually dial in the type and level of compensation required by moving the exposure indicator either toward the + or - symbol in the exposure display visible through the viewfinder, or on the camera's LCD. If shooting in one of the camera's automatic or semi-automatic modes, use your DSLR's exposure compensation facility to set the level of compensation required. Usually this involves depressing a dedicated exposure compensation button – indicated by a -/+ symbol

▶ *Correcting exposure*
This is a typical example of how a subject can deceive your metering system. When I photographed this gull, the camera attempted to record its bright, white plumage as mid-tone, so the result is underexposed. I quickly dialed in a positive compensation of one stop and the subsequent image is correctly exposed.

Pentax K10D, 55–200mm
(at 200mm), ISO 200, 1/800sec
at f/5.6, handheld.

▲ - 2

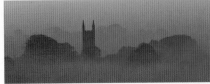

▲ -1

▲ 0

▲ +1

▲ +2

▲ Bracketing

This sequence helps illustrate how bracketing works. Misty conditions can fool a camera's metering system into underexposing results, so I captured a sequence of five images, the first taken at my camera's recommended setting then subsequent frames at -1EV, -2EV, +1EV and +2EV. In this instance, the image taken at +1EV proved the correct exposure.

Nikon D300, 120–400mm (at 400mm), ISO 200, f/11, tripod.

– while simultaneously rotating one of the camera's command dials to dial in the exact level of positive or negative compensation required. Compensation can usually be applied in precise, 1/3-stop increments. Having finished taking your shot, remember to return exposure compensation to +/-0 – fail to do so and the same level of compensation will be applied to all future images, which will result in incorrectly exposed results.

Exposure bracketing

Bracketing is when you take multiple photographs of an identical scene or subject, using different exposure settings. The idea is that one of the resulting frames will be perfectly exposed. Typically, the photographer will take one frame using the camera's recommended light reading, before shooting an under- and overexposed frame using an increment of up to one stop. However, for added precision, it is often better to shoot a larger bracketed sequence of seven or even nine frames, each taken at 1/3- or 2/3-stop increments either side of the original setting. Although this can be done manually – either by using exposure compensation or by shooting in manual exposure mode (see page 63) – many DSLRs are designed with an automatic bracketing program. This feature allows the user to select the number of images in the series, and the level of exposure increment. The photographer can then later compare the images from the series, before deciding which one is the most accurate.

Bracketing is a highly useful and effective method of obtaining the correct exposure. While there is no need to bracket every shot, it is a technique well suited to situations where it is difficult to determine the exact exposure; for example, when the light is contrasty or very changeable, or when shooting very bright, reflective or backlit subjects that can fool your camera's metering system. Bracketing is also a useful precaution for beginners, who are more liable to make the odd exposure error.

Bracketing played an essential role in film photography. However, there is less need to bracket settings today with the advent of digital capture as, thanks to histograms, exposure can be assessed at the time of capture. Also, a degree of exposure error can be easily corrected post capture. However, if the light is changing quickly and you haven't time to scrutinize histograms, quickly shooting a bracketed sequence can prove a good option in order to guarantee a perfectly exposed result.

Exposure mode programs

DSLRs have a choice of exposure mode, each one offering a varying level of control. Many cameras boast a number of pre-programmed modes designed to optimize settings for specific conditions or subjects. However, photographers often prefer to rely on the 'core four', which are: program, aperture-priority, shutter-priority and manual. They are often referred to as the 'creative modes' – affording a greater degree of control over exposure.

Your choice of exposure mode is important, as it has the potential to greatly alter the look of the final image. Therefore, it is wise to be familiar with the purpose of each, so you can match the most appropriate mode to the conditions or subject.

Programmed auto

Programmed auto (P) is a fully automatic mode. The camera itself selects the aperture and shutter speed combination, allowing the photographer to concentrate on composition alone. DSLRs are so sophisticated today that this mode can be relied upon to achieve correctly exposed results in the majority of situations. However, as the camera is in complete control of the exposure equation, this mode can stifle creativity and artistic interpretation. After all, a camera is simply a machine. It cannot predict the effect you are striving to achieve; therefore, programmed auto mode is best employed for snapshot photography only. If you want to fulfil your photographic potential, don't use it as your default setting. Instead, grasp control back from the camera by using S, A or M modes.

▼ *Beach huts*

My camera's programmed auto mode was ideally suited for this snapshot. However, if you want to improve your photography,

you need greater control over exposure and should switch to a semi-automatic mode or manual.

Nikon D700, 17–35mm (at 20mm), ISO 200, 1/100sec at f/8, polarizer, handheld.

▶ Bird movement

When photographing moving subjects, the shutter speed you employ will affect the feel and look of the resulting image. Select a shutter speed too fast, or too slow, and the shot may be ruined. For example, the first two images in this sequence (1, 2) suffer from subject blur. However, by using shutter-priority mode to select a faster exposure of 1/500sec, I was able to freeze the bird's movement on my third attempt (3).

Nikon D200, 100–300mm (at 300mm), ISO 200, f/8, tripod.

Shutter-priority auto

In shutter-priority (S or 'Tv') auto mode, the photographer manually sets the shutter speed, while the camera selects a corresponding aperture to maintain an overall correct exposure. Typically, shutter speeds can be set to values ranging from 30sec to 1/4000 – or even faster on some models.

This mode is most useful for determining the appearance of motion (see page 54). For example, if you wish to blur subject movement, then you should select a slow shutter speed. Exactly how slow depends on the speed of the subject's motion, but an exposure in the region of 1/2sec is usually a good starting point. In contrast, if you wish to freeze the subject's motion, then you should prioritize a fast shutter speed. Again, the setting should be dictated by the speed of the subject's movement. For example, a fast-moving subject will naturally require a quicker shutter speed in order to freeze it. However, an exposure upwards of 1/500sec should prove sufficient to capture all but the fastest action. Shutter-priority mode is a useful method for quickly selecting a sufficiently fast shutter speed to eliminate the risk of camera shake in situations where it is impractical to use a tripod.

If there isn't sufficient light to use a fast enough shutter speed to capture the subject's movement, select a larger aperture or use a higher ISO sensitivity.

Exposure tip

Aperture-priority auto

This is arguably the most popular mode among enthusiasts. Aperture-priority (A or 'Av') is similar in principle to shutter-priority but works in reverse. So, the photographer manually selects the lens aperture, while the camera automatically sets a corresponding shutter speed depending on the meter reading.

The f-stop selected dictates the depth of field available: the smaller the aperture, the more depth of field and vice versa. Therefore, this mode is intended to give photographers full creative control over depth of field (see page 46).

Depth of field can be used creatively in many ways. For example, scenic photographers often require foreground-to-background sharpness. Therefore, aperture-priority mode is a quick method to select the small aperture required to ensure the foreground, middle distance and background are all rendered crisply. The resulting shutter speed is often immaterial, as the subject is static and a tripod is usually used.

Alternatively, you might want to select a large aperture to purposefully create a shallow depth of field. This can be helpful if you wish to place emphasis on your point of focus or to isolate your subject from its surroundings – useful when taking portraits or shooting floral close-ups. It is important to note the

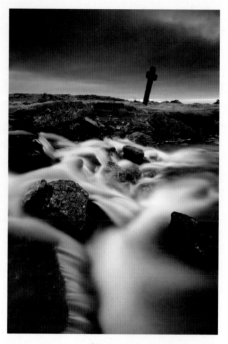

▲ *The windy post*
In order to keep everything in focus, from the foreground stream and rocks to the distant cross and moorland, I needed to prioritize a large depth of field. Using aperture-priority mode, I selected an aperture of f/22, which provided the wide depth of field needed.

Nikon D300, 10–24mm (at 10mm), ISO 200, 8sec at f/22, 3-stop ND grad, 3-stop ND, tripod.

◀ *Banded demoiselle*
When I photographed this damselfly, I opted for aperture-priority mode to enable me to intentionally select a large aperture to create a shallow depth of field. This helped isolate the insect from its surroundings.

Nikon D300, 150mm, ISO 200, 1/60sec at f/4, reflector, tripod.

Despite its name, aperture-priority is also a quick way to set the fastest or slowest shutter speeds. To select the quickest shutter speed, set the aperture to its widest setting; to select the slowest shutter speed simply set the narrowest aperture available.

range of apertures available is not determined by the camera itself, but by the lens attached. This will vary depending on its speed, determined by its maximum aperture (smallest f-number).

Manual

As the name suggests, manual (M) mode overrides the camera's automatic settings. The photographer sets the value for both aperture and shutter speed, providing them with full control over the exposure equation. Without doubt, this is the most flexible exposure mode, but it is also the mode that relies most heavily on the photographer's knowledge and input.

The user can set a shutter speed within the camera's range and select an aperture within the minimum and maximum value of the lens attached. Similar to the other exposure modes, the camera takes a light reading from the scene or subject when the shutter-release button is semi-depressed. However, the camera doesn't apply the values to the exposure settings. Instead, the information is displayed in the viewfinder and/or LCD control panel, and is left to the discretion of the photographer.

Thanks to the control that manual mode provides, it is quick and simple for photographers to 'tweak' the camera's recommended settings; for example, in very bright, dark or contrasty conditions the camera's metering system may be fooled, but by using manual mode it is easy to compensate accordingly. Or, you may want to ignore the recommended settings in order to expose creatively.

▼ *Misty morning*

I was concerned that the light reflecting from the morning mist would trick the camera into underexposing this scene.

Using the manual mode, I was quickly able to adjust exposure settings to compensate.

Nikon D700, 24–70mm (at 40mm), ISO 200, 1/60sec at f/11, 2-stop ND grad, tripod.

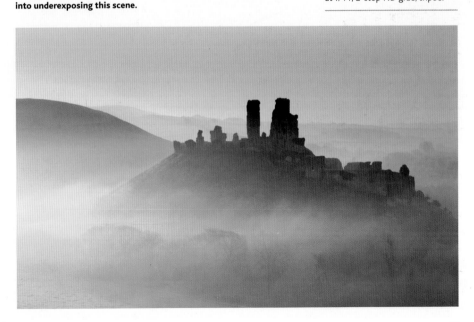

Auto picture modes

In additional to the traditional 'core four' exposure modes, most DSLRs boast a variety of subject-biased programs. Often termed as 'picture' or 'subject' modes, the programs are developed to bias settings according to a specific type of photography. Basically, they are variations of programmed-auto mode (see page 60), with the camera setting both lens aperture and the corresponding shutter speed.

By selecting one of the pre-programmed modes, such as 'sports', 'portraits' or 'close-up', the camera knows whether to give priority to shutter speed, as it would for sport, or aperture, as it would for scenic subjects. Admittedly, picture modes don't offer photographers the same level of control as shutter-priority, aperture-priority or manual. However, they are well suited to beginners who are still unsure about which exposure settings to select in specific shooting conditions.

Picture modes are found on the majority of digital cameras – particularly entry-level models. They are usually represented with appropriate symbols on the camera's mode dial. The number and type included will vary depending on the make. Featured below is a small handful of the most popular 'picture modes' included on many DSLRs.

Sports

The subject is presumed to be moving, so the camera automatically employs a fast shutter speed to freeze movement. As a result, a wide aperture is selected and depth of field will be shallow. The camera will be set to continuous AF and also continuous shooting, so it can record action sequences. In addition to sports, this mode is well suited to any moving subject, for example, running animals, flight and moving vehicles.

Portrait

In this instance, the camera selects the best aperture and shutter speed combination for portrait and people photography. A wide aperture is prioritized to intentionally soften and blur background detail. For the best results, try using a short telephoto lens (70–100mm).

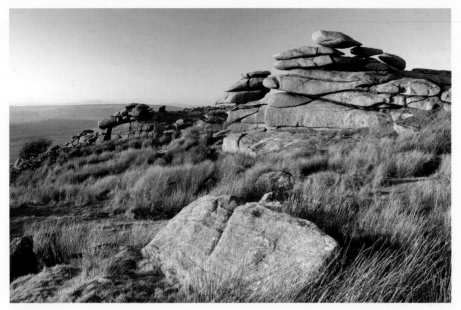

Landscape

In this mode, the camera will give priority to a large depth of field, to maximize background-to-foreground sharpness. It will also attempt to set a shutter speed sufficiently fast to prevent camera shake. The flash system will be disabled, as the subject is presumed to be too far away.

Close-up

The camera attempts to select the best f-stop and shutter speed combination to provide enough depth of field to render close-up subjects in focus. The camera automatically activates the central AF sensor, assuming that the subject will be positioned centrally in the frame. This mode is suited to all types of close-up subjects, such as plants and insects.

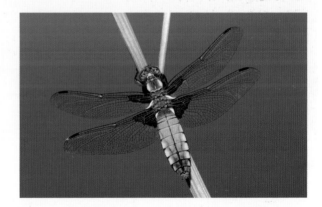

Auto picture modes can prove a quick, hassle-free method of selecting appropriate settings for the scene or subject you are photographing. However, they offer the user limited creative control, so use them sparingly.

Exposure tip

Live View

Live View – or Live Preview – is now a standard camera feature, found on all new digital cameras. Effectively, it allows photographers to use their camera's LCD monitor as a viewfinder. This is possible thanks to the camera continuously and directly projecting the image from the sensor onto the LCD screen.

Put simply, Live View allows photographers to preview the photograph they are about to take, providing an alternative to using a viewfinder. While many viewfinders have a slightly restricted viewfinder coverage of between 94–98%, Live View displays 100% of the image area, making it easier

to accurately compose photographs and eliminating the risk of distracting, 'unseen' elements creeping into the edges of the frame. Understandably, Live View is becoming an increasingly popular way to compose and focus images. It is possible to zoom into specific areas of the projected image in order to fine-tune focusing. This is ideally suited to positioning your point of focus with maximum precision – focusing on the hyperfocal distance (see page 48), for example, or when working with a very shallow depth of field.

Live View is also useful when you wish to compose images from a high or low viewpoint, when it isn't easy or practical to look through the viewfinder itself. The continuous image displayed on the LCD helps ensure you are getting composition right, even when your eye isn't pressed to the

▼ *Vari-angle screens*
Some DSLRs come with an articulating screen with a hinge or pivot, allowing photographers to change the screen's position. This type of vari-angle design is ideal when shooting from awkward perspectives, like high or low viewpoints, and allows for convenient and comfortable viewing.

Most modern cameras also have the ability to capture movie clips and audio. The latest models are capable of capturing full High Definition (HD) (1080p) movies in 30p, 25p and 24p with a recording time of up to 30min, providing fresh photographic opportunities.

Exposure tip

viewfinder. Also, on some models, it is possible to use Live View in combination with your camera's depth-of-field preview button (see page 47). As a result, it allows you to accurately review the extent of depth-of-field achieved at any given aperture. Live View will still operate adequately in low light and on some cameras it is possible to simultaneously view

a live histogram to help ensure exposure settings are correct before releasing the shutter – a useful exposure aid. On some models, it is also possible to overlay a rule of thirds (see page 73) grid to aid composition and also other useful features, like virtual horizon, which acts like an in-camera spirit level to help you capture level horizons.

▼ **Live View**

Live View is an excellent digital tool, capable of aiding composition and focusing, while also helping photographers to achieve a correct exposure.

File formats

Digital images can be captured, and stored, in different file types. The format of the digital file plays a key role, helping to determine image quality, size and the amount of memory that the picture will use on the storage card, and on your computer. The majority of digital cameras allow you to capture images in Jpeg or Raw format, with many higher-specification models offering the extra option of Tiff format. Also, once downloaded onto a computer, they can be saved as a number of other file types, such as a DNG (Digital Negative) or PSD (Photoshop document).

Raw

Put simply, a Raw file is unprocessed data. It is a 'lossless' file type and often considered the digital equivalent of a film negative. Unlike Jpegs or Tiffs, the shooting parameters are not applied to the image at the time of capture, but are kept in an external parameter set that is accessed whenever the Raw file is viewed. Once downloaded, a Raw file needs to be processed using compatible Raw conversion software (see page 170). It is at this stage that you can fine-tune the image and adjust the shooting parameters like sharpness, contrast and white balance.

Raw is a relatively forgiving format with comparatively wide exposure latitude, so it is also possible to correct a degree of exposure error during conversion. Once processing is complete, Raw images should be saved as a different file type – typically Jpeg or Tiff – but the original Raw file remains unaltered.

Raw is a flexible file type and image quality is the highest possible. Therefore it is the preferred format for many photographers. While there are many advantages to shooting in Raw, the larger size of the files means they consume card and disk space more readily. Also, being larger, the files take longer to open and – due to the necessity of having to process Raw files – more time is required in front of a computer.

Jpeg – Joint Photographic Experts Group

Jpegs are a 'lossy' file type, meaning some data is discarded during compression. The pre-selected shooting parameters, such as white balance and sharpness, are applied to the image in-camera. Therefore, after the file is transferred from the camera's buffer to the memory card, the photograph is ready to print or use after download. This makes Jpegs ideal for when you want to produce the end result quickly and with the minimum of fuss. However, the file is less flexible as a result, and it is trickier to alter the shooting parameters during processing. So, if you do make a technical error, you are less likely to be able to salvage the photo than if you had made the same mistake shooting in Raw.

Digital cameras allow you to shoot Jpegs in different quality settings and sizes – typically Fine, Normal and Basic. You can also capture either L (large), M (medium) or S (small) Jpegs (exact image size will vary depending on the resolution of the camera). The Basic and Normal settings – along with smaller file sizes – are ideal if you are taking snapshots, want lower resolution images to send via email or only intend printing below 10 x 8 in size. However, for optimum image and print quality, it is best to always shoot in Jpeg Fine, set to its largest resolution. Although a convenient and popular file format, each time a Jpeg is re-saved, data is lost; so this should be taken into account if you plan on making future adjustments to the file.

Tiff – Tagged Image File Format

In addition to Raw and Jpeg files, some DSLR cameras are also capable of capturing images as Tiffs. These are lossless files, so photographers who shoot in Raw often tend to save and store their images in Tiff format once the original file has been processed. However, shooting in Tiff in the first instance has its disadvantages, as it is a fully developed file with the pre-selected shooting parameters already applied – similar to shooting in Jpeg. Therefore, it cannot be adjusted with the same impunity as a Raw file. In addition to this, unlike compressed Jpegs, Tiffs are large, filling memory cards quickly and slowing the camera's burst rate. Therefore, they are a less practical file type for image capture. Instead, Tiffs are a format better suited to storing converted Raw files.

▼ Picture quality

To help illustrate how image quality is affected by compression, I saved this image of a large red damselfly (1) at different compression ratios. It is easiest to show image quality by enlarging just a small section. The second image shows the original Tiff. The image quality of the Jpeg set to its 'Finest' setting (3) is comparable to the Tiff, with no discernable difference between the two. Even at a 'Normal' form of compression, image quality remains good (4). However, at the 'Basic' setting (5), compression is high, leading to a significant loss of image data and picture quality.

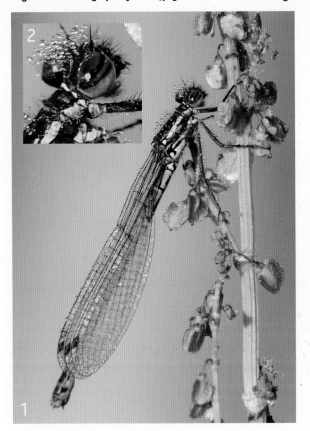

Compression

Due to their large size, when digital images are captured they are normally compressed in some way. The reduction in file size allows more images to be stored in a given amount of disk or memory space. There are two forms of compression: lossless and lossy. As the name suggests, lossless (LZW) compression stores images without losing any information so image quality is optimized. In contrast, some information is discarded when lossy files are compressed – the greater the compression, the more detail that is lost. This will not often result in a visible drop in picture quality and, being smaller in size, i.e. bytes, not its physical dimensions – they are not quite so memory-intensive. There are pros and cons to both types of compression, but to maximize image quality it is best to opt for a lossless file type, such as Raw.

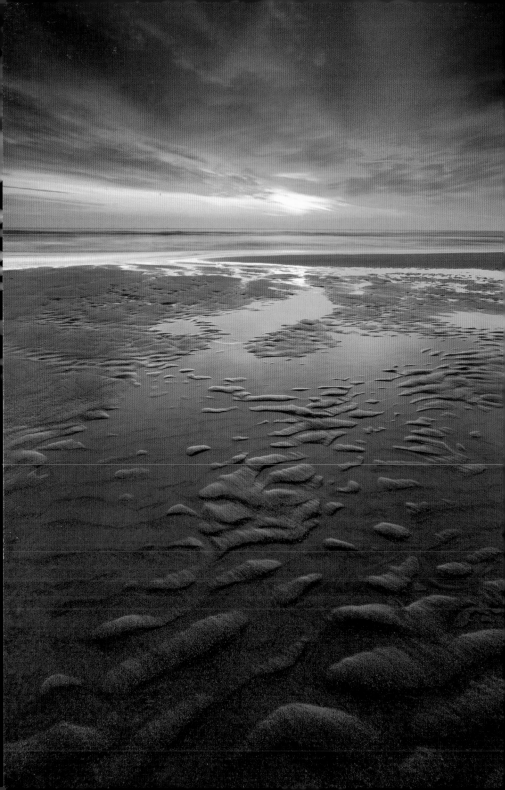

2 Exposure in practice

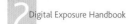
Exposure in practice

A good understanding of exposure is essential to creative photography. Only when equipped with this knowledge can you fully grasp creative control of your digital camera. It will help you to adjust the shooting parameters confidently and make the right decisions when taking pictures on a day-to-day basis.

You may understand the mechanics of exposure, but this knowledge means little unless you put the theory into practice. There are no general 'hard and fast' rules when taking pictures – the way you apply exposure will be dictated by the subject, light and the result you wish to achieve. Every picture-taking opportunity is unique and should be treated as such.

Different subjects will require a different approach. For example, when shooting landscapes, achieving a wide depth of field is often a priority, requiring the selection of a small f-stop. In contrast, when shooting sports or wildlife, a fast shutter speed is often needed in order to freeze rapid action.

The 'exposure equation' can be manipulated in lots of different ways, according to the subject, but knowing when to apply which settings takes time and experience. This chapter is dedicated to exposure in practice – looking at its effect and role in combination with a handful of traditionally popular photographic subjects. However, while the following pages will hopefully help you and provide a good guideline, it is only through taking your own images that things really begin to make sense. There is no better way of learning than by doing...

▼ *Afterglow*

Through experience I knew a slow shutter speed would suit this scene, reducing the water's movement to an ethereal blur for a creative result.

Nikon D700, 17–35mm (24mm), ISO 200, 20sec at f/20, 3-stop ND, tripod.

Compositional rule of thirds

Rules are there to be broken, but when it comes to composition, the so-called 'rule of thirds' is a reliable and effective guideline. It was first developed by painters centuries ago, but remains just as relevant to visual artists today.

The idea is to imagine the image space split into nine equal parts by two horizontal and two vertical lines. In fact, some DSLRs can be programmed to overlay a rule of thirds grid in the viewfinder – or Live View – to aid composition. The points where the lines intersect are, compositionally, very powerful. Therefore, by simply placing your subject, or a key element within the scene, at or near a point where the lines intersect you will create a more balanced, stimulating composition overall. This rule is relevant to all subjects, but particularly to those featured in this chapter.

Generally speaking, by using this approach, you will create images with more depth, balance, energy and interest than if you had placed your subject centrally in the frame. While you shouldn't always conform to the rules, follow this age-old guide and your images will be consistently stronger as a result.

▼ *Portland Bill*
In this image the horizon is positioned so that the sky forms one third and the foreground two thirds of the image space. Also, the lighthouse is intentionally placed roughly one third into the frame. The composition appears far stronger, with a better balance, than if the lighthouse and horizon had been placed centrally.

Nikon D700, 17–35mm (at 17mm), ISO 200, 30sec at f/11, 3-stop ND grad, 10-stop ND, tripod.

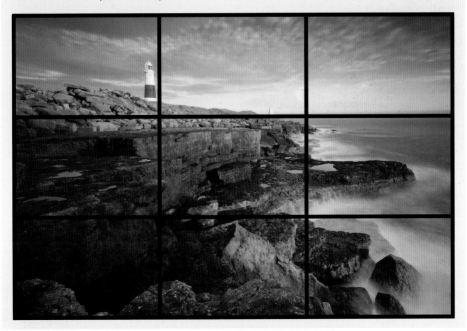

Landscape photography

A good working knowledge of exposure is essential for whatever subject you photograph. However, it could be argued that this is never more important than when shooting scenics. Landscape photography is one of the most popular and accessible subjects, but while anyone can take a decent snap of the vista before them, intelligent and careful use of light, composition and depth of field is essential if you wish to capture an arresting view.

One of the most challenging forms of photography is landscape photography. This is mostly due to the great changeability of light. Scenic images rely heavily on the quantity, quality and direction of light for their impact and drama. However, natural light is constantly changing. The position of the sun, and its intensity, alters throughout the day, and also according to the season. A camera's TTL metering will automatically adjust exposure depending on the level of light, but it is still important to be aware of its effect on exposure and the way it shapes the landscape.

The light during the so-called 'golden hours' – an hour after sunrise and an hour before sunset – is best suited to scenic photography. While the light at other times of day can still produce very usable results, particularly if the conditions are stormy or dramatic, it is dawn and dusk that are best for scenic photography.

At these times of day, the sun is low in the sky. Not only is the light soft and warm as a result, but the long shadows cast help to accentuate the landscape's texture and create a perception of depth.

While the pupils of our eyes work like a constantly changing aperture, enabling us to see detail in a wide range of brightness, a camera lens with a fixed aperture is more limited. Typically, there is an imbalance in light between the sky and darker foreground. Although this can be negligible, it can also amount to several stops of light and the contrast in brightness can often prove too great for the sensor's dynamic range (see page 28). Recognizing this is a key skill for landscape photographers. This light imbalance needs to be corrected, otherwise the image will either have an overexposed sky, if you expose for the ground, or an underexposed foreground, if you correctly meter for the sky.

Graduated neutral-density filters (see page 156) are the only practical method to correct exposure in-camera and for many scenic photographers they are an essential tool. Alternatively, it is possible to shoot two or more exposures of the same scene, using different exposures, in order to later merge or blend them during post processing (see page 178). By doing so, it is possible to produce a result that is correctly exposed throughout. The aim is still to create a natural-looking result, though; the technique shouldn't be confused with High Dynamic Range (HDR) photography.

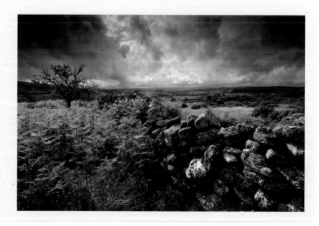

▶ *Stormy sky*
Traditionally, early morning and late evening, when the sun is low in the sky, are the best times of day to shoot scenics. However, if the conditions are stormy, with dark brooding skies, it is possible to capture dramatic scenic images at any time of the day.

Nikon D200, 10–20mm (18mm), ISO 100, 1/20sec at f/16, polarizer, tripod.

Overcast light may often be less dramatic for landscape images, but it shouldn't be overlooked. In fact, when shooting woodland scenes, dull conditions can often prove best. Bright light filtering through trees can create high contrast that cannot be corrected using filtration. By intentionally shooting in overcast weather, it is possible to record colour and detail with greater accuracy.

Exposure tip

▼ *Coastal sunset*

In this instance, I needed to combine two graduated neutral-density filers – equivalent to five stops of light – to produce a natural-looking result. This enabled me to record detail in the foreground, while also preventing the bright, colourful sky from overexposing.

Nikon D300, 10–20mm (18mm), ISO 100, 20sec at f/14, 3-stop and 2-stop ND grads, tripod.

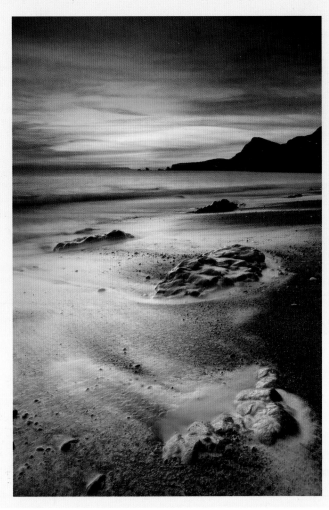

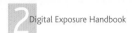

Composition and foreground interest

While light is a key ingredient to a landscape image's success, if the composition is poor, or the depth of field insufficient, the opportunity will be wasted. Eye-catching scenics are normally the result of creating an interesting and balanced composition. This is usually achieved by including some type of foreground interest, designed to lead the viewer's eye into the frame. However, to ensure everything within the composition is recorded acceptably sharp, from your foreground to infinity, it is important you set an appropriate aperture.

When you peer through the viewfinder, the key to good composition is to arrange the main elements within the landscape so that they form a visually interesting scene. The composition needs to hold the viewer's attention – you need to take their eye on a journey around the frame from the immediate foreground to the distant background, and back again. The 'rule of thirds' (see page 73) is an important tool for scenic photography.

Scenic images can often be dramatically improved by including something in the immediate foreground. However, it must remain in keeping with the scene and genuinely enhance the overall composition – don't include foreground interest just for the sake of it. Potentially, almost anything can be used. For example, a wall, river, rocks and boulders, flowers, crops, fence, footpath or road can provide your photo with a suitable 'entry point' and help add depth and scale. Often, this approach works best in combination with a wide-angle lens. By using a short focal length and moving quite close to your foreground, you can stretch perspective and create dynamic, eye-catching compositions.

Another benefit of using wide-angle lenses is that they possess extensive depth of field. Therefore, by selecting a small aperture it is possible to record everything, from your foreground to infinity, in acceptable focus. It is usually best to opt for an aperture in the region of f/11 to f/16. This will provide a generous depth of field while also minimizing the effects of diffraction (see box on the left). Remember to focus on the hyperfocal point (see page 48) to make the most of the depth of field available.

Typically, shutter speeds are quite slow when shooting landscapes. This is because of the relatively small apertures required, and also the use of filtration, such as polarizing and neutral-density filters, which absorb light. So, if you shoot handheld, camera shake is a genuine concern, even if using a lens with image stabilization. In practice, a tripod is essential. Not only will it solve the problem of shake, but it is also a great compositional aid, allowing you time to scrutinize and fine-tune your composition.

Lens diffraction

Diffraction is an optical effect that softens the overall image quality of photographs taken using very small apertures. When image-forming light passes through the aperture, the light striking the edges of the diaphragm blades tends to diffract or, in other words, it becomes scattered. This softens image sharpness. At larger apertures, the amount of diffracted light is only a small percentage of the total amount striking the sensor. However, as the aperture is stopped down (reduced in size), the percentage of diffracted light effectively grows much larger. Therefore, even though depth of field increases, image sharpness will deteriorate.

To maximize image sharpness, it's best to opt for your lens's optimum aperture – the f/stop that suffers least from diffraction. To some extent, this will vary depending on the quality of the lens itself. The more perfect the aperture 'hole', the less light will get dispersed; so it's a good idea to do your own lens tests by shooting a series of images and comparing the results. Broadly speaking, f/11 is considered to be the smallest aperture that remains largely unaffected, or is 'diffraction limited', on cropped-type cameras. If using a full-frame DSLR, this 'guideline' tends to be around f/16.

Using the appropriate f-number for your camera's sensor type will enable you to maximize image sharpness, but remember to utilize the full depth of field available to you (at any given f/stop) by focusing on the hyperfocal point (see page 48). When you require a very large depth of field, don't be afraid to select a smaller aperture if necessary – the effects of diffraction only grow truly noticeable on larger prints.

▶ *Moorland*
Practically anything can be used as foreground interest or a 'lead-in line', as long as it is faithful to the scene. Here, the image was composed so that a large granite boulder formed the foreground, and helped lead the viewer's eye into the shot.

Nikon D700, 17–35mm (at 17mm), ISO 200, 1/4sec at f/16, 3-stop ND grad, tripod.

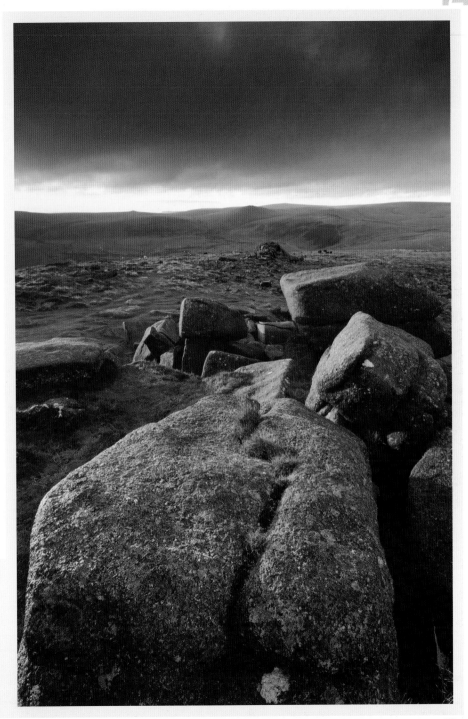

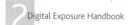
Urban architecture

Architecture is all around us. Big or small, old or new, industrial or residential – buildings come in many shapes and sizes and can prove highly photogenic. While houses, office blocks, skyscrapers and places of worship may be designed and constructed to serve a functional, practical role, their huge photographic potential shouldn't be overlooked.

Urban landscapes can be a dramatic subject – day or night. Towns, cities and urban areas are full of interest and it is possible to capture great images with just a very basic set-up: a standard zoom will normally suffice. Often, it is best to opt for strong, bold compositions, in order to create images with

impact – maybe using the shape of one building to frame another. High and low viewpoints often prove the most dramatic and, while angles may converge as a result, this can actually enhance the final result.

The appearance of architecture alters greatly throughout the day as the position of the sun changes. Light and shade help emphasize a building's form and design. East-facing buildings receive most light in the morning, while west-facing structures will be lit in the afternoon. However, bear in mind that a building might be in shade for many hours a day, depending on the position and height of neighbouring buildings. Therefore, it can prove beneficial to visit a location beforehand, at different times of the day, to observe how the light affects a building or specific view. The 'golden hours' of sunlight – an hour after sunrise and an hour before sunset – will often provide the most attractive light, giving buildings a warm, orange glow.

▼ *Modern architecture*
New developments and modern architecture can be very photogenic, with eye-catching and unusual designs. They often suit a very low or high viewpoint to create arty, abstract-looking results.

Nikon D300, 12–24mm (at 14mm), ISO 200, 1/180sec at f/11, polarizer, handheld.

Old buildings, often found at the heart of a city, remain among the best architecture to photograph, usually with beautifully constructed pillars, arches and stonework. This type of architectural detail, whether exterior or interior, shouldn't be overlooked and is often best photographed in isolation using either a medium telephoto lens or tele-zoom to crop in tight. Old buildings can also look good photographed in context with a modern construction – the contrast between old and new creating visual interest. Modern buildings constructed predominantly from glass can look really striking, particularly if photographed along with some very strong reflections of, say, a blue sky or neighbouring buildings.

When photographing buildings, aperture selection should be your priority – opting for the f-number that will provide you with sufficient depth of field to keep the building sharp throughout. After all, buildings are static, so the shutter speed is of no great concern unless you are shooting handheld. Motion can work well as part of an urban view; for example, a long exposure will 'ghost' the movement of pedestrians and vehicles. Therefore, a neutral-density filter (see page 152) can prove a useful accessory to keep in your camera bag.

Converging verticals

When photographing architecture, converging angles, or verticals, is a common problem. This is a term used to describe the way parallel lines in an image appear to lean inward to one another. This perspective distortion is created when we angle our camera upward or downward, which is often necessary when photographing a tall building from nearby in order to photograph all of the structure. The effect is further exaggerated when using a wide-angle lens.

Converging angles can look odd, giving the impression a building is leaning or falling over. However, the effect can be used to create some very eye-catching, dramatic or even abstract-looking results. Therefore, there will be times when you should actually try to emphasize the effect, rather than attempt to correct it. You can do this by moving closer to the building, angling your camera more or by attaching a shorter focal length.

When converging angles are undesirable, you can minimize the problem by moving further away and using a longer focal length. However, this is not always practical and it may be better to try to correct it post capture using software. Many Raw converters are designed with tools to alter perspective. In Photoshop, open the picture and select the whole image by clicking Select > All. Next, click Edit > Transform > Perspective. Click and drag the markers until the verticals are correctly aligned. If you need to increase canvas size, do so by clicking Image > Canvas size.

Do not photograph sensitive buildings, such as government-owned buildings, airports and schools, unless you have prior permission. The authorities may question whether your intentions are purely creative and, in some countries, you can be arrested for photographing certain buildings.

Exposure tip

▶ *Perspective distortion*
Converging angles can create the impression that a building is leaning or about to topple over. Although the effect can be undesirable, used appropriately, it can also create some very bold and interesting results.

Nikon D300, 12–24mm (at 18mm), ISO 200, 1/100sec at f/11, polarizer, handheld.

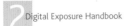

Night photography and exposure

Urban scenes and city skylines adopt a special quality when photographed at night or in low light. Street and flood lighting helps to emphasize the design and shape of buildings and, when combined with the little natural light remaining, can create images bursting with impact. The best time of the day to photograph low-light cityscapes is the hour between sunset and nightfall, when the warm sky will help to enhance the outlines of subjects. However, while this type of 'twilight' image can prove highly effective, equally, they can be hugely disappointing if you get the exposure equation wrong.

When taking images at night time, the resulting long exposure can present photographers with one or two challenges. Shutter speeds may be anything up to 30sec or longer. Therefore, a good tripod is essential to keep your camera still during exposure. Also, release the shutter using the camera's self-timer, or via a remote device or cord, as physically depressing the button can create a small degree of movement that can soften the image.

In a bustling city, there will normally be a certain amount of movement within your scene – moving traffic or people, for example. Due to the lengthy shutter speeds you will be employing, this motion will be blurred, creating some interesting effects. For instance, the trails of light created by car headlamps and rear lights will add visual interest and an extra dimension to your night images.

When photographing in low-light conditions, meter for the scene in the same way you would at any other time of the day. Often metering will

▼ *Low light*

A camera's metering can fail to work well in low light conditions. By switching to spot metering, it is possible to take two or more readings from different areas of brightness within the image. You can then calculate an 'average' exposure. It is also worth bracketing to guarantee a correct result.

Nikon D300, 80–400mm (280mm), ISO 200, 8sec at f/11, tripod.

If you are setting up a tripod on a pavement, be considerate where you position the legs of your support and be mindful not to obstruct other people.

Exposure tip

remain accurate, despite the lack of light. However, all meters operate within a finite range in which they can accurately measure light; therefore problems can occur if the light levels are so low that they are beyond a meter's sensitivity range. Review histograms regularly and be careful not to grossly underexpose results. When working in such

extremes of light, it can prove worthwhile bracketing exposures. Finally, remember, long exposures can potentially enhance the effects of signal noise (see page 43), so turn on your camera's long exposure noise reduction facility before you begin shooting, or apply an appropriate amount of noise reduction using software post capture.

▼ *Light trails*

It is best to shoot night-time, urban landscapes within an hour of sunset. The light trails of car head and rear lights, created by the long exposure time, can look striking. Therefore, select a viewpoint where you can include them within the shot. In this instance, a bus created the unusual streaks of light.

Nikon D300, 12–24mm (at 13mm), ISO 200, 25sec at f/22, tripod.

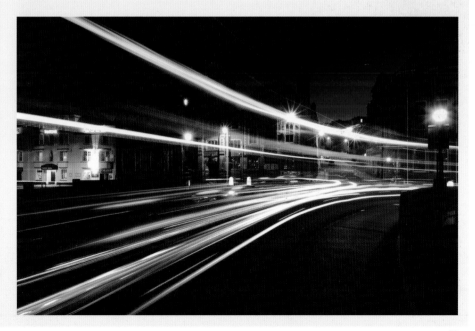

Wildlife photography

Natural history photography has a reputation for being highly specialized, requiring long, pricey telephoto lenses and exotic locations. In truth, regardless of the equipment you own or your budget, it is possible to take good, frame-filling shots of wildlife – and you may not need to travel further than your own back garden or a local park to find suitable subjects. Wildlife can be a challenging and technically demanding subject. However, by practising your knowledge of exposure, you greatly enhance your chances of producing successful results.

Birds

Few subjects are more challenging to photograph than birds. They can prove difficult to approach and will fly away if disturbed. While a long focal length, in the region of 400mm or 500mm, will help – particularly if combined with a DSLR with a cropped-type sensor (see page 26) – it is surprising just how near to the subject you need to be to shoot frame-filling images, particularly of smaller species. Therefore, it is best to begin by photographing birds that are relatively accustomed to human activity; for example, ducks and waders at a local reservoir or wetland. Often, they will tolerate a close approach on foot, so they can prove good subjects with which to begin honing your skills. Larger birds, such as

▼ **Moorhen**
One of the best places to begin honing your wildlife photography skills is a local reservoir, wetland, park or canal, where the resident bird life is more tolerant of human activity. This photograph was taken at a local canal, the moorhen posing happily while I took photos from just a short distance away.

Nikon D70, 100–300mm (at 300mm), ISO 200, 1/250sec at f/4, handheld.

▶ *Blackbird*

When photographing wildlife, try to capture some form of behaviour to give your images more interest and help them to appear less static. This could be flight, courtship, hunting or singing. In this instance, I triggered the shutter just as this blackbird foraged for food amongst the heavy snow.

Nikon D300, 120–400mm
(at 400mm), ISO 400,
1/400sec at f/5.6, handheld.

geese and swans that are already used to being fed, can be enticed using some grain. If they allow you to get very near, try using a short focal length, or even a wide-angle lens, and, shooting from a low angle, take a shot that shows the bird within its environment. The shot will have far more impact than a standard portrait.

Truly wild birds will rarely allow you to get within shooting distance by stalking on foot. Instead, a hide of some sort is required. Compact and collapsible hides are available quite cheaply, and are perfect for concealing your whereabouts. Alternatively, try making your own. Place your hide close to a feeding station, or a spot where you know, or have been told, that birds visit regularly. Try to enter your hide before daybreak, to minimize subject disturbance.

When possible, try capturing an element of behaviour; for example, a display of courtship, singing or flight. This will give your bird images more impact and help them to stand out from others. Flight photography, in particular, is quite tricky, but the results can look amazing. Keeping the subject in sharp focus, while you follow their flight path through the viewfinder, is made easier by using your camera's continuous AF shooting mode, designed to track moving subjects. To photograph birds in flight, or other subject movement, you need to prioritize a fast shutter speed. Naturally, the speed you require to freeze your subject's motion is relative to that of the subject's, but, generally speaking, it is best to opt for an exposure upwards of 1/500sec. In order to do this, you will probably need to select a large aperture. Whilst this will help to throw back- and foreground detail pleasantly out of focus, your focusing will need to be pin-point accurate as the resulting depth of field will be shallow.

Exposure
tip

Garden wildlife

Whether your garden is big, small, urban or rural, it can be used to get close to wildlife. Most gardens are home to a variety of garden birds, small mammals, amphibians, spiders, snails and insects. Larger animals, such as foxes, might also visit regularly. One of the benefits of shooting garden wildlife is that, generally speaking, it is more accustomed to human activity and therefore more approachable. A focal length in the region of 300mm or 400mm will often prove sufficient for birds or mammals, while a macro lens or close-up attachment is ideal for mini beasts.

▼ *Meadow Pipit*

This image was taken in my back garden during a cold spell of weather. Birds were attracted to the food I was placing out for them on my snow-covered lawn. I lay down close by and, using a long telephoto lens, photographed them while they fed.

Nikon D300, 120–400mm (at 360mm), ISO 400, 1/400sec at f/5.6, handheld.

What is the ideal ISO sensitivity for wildlife photography?

There is no right or wrong answer to this. A good general rule is to employ the lowest practical ISO rating that provides you with a sufficiently fast exposure. This will depend on a number of factors, including available light and artistic interpretation. However, a fast shutter speed is often a priority when photographing wildlife, to freeze subject movement and eliminate the risk of camera shake – a common problem when using long, weighty telephotos. While lenses with image stabilizing technology will help minimize the risk of shake, in low light you may need to select a high ISO sensitivity to generate an exposure fast enough to freeze the subject's movement, particularly if it is running or in flight. While increasing a camera's ISO from its base setting will generate more noise (see page 43), thanks to advances in sensor technology, noise remains well controlled even at ratings upwards of 1600. Therefore, nature photographers shouldn't be afraid of increasing ISO when the situation or light dictates. After all, even if image quality is slightly degraded, this is still preferable to a shaky image or one with unintentional subject blur.

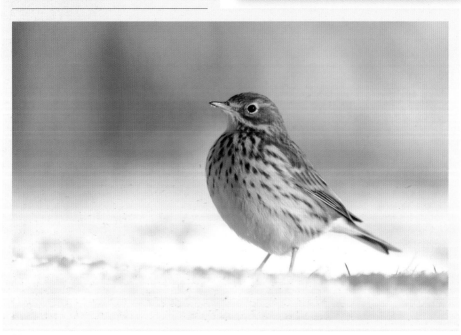

If you are new to wildlife photography, it is worth visiting a zoo or safari park where you can practise techniques and experiment with exposure. If wire fencing is proving distracting, select your lens's largest aperture to help throw distracting backdrop detail unrecognizably out of focus.

To entice wildlife nearer to your lens, try placing suitable food at a predetermined point – a technique known as 'baiting'. Consider the light's direction (see page 106) before setting up your 'feeding station', ensuring that the spot you select receives ample sunlight at the time of day you intend taking pictures. Try placing the bait near to a window or shed that you can then use as a makeshift hide. Disguising your whereabouts, by hanging camouflage netting over the open window, will enable you to shoot from the comfort of indoors. You can also add photogenic 'props' near your feeding station for the birds to perch on, such as a branch with colourful blossom, a spade handle or washing line.

Don't overlook the smaller, less obvious creatures residing in your garden. If you have a garden pond, or there is one nearby, you may find frogs in damp vegetation. A low, eye-level viewpoint is usually best for amphibians, combined with a large aperture of f/2.8 or f/4 to render its foreground and background attractively out of focus. Also, look for

reptiles, snails and small invertebrates. They might not be the most glamorous of subjects, but they can create interesting images. Natural light is often restricted when shooting in close-up. If it needs supplementing, consider using macro flash (see page 132) or a reflector (see page 120).

 Slow worm

This slow worm was photographed in my garden. Reptiles can be enticed by providing suitable shelters in your garden, such as corrugated iron sheets, rubble or wood piles.

Nikon D70, 105mm, 1/125sec at f/13, ISO 400, handheld.

People

Practically anyone who has ever picked up a camera will have taken pictures of people at one time or another, from simple family and holiday snapshots, to professional wedding, portrait and nude photography. As with any type of subject, good technique is needed to capture fresh, eye-catching photographs. However, the key ingredient to successful people pictures is having the ability to recognize, capture and portray a person's mood, emotion and personality.

Communication

Entire books are dedicated to the skill and art form of people photography. Even though, theoretically, a photographer can control light, composition and the subject, capturing consistently good portraits is far from easy. Too often, people pictures fail simply due to the fact that they look unnatural, contrived or the sitter looks awkward or 'stiff'. Therefore, in many situations, your ability to communicate – putting your sitter at ease – is every bit as important as your technique and use of exposure.

Unless you are using a professional model, few people enjoy having their picture taken. Let's face it, it can be an intimidating prospect. Therefore, you first have to ensure your sitter is feeling relaxed, otherwise they will be uncomfortable and anxious and your images will reflect this. Good communication skills are essential. Keep talking, explaining what you are doing and why and ensuring they know the type of image you are striving to

▼ *Friends and family*
Generally, friends and family will be happy to be photographed and will act fairly relaxed in front of your camera. In this instance, I asked my young nephew to pose for me. We had fun playing with different viewpoints and expressions. The natural light was supplemented using a large reflector and the sky provided a clean, simple backdrop.

Nikon D300, 18–270mm (at 20mm), ISO 200, 1/125sec at f/8, handheld.

To give your portraits added mood, consider adding a soft focus filter effect post capture. Doing so can also help disguise spots or imperfections in your subject's complexion.

achieve. If possible, show them examples of different poses and styles beforehand, so that they have a better idea of what you require from them. This will be of particular help to anyone not accustomed to having their picture taken.

When you begin shooting, work confidently and be in control. Offer encouragement to your sitter and, calmly and politely, give clear instructions on how you want them to pose and look. As your sitter grows more confident and relaxed, you will notice that their expressions and body language appear more natural and the resulting images will be better. The relationship between photographer and sitter is a key factor to an image's success. Once you have mastered this, the job of taking good portraits will become far more straightforward.

Focal length

The look and feel of the portraits you take is influenced by many things. Naturally, your subject's pose and expression will greatly dictate the image's mood, but focal length is also a key consideration. A wide-angle lens can be used to create distorted, wacky portraits, whilst a tele-zoom is normally the best choice for candid shots. For the majority of

Environmental portraits

One method to help reveal your subject's personality is to photograph them within a fitting environment. This type of portrait might be shot in that person's place of work or possibly their home – for example, a baker in a bakery, a postman doing his rounds or maybe even a busker in a street environment. This type of approach can produce unusual, eye-catching images that reveal far more about the subject than a standard portrait is able to. The surroundings are of equal importance to the person you are photographing, so creating a balanced composition is important. Often, a short focal length is best – a 24–70mm standard zoom being a versatile and effective focal range. In this instance, you will require a wider depth of field to keep both your subject and their surroundings in acceptable focus. An aperture in the region of f/11 or f/16 should be adequate.

portraits, a short telephoto, in the region of 75mm to 180mm, will often prove best. This is a flattering focal length that also allows a large enough working distance to ensure your subject doesn't feel too self-conscious or intimidated.

▶ *In trouble with the law*
Environmental portraits can reveal or imply so much about the subject. Using a wide-angle lens, it is possible to create eye-catching portraits by shooting your subject close-up, with the background portraying something about your subject.

Nikon D2x, 16mm, ISO 100,
1/60sec at f/22, tripod.

Light and exposure for portraits

Lighting is a crucial ingredient to any portrait image. How the subject is lit will not only help determine their appearance, but it should also complement the look and mood of the subject. Although for some types of people photography you will simply have to work with the ambient light available – candid shots, for example – often you will have at least some control over lighting. Both natural and artificial light are suitable for portraiture and, even if you don't have the budget or luxury of using a professional studio environment, it is still possible to create stunning results in the comfort of your home. In fact, many photographers prefer using natural light to illuminate their subject, believing flash or studio lighting is unable to match the natural qualities of sunlight. In truth, both types of light have their merits – it depends on the result you want.

While strong sunlight might suit some subjects, bright but overcast conditions are best for people. A cloudy sky will act like a giant diffuser, softening the light and proving flattering to skin tone. In contrast, bright direct light, particularly during midday when the sun is overhead, is too harsh, creating ugly shadows underneath facial features and also causing your sitter to squint. This is one of the reasons why wedding photographers will often pose people in the shade of a tree or building.

Daylight can also be used when shooting indoors; for example, natural light entering a room via a window or patio doors. If the light is too strong, it can be diffused by hanging muslin or net curtain across the window. Be mindful of your subject's background. Often it is best to keep the backdrop clean, simple and uncluttered. To help draw attention to your point of focus – typically, your subject's eyes – employ a large aperture in the region of f/4. This will create a shallow depth of field that will help throw the background pleasantly out of focus. It will also help generate a relatively fast shutter speed that will enable you to shoot handheld, which is preferable when taking portraits, allowing you to alter your shooting position quickly and freely. The drawback of using natural light is that you can't control it and it has a nasty habit of

changing when you least want it to. For this reason, many professional portrait photographers spend much of their working life in a studio environment, gaining precise control over the direction of light and the way the subject is lit. Studio lighting can prove costly, but similar results can be created using two flash heads. While light can look less natural, a specific area of the image can be emphasized through the way it is lit. Even strong, contrasty light can prove effective when used precisely and appropriately in a studio – it will depend on the effect you wish to achieve.

▼ *Georgie*

In a studio, it is easier to create some sort of artificial set-up, or utilize props, that can either complement or conflict with your model – the choice is yours. As ever, lighting is a crucial ingredient. In this instance, the way the model is lit makes her stand out boldly against her contrasting environment, creating an eye-catching and unusual result.

Nikon D2x, 18–70mm (at 24mm), ISO 100, 1/60sec at f/10, Bowens lighting kit.

Exposure tip

To lift shadows beneath your subject's eyes or nose, ask them to hold a reflector or sheet of white card on their lap, angled to reflect light upward.

Candid photography

Candid photography relies on spontaneity. It can be best described as an unplanned, unposed and unobtrusive form of people photography, where the photographer captures a moment of everyday life. Often, pictures are taken from further away, so that the photographer remains largely unnoticed. A focal length in the region of 200mm is ideally suited. As a result, candid images look completely natural.

Good candid photography relies on timing; for example, a split second too early or late and the person being photographed may turn and look in the wrong direction or change their expression. Therefore, you need to work quickly.

Wedding receptions, bustling markets, high streets and festivals are among the places where great candids are possible. However, some people do object to having their picture taken. So, if possible, introduce yourself first and ask permission. Presuming they agree, simply wander off and place yourself strategically within shooting range. They will soon forget you are there. You can then begin shooting natural-looking candids.

For this type of photography, a relatively large aperture of f/4 or f/5.6 is often best, helping to throw background detail quickly out of focus and placing greater emphasis on your subject.

▶ *Fun on the beach*
Good candid images rely on spontaneity and timing. Your subject should be unaware of you and your camera, so that images are natural and genuine. However, when photographing children in particular, always seek permission from a parent or guardian first.

Nikon D300, 24–70mm
(at 70mm), ISO 200,
1/180sec at f/5.6, handheld.

Still life

For centuries, artists have depicted still lifes. The term refers to a depiction of inanimate objects – man-made or natural – arranged creatively by the artist. Still life photography is popular and accessible to all. You don't even need to set foot outside: a typical household is full of objects with huge picture potential. It is a great subject with which to hone your compositional, lighting and exposure skills, as the subject is stationary and the photographer has complete control over every aspect of capture. However, that isn't to say it is easy – after all, this is one of the very few subjects where you have to 'make' the picture before you can take it.

One of the key skills to still life photography is having the ability to identify suitable subjects. With a little thought and imagination you will soon think of far more original subjects than the clichéd bowl of fruit or vase of flowers. Even the most mundane, everyday objects can create bold photographs. Have a wander around your home, looking with a creative eye. Cutlery, stationery, work tools, bottles and jars, flowers, fruit, vegetables and toys are all subjects with potential – either photographed in isolation or combined with another object.

As you would expect, how best to light your subject is a key consideration. Some form of artificial light – flash or studio lighting, for example – will often be necessary as, typically, you will be working indoors. Using artificial light, a photographer can control its direction and quantity to create just the effect desired. However, if you are new to still life photography, you may find it easier simply to use ambient light to begin with. By doing so, you can see the light's effect on the subject. If you are using household light, be aware that tungsten light (see page 118) has a lower colour temperature than daylight. As a result, a warm, orange cast will affect exposures taken under tungsten, unless you correct this via your white balance setting, or during Raw conversion. Alternatively, use window light, diffusing it if necessary with muslin or a similar material.

▲ Cutlery
Everyday objects that you wouldn't normally consider photographing can be transformed thanks to the three key ingredients to a successful still life: lighting, composition and arrangement. In this instance, I carefully positioned a knife, fork and spoon, using a lightbox to create a simple, white backdrop.

Nikon D200, 150mm, ISO 100, 1/20sec at f/14, tripod.

▶ Pencils
Look around your home and you will soon find plenty of potential still life subjects. Often a simple arrangement is best – don't over-complicate things. While mono can create mood and a feeling of nostalgia, colour will create impact. In this instance, I arranged a number of coloured pencils, positioning them diagonally to strengthen the composition.

Nikon D70, 105mm, ISO 200, 1sec at f/14, tripod.

Equipment and set-up

Still life images are normally taken close up. While, for larger arrangements, a standard zoom lens should be adequate, for smaller subjects, opt for a macro lens or close-up attachment. A tripod is essential, allowing you to alter your arrangement knowing the camera's position is fixed and your composition won't change. It will allow you to make as many 'tweaks' to your set-up as you want, until you achieve just the right look and balance through the viewfinder.

You can buy specific still life tables or coving (a curved white background that makes it easy to shoot objects against a neutral backdrop). They are ideal for product photography and are available in a variety of designs and sizes ranging from small table-top set-ups to large professional studio tables. The 'Magicstudio' range by Novoflex is ideally suited to still life work, being compact, portable and easy to store. However, if you don't want the extra expense, a table top can easily be used as a makeshift mini studio. You can even move it adjacent to a window should you wish to use natural light. Here, you can begin to arrange your still life.

The background you select will play a significant role: the right backdrop will help the subject stand out, while the wrong one will only hide it. It is normally best to keep it simple, ensuring it is complementary to your main subject. A piece of black or white card, available cheaply from a craft shop, will create a simple, neutral backdrop.

When you begin arranging your still life, start modestly. Often 'less is more' when shooting this style of image and simplicity is best. Look at the way the light affects the shadows and the shape of the item. Keep 'building' your arrangement, making fine adjustments until you are finally satisfied.

Exposure for still lifes

It is impossible to make any general statements about the exposure settings best employed for still life photography – it will depend on the subject, focal length and the effect you desire. If you require back-to-front sharpness, select a small aperture. The resulting shutter speed may be slow, but this won't matter as the subject is stationary and the camera is mounted on a tripod.

To create artistic-looking still life images, select a large aperture to create a narrow depth of field. By doing so, only your point of focus will be pin-sharp – with everything in front and behind drifting pleasantly out of focus. This can prove to be a very effective approach, but still life photography is highly subjective – experiment in order to discover what you like and dislike.

◀ *Water droplets*
Simple ideas often create the most eye-catching results. This image was created by positioning a print of the H2O symbol for water behind droplets on a windowpane. The refracted image of the symbol can be seen in each and every tiny drop.

Nikon D200, 150mm, ISO 100, 1/10sec at f/18, tripod.

▶ *Keyhole*
Not all still life images have to be set up. 'Found still lifes' refer to photographs taken of subjects that the photographer has chanced upon, rather than pre-arranged. In this instance, I saw the peeling paintwork on an old blue door and recognized the still life potential. I used the keyhole as a point of interest. The cloudy, overcast conditions provided nice, diffused lighting.

Nikon D200, 150mm, ISO 100, 1/20sec at f/14, tripod.

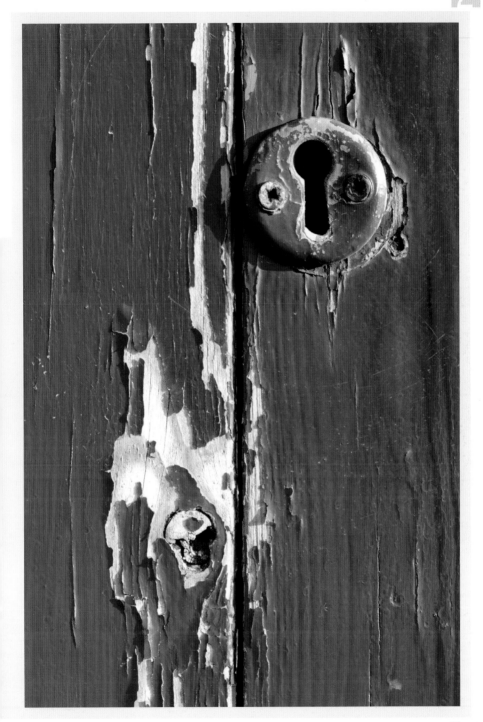

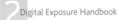

Abstracts and patterns

Abstract is like no other form of picture taking. The normal 'rules' of exposure and composition can often be disregarded altogether. For example, the compositional rule of thirds can be ignored, focusing doesn't always need to be pin-sharp and images can be 'technically' over- or underexposed. Photographers who shoot abstracts and patterns simply use imagination, creativity and originality to capture stunning, eye-catching images.

Almost anything can be shot in an abstract way: big or small, indoors or out. Unusual angles of architecture or modern buildings, the human form, floral close-ups and textures – natural or synthetic – are typical of the type of subjects popular among abstract photographers. If you are still lacking inspiration, type 'abstract photography' into a search engine online and look through the results – this should give you a few extra ideas. However, it isn't necessarily the subject matter itself that is important; it is the photographer's own interpretation of that particular subject.

Choosing a subject

Abstract photography is the process of using colour, tone, symmetry, patterns, form, texture and repeating lines or shapes to create an image. The subject matter doesn't need to be recognizable or the pictures have any great meaning: it is purely art. As a result, this is a highly subjective form of photography; there are no definitive 'rights' or 'wrongs'.

▼ Reflections

Abstract photography places greater emphasis on texture, detail, form and colour, rather than capturing the subject in full. With a little imagination, even very ordinary, everyday subjects can create bold imagery. In this instance, I isolated colourful reflections on a local canal.

Nikon D200, 80-400mm (at 400mm),
ISO 200, 1/160sec at f/8, tripod.

Traditionally, the two lens types best suited to abstract photography are a macro lens, to help isolate detail, and a super wide-angle or fisheye lens, which can be used to creatively distort a subject's appearance.

Exposure for abstracts and patterns

Although creativity is the key ingredient to abstract photography, you still need to be technically competent: shooting abstracts is not an excuse to be lazy. Without a good, working knowledge of exposure, you will be unable to reproduce your thoughts and visions. The f-number you select will be largely dictated by the level of depth of field

required. Often, to create arty, abstract-looking images, a shallow depth of field is best, throwing practically everything other than the point of focus into a soft haze of colour. Visually, this can prove a highly effective approach. Also, through selecting a large aperture, the resulting shutter speed will often be fast enough to allow you to shoot handheld should you wish. While normally I encourage using a camera support whenever practical, when shooting abstracts the freedom of shooting handheld can help promote creativity and original shooting angles. Another popular technique is to blur subject movement through the use of a slow shutter speed (see page 54).

Digital capture has encouraged creativity and experimentation. By reviewing the results achieved via image playback, you can see what works and what doesn't. You can then alter your set-up or exposure settings accordingly until you achieve exactly the effect you desire.

▼ *Water droplets*

We are constantly surrounded by potential abstract subjects. With this type of photography, the possibilities are endless – your only restriction is your imagination. A close-up of water droplets that had formed on a discarded metal pedal bin, created this interesting and eye-catching pattern.

Nikon D70, 150mm, ISO 200, 1/8sec at f/10, tripod.

Abstracts and patterns in nature

While many man-made objects are well suited to being photographed in an abstract way, there is no better provider of suitable subjects than nature. New patterns are formed naturally every day, so where better to begin looking for potential abstract subjects than the great outdoors.

Usually, a camera records a subject with a high degree of realism, but, by definition, an abstract image is not a recognizable, accurate representation of the subject. The photographer simply identifies a point or area of interest, isolating it through the focal length of the lens or by moving near to the subject.

Form is primary; content is irrelevant. Therefore, you need to rethink how you would usually photograph any given subject. You need to look with fresh eyes at natural subjects that you might normally ignore, such as moss, bark, geology and sand. By photographing such subjects in an abstract way, employing an unusual angle or using a creative technique, you will achieve stunning results.

It is not just miniature natural objects that form interesting abstracts. Rather than photograph subjects using a traditional approach, try shooting them more imaginatively. Once again, motion can be a useful visual tool. Usually, any camera movement during exposure would result in a ruined image. However, this is abstract photography, so no approach should be ruled out completely. In fact, intentionally moving the camera during a relatively slow exposure of around 1/2sec can create very impressionistic results, particularly when combined with strong lines, such as trees. While this technique can prove hit and miss, maybe taking several attempts to get right, panning the camera during exposure (either from side to side or up and down) can create visually arresting photos. Another fun technique to try is zoom bursts. Adjust the focal length of your zoom from one extreme to the other during an exposure of around 1sec to create bizarre results.

◀ Thorn

You will need a sharp creative eye to shoot abstract-looking texture and detail. Simplicity is often key – the sharp form of this single, backlit thorn created a striking close-up.

Nikon D300, 150mm, ISO 200, 1/60sec at f/4, tripod.

◀ Sand pattern

Natural abstracts are often easily missed, so you need to look carefully. In this instance, the low, evening light emphasized the ripples in the sand, creating a simple, but attractive pattern.

Nikon D70, 105mm, ISO 200, 1/30sec at f/16, tripod.

▲ Blurred trees

When shooting abstracts, the traditional 'rules' can be largely ignored. In this instance, I 'panned' my camera vertically during the exposure. By doing so, I created this blurry, streaky effect of a group of trees.

Nikon D800, 70–200mm (at 200mm), ISO 100, 1.3sec at f/16, handheld.

Close-up photography

Practically any object is suited to being shot in close-up. By moving nearer to your subject, you will reveal intricate detail, colour and texture that would otherwise go unnoticed. Close-up photography allows us to view subjects from a totally new viewpoint and capture visually striking photographs indoors or out.

Equipment for close-ups

It is a common misconception that to capture great close-up images you need pricey, specialist kit, such as a dedicated macro lens that is optimized for close focusing. In truth, many standard zooms offer a useful reproduction ratio of around 1:4 at their longest end, which is sufficient magnification to photograph many small subjects.

There are also lots of close-up attachments available, many of which are inexpensive. For example, supplementary close-up lenses provide a good introduction. These are circular filters that screw into the lens's filter thread and act like a magnifier. They are available in different strengths and filter diameters – a +3 or +4 dioptre is a good starting point. They don't affect normal camera functions such

as metering or auto focusing. However, they do tend to suffer from chromatic and spherical aberration and the camera-to-subject working distance tends to be short. Despite this, they are a cheap and useful introduction to the fascinating world of close-ups.

Also available are auto extension tubes, which are hollow rings that fit between the camera and lens. They work by extending the distance between the sensor and lens. This allows the lens to focus closer than normal, increasing magnification. However, they do reduce the amount of light entering the lens, and this naturally affects exposure, as a longer shutter time is required to achieve a correct result. While your camera's TTL metering will automatically adjust for any reduction in light caused by using a close-up attachment, it is useful to be able to calculate the level of light absorption. Simply set your lens to infinity and then take a meter reading from an even-toned object, such as a wall. Next, take a subsequent meter reading of the same object, but with the extension tube attached. Compare the two meter readings – the difference is the absorption factor. For example, if the first reading is 1/500sec at f/8 and the second, with the attachment, is 1/250sec at f/8, then the loss of light incurred by using it is one stop. Knowing the level of compensation required is essential if you are using a handheld light-meter or a manual extension tube.

► *Spider's web*
Almost anything can create a bold image in close-up, even everyday objects that you would normally overlook. Using a close-up attachment, it is possible to isolate interesting colour or detail, drawing attention to a specific area. I photographed this dew-laden spider's web using a large aperture to create a shallow depth of field.

Nikon D300, 150mm, ISO 400, 1/30sec at f/2.8, tripod.

Lighting for close-ups

Light grows progressively more limited at higher magnifications. Also, by working in such close proximity to the subject, it can be difficult (if not impossible) to avoid casting the subject into shade. Sometimes the problem can be alleviated by altering shooting position or by using a longer focal length to increase the subject-to-camera distance. However, when this isn't practical, you may need to supplement the available light. For the most natural-looking results, reflect light back onto the subject using a reflector (see page 120). The light can be intensified or reduced simply by moving the reflector closer or further away from the subject.

Compact, collapsible versions are relatively cheap and a good accessory to keep in your camera bag. Alternatively, a piece of white card or aluminium foil can be used. If using a reflector isn't practical, try using flash instead (see page 124). However, flash from a hotshoe-mounted flashgun can miss (or only partly illuminate) the subject – the light either passing over it or being obstructed by the lens. Therefore, position your flashgun off-camera, using an off-camera flash cord or consider investing in a dedicated macro flash (see page 132).

What is reproduction ratio?

Reproduction ratio is a way of describing the actual size of the subject in relation to the size it appears on the sensor, not the size to which the image is subsequently enlarged on a screen or when printed. For example, if an object 40mm wide appears 10mm on the sensor, it has a reproduction ratio of 1:4 – or quarter life-size. If the same object appears 20mm in size, it has a ratio of 1:2 – or half life-size. If it appears the same size on the sensor as it is in reality, it has a reproduction ratio of 1:1 – or life-size. This can also be expressed as a magnification factor, with 1x being equivalent to 1:1, or life-size.

▼ Common frog

Nature is a popular subject, but natural light is often restricted due to the high levels of magnification required to get frame-filling shots of miniature subjects. Light bounced onto the subject via a reflector will be less intrusive than a burst of artificial flash. Here, I used a small reflector to evenly illuminate this frog.

Nikon D300, 150mm, ISO 200, 1/320sec at f/4, reflector, handheld.

Depth of field for close-ups

On page 46 we looked at depth of field and the way its affects our images. One of the greatest challenges of close-up photography is working with a more limited depth of field than normal. The zone of sharpness, in front and behind the point of focus,

for any given f-stop, grows progressively shallower as the level of magnification is increased; for example, when photographing a flower, its stamens may be recorded pin-sharp, but the petals in front and behind might be rendered out of focus. Moving further away from the subject will create a larger depth of field, but this would defeat the object. Instead, the logical solution is to select a smaller aperture (higher f-number), as this widens depth of field. As a result, the light reaching the sensor is reduced so, to compensate, the shutter speed has to be lengthened to maintain the correct exposure.

However, when taking pictures at high magnifications, even the smallest movement is exaggerated, so the risk of camera shake (see page 52) is greatly enhanced – particularly when also using a relatively slow shutter speed. Presuming the subject is static, the best solution is to use a tripod to support the camera. However, if the subject is moving or being wind-blown, the shutter speed may not be fast enough to freeze its motion. In instances like this, select a faster ISO rating to generate a quicker shutter, or consider using macro flash (see page 132).

A good understanding of depth of field is important for creative close-up photography. The degree of back-to-front sharpness can greatly alter the subject's appearance in the final image. Contrary to popular belief, a large depth of field is not always desirable when shooting close-ups, as it can render too many distracting foreground and background elements in focus. For this reason, manipulate the shallow depth of field to help you isolate your subject from its surroundings and direct the viewer's eye to your point of focus. Employ a large aperture of between f/2.8 and f/8 to do this. Depending on the level of magnification you are employing, depth of field may only be a matter of millimetres, so accurate focusing is essential. When you need to place your point of focus with pin-point accuracy, it is best to focus manually using Live View (see page 66). Presuming you are using a tripod, Live View allows you to zoom into the area you wish to focus on and carefully fine-tune focusing.

▼ **Thick-legged beetle**
This colourful beetle was only ³/₄in (20mm) in length. I had to employ a reproduction ratio of approximately 1:2 to ensure it was large enough in the frame. However, at such a high magnification, depth of field is severely restricted. To compensate, I selected a relatively small aperture of f/14 to provide sufficient depth of field.

Nikon D200, 150mm, ISO 200, 1/40sec at f/14, tripod.

In order to maximize the available depth of field at any given f/stop, try to keep your camera parallel to the subject, rather than at an angle. This is because there is only one geometrical plane of complete sharpness, so you want to place as much of your subject within this plane as possible.

Exposure tip

▼ Isolate your subject

Sometimes you will want to achieve front-to-back sharpness to ensure everything within the frame remains in focus. However, intentionally using a shallow depth of field helps draw attention to your chosen point of focus, isolating the subject from its background. In this instance, a single wood anemone flower is rendered sharp, while the surrounding out-of-focus flowers create a flattering backdrop.

Nikon D300, 150mm, ISO 200, 1/1250sec at f/4, handheld.

Close-up or macro – what is the difference?

The terms 'close-up' and 'macro' are often used interchangeably. However, there is actually a distinct difference between the two. Technically speaking, a 'close-up' is an image captured using a reproduction ratio ranging from 1:10 to just below life-size; while 'macro' is life-size to 10:1 life-size. Anything taken with a greater magnification than 10x life-size belongs to the specialist field of 'micro' photography.

Photographers, books and magazines often use the word 'macro' loosely, using it to describe practically any close-up image. While this might be technically incorrect, in truth the distinction is fairly academic.

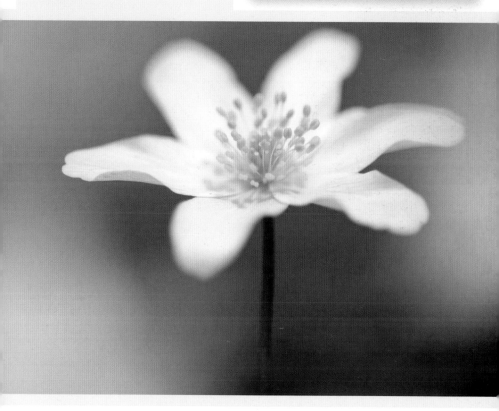

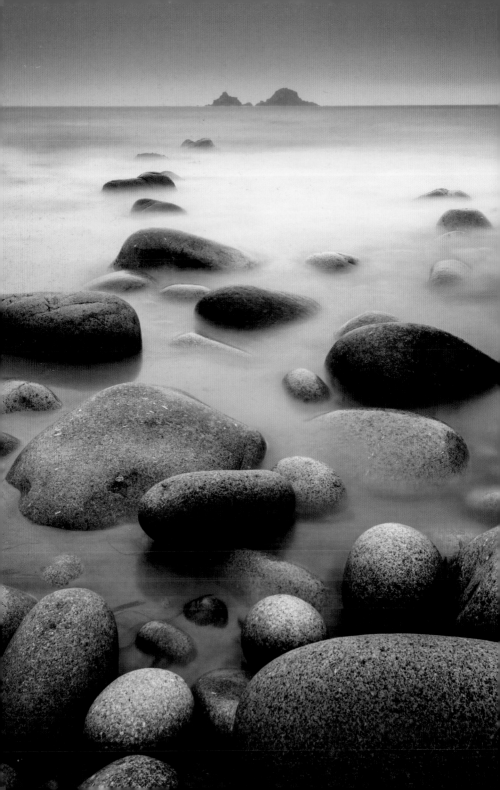

3 Ambient light

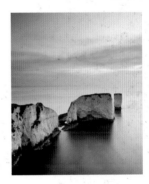

Ambient light

A term regularly used by photographers, ambient light can also be known as 'available' or 'existing' light. It refers to the illumination surrounding a scene or subject by which to take photographs. Typically, ambient light isn't supplemented or added to in any way by the photographer. For example, sunlight, tungsten lighting or even candlelight can be the source of the ambient light used in your photographs.

Natural ambient light is the best form of illumination – I'm a great advocate of using natural light whenever practical. Although, unlike flash (see page 124) a photographer has no control over ambient light, once you learn how to use it to good effect, your images will always look natural, with colours faithful to the original scene or subject.

Light is an image's most vital ingredient. The quantity, quality and direction of light will have a huge bearing on the look of the final image.

◀ *Evening light*
This is a simple image, essentially comprising of two rocks and a windswept tree. The shot relies on the soft, warm, evening light for its aesthetic appeal. At a different time of day, when the quality of light wasn't as good, this image wouldn't have succeeded.

Nikon D200, 10–20mm
(at 11mm), ISO 100, 1/2sec
at f/16, polarizer, tripod.

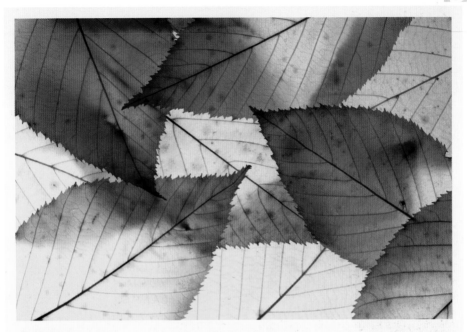

▲ *Backlit leaves*

The level and direction of illumination can alter a subject's tonality, affecting its brightness and colour. These leaves would **normally be mid-tone but in this image, due to being backlit, they appear lighter and more vibrant.**

Nikon D200, 150mm, ISO 100, 1/10sec at f/14, tripod.

By simply altering your shooting position, a subject can look radically different. For example, a subject that is backlit or cast into silhouette can look far more dramatic than if simply lit from the front or side.

The colour of light will also influence your results. Digital cameras are designed with a white balance setting to enable photographers to neutralize colour casts created by different types of ambient lighting. However, it is worth remembering that sometimes a cast should be enhanced, rather than removed, as it can improve an image aesthetically.

Light's effect on tonality

A subject's tonality can be greatly affected by the intensity and direction of light, altering its apparent colour and general appearance. For example, a very dark object can appear to be white or even silver depending on just how the light falls on it. Also, translucent subjects, such as a leaf or the wings of a butterfly, can be rendered much lighter when backlit (see page 107).

Tonality is rarely fixed, so nuances like this will greatly influence the way the subject is recorded, and later perceived, by the viewer. Recognizing just how light can alter the tonality of your subject will help you to reproduce it just as you wish in a photograph.

Direction of light

The light's direction is of huge significance, helping to determine a subject's appearance when captured in the two-dimensional form of a photograph. There are four broad categories: front lighting, backlighting, side lighting and overhead lighting. Matched to the right scene or subject, each type is capable of producing striking – and very different – results.

Front lighting

The easiest to handle, front lighting illuminates the front of the subject evenly, removing visible shadows. Therefore, while it is fine for showing subjects with no particular emphasis, this form of light often produces flat, formless results, lacking contrast, impact and atmosphere. This is why it is often best to ignore the old advice of 'always take pictures with the sun behind you' – it's suited to a different age of photography. That said, when the

sun is low over the horizon, it can provide excellent colour saturation. With low front lighting, an additional problem is that you have to avoid your own shadow appearing in the picture when using short focal lengths.

Overhead lighting

Overhead light, created by the sun's high position during the middle of the day, for example, typically produces harsh, unflattering light. It can make subjects appear flat and, unless the subject is horizontal, it isn't good at emphasizing texture or form. Depending on the situation, overhead light

▼ *Beach huts*

Side lighting is best for highlighting texture and form. It is particularly well suited for defining the shape of multi-dimensional objects, like buildings.

Pentax K10D, 18–55mm (at 18mm), ISO 100, 1/80sec at f/11, handheld.

can also create areas of high contrast with unpleasant, unflattering shadows, although they can easily be relieved by using fill-in flash (see page 134) or a reflector (see page 120).

Side lighting

One of the best and most regularly used forms of light, side lighting helps to add depth to a subject and create a three-dimensional feel. It is for this reason that many outdoor photographers prefer shooting at the beginning and end of the day. Side lighting highlights form, defining shape and edges, although to what degree depends on the subject itself and the angle and intensity of the light source. Side lighting will normally produce images with a good degree of contrast, while strong, low side-lighting has a modelling quality. However, this can present a problem if the contrast in light is greater than the sensor's dynamic range (see page 28).

Backlighting

While you should never point your lens in the direction of a bright light source, backlighting, where the subject is illuminated from behind, is one of the most dramatic forms of lighting. However, it can also prove the trickiest to meter for. Metering systems tend to underexpose backlit subjects, so check histograms regularly and apply positive compensation (see page 58) if necessary. Backlighting can create attractive rim lighting, where there is still detail rendered on the face side of the subject and a golden halo of light surrounds it. Silhouetting is the most extreme form of backlight, with the subject recorded without colour or detail (see page 108). Translucent subjects, such as leaves and butterfly wings, can look particularly beautiful backlit, highlighting detail and colour. However, when shooting towards the light, the risk of lens flare is enhanced – so attach a lens hood, and be prepared to alter your shooting position slightly if necessary.

Exposure tip

If your images suffer from lens flare, it is usually possible to remove it (to some degree, at least) using the Clone Tool or Healing Brush in photo editing software.

Lens flare

Flare is the product of non-image-forming light reaching the sensor; normally caused by shooting in the direction of intense light, such as the sun. Flare can appear in many different forms, but typically it will be brightly fringed polygonal shapes of varying size, in addition to bright streaks and a reduction in contrast. It is created when light doesn't pass directly along its intended path and instead bounces back and forth between the internal lens elements before finally striking the camera's sensor. Although flare can be used creatively, it is normally undesirable, degrading picture quality. For this reason, modern lenses are designed with surface coatings to combat its effects and a detachable lens hood is normally supplied as standard.

 Marbled white butterfly
Translucent subjects, such as insects' wings, are well suited to being lit from behind. Backlighting highlights a subject's shape, form and miniature detail.

Nikon D300, 150mm, ISO 100, 1/30sec at f/7.1, tripod.

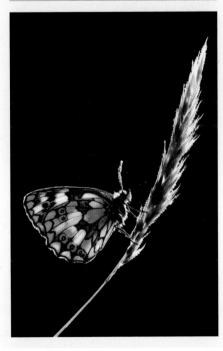

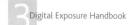
Silhouettes

It could be argued that a silhouette is the result of poor exposure. It is the most extreme form of backlighting, where the subject is recorded as a black outline, without colour or detail, against a lighter background. Effectively, the subject is grossly underexposed. However, silhouetted subjects create powerful imagery, especially when contrasted against a clean backdrop or colourful sky. Silhouettes prove, once again, that there is no such thing as a 'correct exposure' – it all depends on the effect you desire.

Choosing a subject

Silhouettes are easiest to achieve at either end of the day, when the sun is lower in the sky. What the photographer is striving for is a photograph where the main subject is devoid of detail or colour. For this reason, it is important to select a subject with a strong, instantly recognizable outline. People, buildings, a cityscape, animals or lone trees are good examples of suitable subjects. In my opinion, the key to shooting successful silhouettes is to keep the composition simple; too many competing elements within the frame will lessen the picture's impact.

Exposing silhouettes

To create a silhouette, the subject needs to be backlit and contrasted against a brighter background. To achieve an exposure that will cast your subject into silhouette, it is usually best to switch to spot metering mode (see page 22) and then take a meter reading from an area of brightness behind your subject. Ideally, the difference in stops between the metered area, and the subject you intend silhouetting, needs to be greater than the dynamic range of your camera's sensor in order to produce

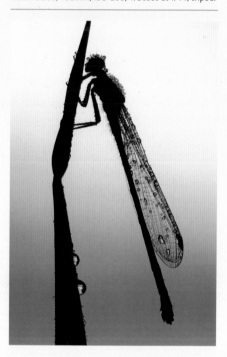

▼ *Damselfly*
Strong, recognizable subjects can look striking silhouetted. Silhouetting a subject will place emphasis on shape and form. Keep compositions clean and simple.

Nikon D300, 150mm, ISO 200, 1/30sec at f/11, tripod.

a true silhouette. Presuming that it is, when you take the photograph using the settings from your spot meter reading, your subject will be rendered pure black, producing a perfect silhouette. Check the image's histogram (see page 30) to be certain – the majority of the pixels should be skewed towards the left-hand edge.

Exposure tip

When spot meter reading from a brightly lit portion of the frame, be careful not to look directly at the sun through the camera, as this can be damaging to eyesight.

◀ *Jigsaw puzzle*

Silhouettes can also be created indoors by positioning a flash, lamp or lightbox behind your subject and using it as your principal light source. To take this image, I arranged a section of jigsaw on a lightbox and metered for the highlights. As a result, the puzzle itself was grossly underexposed, creating the effect I desired. I removed a piece to create visual interest.

Nikon D70, 105mm, ISO 200, 1/80sec at f/14, tripod.

▼ *Windmill*

Silhouetted subjects stand out particularly well against colourful skies. In this instance, I metered correctly for a bright area of the sky, which cast the windmill into inky silhouette. Avoid using graduated ND filters when shooting this type of scene, as you want your foreground to be devoid of colour or detail.

Nikon D700, 120–400mm (at 320mm), ISO 200, 1min at f/8, tripod.

Quality of light

Photographers often refer to the 'quality' of light, meaning its intensity and colour temperature. This is determined by its source. For example, light from a spotlight, flash or other type of point light will typically produce quite a hard quality of light. In contrast, light that is diffused in some way is deemed quite soft and attractive. The key factors that affect the quality of sunlight are time of day, the season and weather – the light is much less intense and more diffused on a cloudy day, for example. The light's 'quality' can greatly affect the look of your final image.

Talk to any professional outdoor photographer and they will tell you that it is not hills, lakes, trees, rocks, plants and so forth, that they are photographing, but the light reflecting off them. Light helps to define a subject, and its quality and direction (see page 106) can greatly alter an image. It can prove the difference between a good and a great shot. For example, shoot an identical composition, but at different times, in varying types of light, and the results will be radically different.

When photographers talk about the quality of light, they are actually referring to its intensity. High-intensity lighting, such as direct sunlight or spotlighting, is deemed hard, creating well-defined shadows and a high degree of contrast. However, if the sunlight is diffused by cloud, or a soft box is used in the studio, its intensity is lessened. As a result, shadows are softer and contrast is reduced.

Different types of light suit different subjects; for example, when shooting portraits, soft lighting will normally give the most flattering results. When using artificial light, a photographer can manipulate and control the light's intensity to create the effect they want. However, natural light cannot be controlled, so photographers working outdoors have to either make do, or wait until the quality of light changes naturally.

Both cloud cover and the time of day can greatly influence the sunlight's intensity. Blanket cloud eclipsing the sun acts like a giant natural diffuser,

1

The quality of natural light is generally best when the sun is lower in the sky. Not only is the light softer and warmer, but the longer shadows help create the feeling of depth. Therefore, a good rule to remember is 'if your shadow is longer than you are, the light is suitable for taking photos'.

producing even light without shadows – well suited to shooting flora, as colour and detail can be recorded more accurately. In contrast, on a clear, cloudless day, the sun will act like a giant spotlight, casting harsh shadows. The best light is usually produced when

▼ *Granite tor*

In this instance, the scene is transformed by the 'quality' of light. Although only taken moments apart, the quality of light is radically different in the two images. In the first shot (1), the sun was hidden by cloud, so the photo is shadowless and looks rather flat. However, when the sun appeared seconds later, the direct, late evening sunlight transforms the scene, with the light and resulting dark shadows giving the image life and depth (2).

Nikon D200, 10–20mm (at 12mm), ISO 100, 1/10sec at f/16, tripod (2 only).

there is broken cloud. This both diffuses and reflects the light, so contrast becomes more manageable. The position of the light source also has a huge impact on the quality of light. For example, when the sun is high overhead at midday, the resulting absence of shadow leaves the landscape looking flat and 'over-lit'. A similar effect can be observed in a studio. For this reason, the middle hours of the day are generally best avoided – for landscape photography, in particular. The so-called 'golden hours' of light, an hour either side of sunrise or sunset, yields the best quality of light. The sun's rays are not only softened and diffused by its oblique path through the layers of the atmosphere, but they are also often wonderfully warm.

The quality of light can also affect exposure. Hard lighting conditions heighten the level of contrast within a scene, potentially beyond the limits of the sensor's dynamic range (see page 28), making it more difficult to retain detail throughout the image.

Colour of light – white balance

White balance (WB) is an important camera function. Its role is to neutralize colour casts produced by the varying temperatures of light. Most cameras have a useful automatic white balance (AWB) option, where the camera looks at the overall colour of the image and sets WB accordingly, which is reliable and accurate in most shooting situations. However, it will not always produce the best results. For example, if a scene or subject is dominated by one particular colour, AWB is likely to be fooled. Also, the most aesthetically pleasing result will not always be the one that is 'technically' correct; deliberately mismatching the WB setting can create a better visual result.

1,800–2,000K	Candle flame
2,500K	Torch bulb
2,800K	Domestic tungsten bulb
3,000K	Sunrise/sunset
3,400K	Tungsten light
3,500K	Early morning/late afternoon
5,200–5,500K	Midday/direct sunlight
5,500K	Electronic flash
6,000–6,500K	Cloudy sky
7,000–8,000K	Shade

This chart is a useful guide to help you understand the way that colour temperature alters depending on the type of light source.

Colour temperature

Every light source contains a varying level of the three primary colours of red, green and blue (RGB). Lower temperatures have a greater percentage of red wavelengths, so appear warmer; higher temperatures have a greater proportion of blue wavelengths and appear cooler. The temperature of light is measured in degrees of Kelvin (K). For example, the concentrated warm light of a candle flame has a low value of around 1,800K, whilst shade under a cool blue sky is equivalent to around 7,500K. Light is considered neutral at around 5,500K – this rating being roughly equivalent to equal amounts of the RGB wavelengths of white light.

The colour temperature of light has a significant effect on photography, influencing the appearance and feel of the resulting picture. While the human eye naturally compensates for the light's temperature – natural or artificial – so that we always perceive it as white or neutral, a camera's sensor isn't so discerning and requires a helping hand. To capture colour authentically, digital photographers need to match the colour temperature of the light falling on the subject with the appropriate WB setting on their camera. Most photographers rely heavily on WB presets to do this. The presets are designed to closely match a variety of common lighting conditions; for example,

'incandescent', 'fluorescent', 'daylight', 'cloudy' and 'shade'. By setting WB to a specific colour temperature, we are actually informing the camera that the light is that colour, so that it can then bias the setting in the opposite direction. Although the camera's WB presets are unable to guarantee exact colour reproduction, when matched correctly with the prevailing light, they help photographers get acceptably close to it. Many DSLRs also allow photographers to set WB manually, so that it is possible to dial in a specific Kelvin temperature for even greater accuracy. White balance aids, such as the Expodisc and ColorChecker Passport, are available for ultimate colour accuracy. Accessories like this are most suited to studio and wedding photography.

If you shoot in Raw format (see page 68) it is possible to adjust, or fine-tune, an image's colour temperature in photo editing software post capture. This flexibility allows the luxury of being able to correct unwanted colour casts – or add them creatively – during processing.

▼ *White balance comparison*

This sequence of images of an identical scene helps to illustrate the dramatic effect of different WB settings. Presets designed to correct a low colour temperature, such as 'tungsten' and 'fluorescent', will cool down an image; settings designed to balance a high colour temperature, such as 'cloudy' and 'shade', will create a warm colour cast. In this instance, the 'cloudy' setting records the colour temperature of light most authentically, but the corrective and creative possibilities of WB are clear to see.

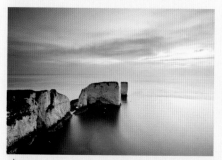

▲ Auto

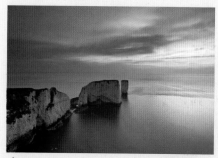

▲ Tungsten

▲ Fluorescent

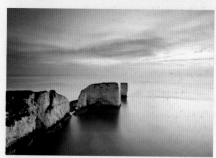

▲ Daylight

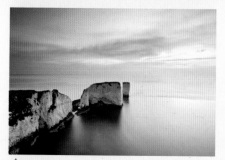

▲ Cloudy

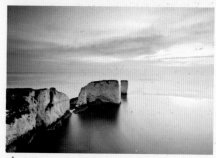

▲ Shade

Correction

If the light's colour temperature isn't correctly balanced, the light will adopt an unnatural colour cast. An artificial hue will often prove destructive, ruining a photograph's natural flavour. It is particularly important to achieve the correct WB in-camera when capturing Jpegs, as colour casts can prove more difficult to correct.

To prevent colour casts forming, match the WB setting with the lighting conditions. It is better to do this than rely on your camera's automatic white balance (AWB) setting. While AWB is capable of excellent results, it can prove inconsistent, struggling to differentiate between the colour of light and the intrinsic colours of the subject itself. Also, it can attempt to compensate for atmospheric lighting conditions that are part of what you're attempting to record. AWB can only 'guess' at the colour temperature required so it can be fooled by tricky or mixed lighting. For example, if the colour of the subject matter is predominantly warm or cool, AWB can mistake this for a colour cast created by the light source itself and alter the subject's natural tone.

One method for guaranteeing accurate white balance is to bracket your WB settings. Bracketing is a term used when taking multiple photographs of the same scene or subject using different settings – most commonly your exposure settings (see page 58). However, the same principle can also be applied to white balance. Some cameras have a function for doing this automatically. If not, simply alter the WB setting manually for each subsequent frame. However, Raw shooters need not worry about bracketing WB settings, being able to easily adjust WB to taste at the post processing stage.

▶ *Correcting colour temperature*
It is important to match your camera's WB setting to the conditions. When I photographed this seascape in dull, overcast conditions, at first I mistakenly left my WB setting on Daylight. As a result, the scene is recorded unnaturally cool (1). To correct this, I quickly switched to the camera's 'cloudy' WB preset in order to match the conditions more accurately. The subsequent shot is far more faithful to the original scene (2).

Nikon D800, 17–35mm (at 28mm), ISO 100, 90sec at f/11, tripod.

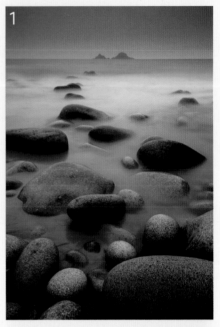

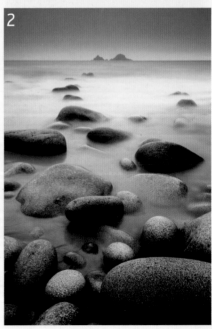

Creativity

Colour that is rendered 'technically' correct will not always create the best results. Depending on the scene or subject, photographs can benefit from being 'warmed up' or 'cooled down'. This is easily and quickly achieved by intentionally mismatching the WB setting with the light's colour temperature.

Warming up images is a particularly popular technique, flattering skin tone in portrait images and enhancing sunrises and sunsets, for example. To do this, select a higher Kelvin value than the ambient light requires. For example, midday daylight is roughly equivalent to 5,500K. Therefore, by selecting a temperature of 6,000K (or your 'cloudy' WB preset), the resulting image will appear warmer. In contrast, a blue hue conveys a feeling of coolness and mystery and is well suited to misty, wet or wintry conditions. To create the effect, manually dial in a lower colour temperature setting. For example, in average daylight, a WB setting of 3,200–4,200K would create a cool blue colour cast. If you prefer, you could try using your camera's 'fluorescent' or 'tungsten' presets to create a similar effect.

Whether you intend on warming up or cooling down your images, adjustments to WB should normally be fairly subtle if you wish to retain a natural feel to your shots. Having said that, don't overlook larger shifts in colour temperature; in some instances, they can prove effective. Experience will help you to intuitively know when to manipulate WB creatively, but experimentation is the key.

▼ *Warming up*
These two images were taken within moments of each other. While the first shot records colour more faithfully (1), the subsequent frame – taken using a higher Kelvin value – looks warmer and is more attractive (2). Intentionally warming up or cooling down images for creative effect is a powerful and useful aesthetic tool.

Nikon D700, 17–35mm (at 35mm), ISO 100, 1/4sec at f/16, 2-stop ND grad, tripod.

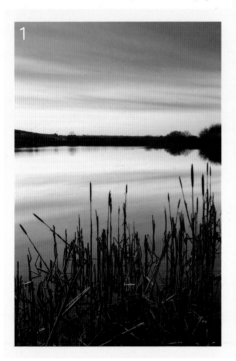

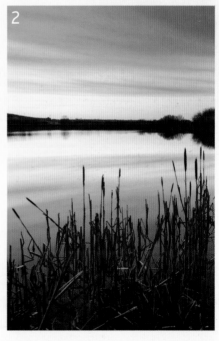

Natural ambient light

Nature provides us with an ever-changing, variable light source: the sun. With the exception of photographers who shoot exclusively in a studio environment, sunlight provides the ambient light for the vast majority of images. The quantity, effect and look of sunlight vary greatly, depending on the weather, time of day and also the season. Although photographers have no control over sunlight, a good appreciation of its many qualities will help you use natural ambient light to its best effect.

While, in terms of distance, sunlight is fixed, its size can effectively vary. For example, on a clear day, direct sunlight can be considered to be a small point light source – relative to its distance from objects on the Earth's surface – producing quite harsh lighting. In contrast, when the conditions are cloudy, the sun's rays are spread and scattered by the cloud, effectively creating a much broader light source and more diffused light. Therefore, the sun's intensity can vary greatly; not just day-to-day, but potentially, from one minute to the next. Due to the changeability of natural ambient light, two identical compositions, taken just moments apart, can look radically different. This is particularly so on days when there is broken cloud. The sun may appear for

▶ *Lake*

Natural ambient light is in a constant state of transience. The light can appear radically different depending on the time of day, season and also the weather conditions. For example, these two images were taken of the same view at around 7am in the morning, but months apart. The results look radically different, as a result of the season and the way the sun's position has changed, altering the sunlight's effect on the landscape.

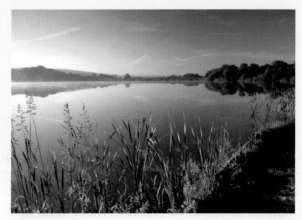

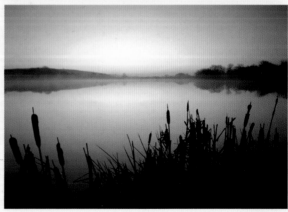

just a few moments before being shrouded in cloud again. In conditions like this, the exact moment you release the shutter can make a vast difference to the final image and also to the length of exposure. Timing is often key when working with natural light.

I have previously mentioned how the quality of natural ambient light changes, relative to the time of day. Typically, outdoor photographers favour the time around sunrise and sunset in which to take their images. The light is naturally softer and warmer. The longer shadows cast help create the perception of depth and accentuate form. If you are working indoors, but using the natural light filtering through a window or door, the time of day remains important, with the so-called quality of light being far more photogenic at either end of the day.

Sunlight is in a permanent state of transience and the time of year also has a dramatic effect. Week by week, the light is subtly changing. The days are either growing shorter or longer and the arc of the sun varies. For example, during winter, the arc of the sun is at its shortest, so it doesn't appear to be as high in the sky as it does during the summer months. As a result, the quality of light remains relatively good throughout the day, even at midday – traditionally the worst time to take pictures.

Thanks to the transience of natural light, a scene or subject rarely looks the same twice. While, on one hand, this can make a photographer's life more difficult, on the other, the changing qualities of natural ambient light make photography far more exciting and unpredictable.

▶ **Windswept tree**

Natural ambient light can be used in many different ways. I took this photograph by shooting in the sunlight's direction, intentionally casting this windswept tree into silhouette to create a simple, graphic image.

Nikon D300, 18–70mm (at 40mm), ISO 100, 1/2sec at f/11, tripod.

Artificial ambient light

The term 'ambient light photography' refers to any light type not added to in any way by the photographer. This means, therefore, not just natural sunlight but artificial light sources, too. For example, light from a table, floor or ceiling light, neon signs, streetlights, car headlights, a fire or candle can all potentially provide the illumination for your pictures.

Basically, any form of existing light not provided by the sun or moon is considered to be artificial ambient light. It can have a very different quality and colour to natural lighting, so photographers need to be aware of

this if they wish to record their subjects authentically. Typically, the majority of images taken using an artificial ambient light source are taken indoors using either incandescent or fluorescent light.

A light bulb that employs a metal filament, heated to a high temperature by the passage of electricity, is considered incandescent light. Most household light bulbs employ tungsten as a filament – a metallic element with a high melting point – and it is for this reason that photographers often use the generic term 'tungsten light' to describe artificial room lighting. Tungsten light is quite inefficient, with much of its energy leaving the bulb in the form of heat, not light. However, it is often perfectly adequate for taking pictures indoors; for example, for shooting portraits or still life images. When using

▼ *Evie*

Our eyes naturally neutralize the warm, lower colour temperature of tungsten lighting. However, unless you adjust your camera's WB accordingly, a warm, 'muddy' cast will affect images taken under incandescent light. In this high-key image (1), the artificially warm effect of tungsten light is obvious

compared to the subsequent shot (2) where I adjusted WB to the camera's 'tungsten' WB preset.

Nikon D300, 105mm, ISO 400, 1/320sec
at f/2.8, handheld.

1

this type of artificial ambient light, it is important to be aware that tungsten filaments emit a much lower colour temperature than daylight. While our eyes naturally neutralize this effect, a camera will record a warm, orange colour cast. Although this can prove attractive, often it will look ugly and unnatural and should be corrected using your WB setting (see page 112). The colour temperature for tungsten light is around 3,000K, so manually adjust WB accordingly or select your camera's incandescent WB preset – designed to neutralize the excessive warmth of shooting under tungsten light.

Fluorescent, or strip lighting, contains mercury vapours that produce ultraviolet light when an electric current is passed through them, causing the tube to glow or fluoresce. Like tungsten, strip lighting produces a colour cast, unseen by the human eye. In most instances, fluorescent light will create a slightly greenish tinge to images. To ensure your shots look natural, select your DSLR's fluorescent WB preset, or a colour temperature value of around 4,200K. Fluorescent light is typically brighter and is spread more evenly than tungsten. The higher level of illumination makes it easier to achieve sufficient exposure, helping to record detail in areas that other types of existing light may not.

Using the artificial light available is useful in a number of different circumstances, such as during a wedding ceremony or indoor sporting event, for instance, when flash isn't appropriate or allowed.

Exposure tip

The advantage of using artificial ambient light, as opposed to flash, is that its effect on your subject is immediately obvious. Unlike flash, subject distance does not have a bearing on exposure – just meter for the subject as you would normally, and shoot. Also, you may be able to control the amount of ambient light by switching lights on or off or diffusing them. However, indoor lighting can be quite contrasty – for example, when your subject is close to the light source and well illuminated, but the surroundings are not. In situations like this, a reflector may be a useful option in order to balance the artificial ambient light. However, you may need to add a supplementary burst of flash to solve the problem. While this means you are no longer relying on the existing light, by bouncing flash (see page 142) off a wall or ceiling, you can effectively reduce contrast without spoiling the image's natural feel.

2

Reflectors

Reflectors are highly useful lighting accessories, particularly suited to portrait, studio and close-up photography. Basically, a reflector is a large reflective 'disc' that works by bouncing light back onto the subject. It can be angled manually to direct light onto the area you require, adding extra illumination to your subject and relieving harsh shadows. It can prove so effective that in certain situations it can negate the need for flash.

Exposure tip

It is easy to make your own small reflector by securing a sheet of aluminium foil to a piece of stiff cardboard. It can then be used to angle light onto your subject.

When light levels are low or limited, a burst of flash can seem like the obvious answer. However, if not applied correctly, artificial light can destroy the natural feel of an image – particularly close-ups of plants or insects. Often, a better alternative is to manipulate the light available by using a reflector.

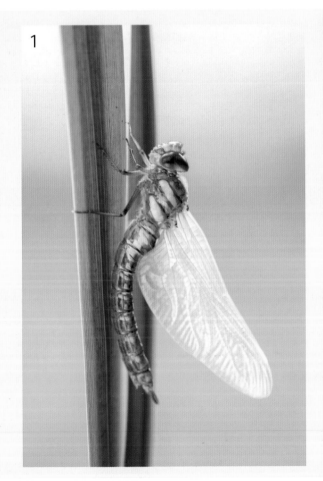

1

▶ *Reflected light*
A reflector can dramatically enhance the look of an image. By carefully bouncing the light onto the subject, it is possible to illuminate the area desired. The results look more natural than using flash. In this instance (1), a reflector has helped illuminate this newly emerged dragonfly, and relieve the ugly, dark shadow areas (2).

Reflectors are relatively inexpensive and available in different sizes and colours. The colour is important: white provides a soft, diffused light; silver is more efficient, but can look harsh; gold or sunfire will add warmth. Many reflectors have a different colour on either side, providing choice depending on the subject matter. For photographers on the move, it is most practical to opt for a collapsible version that folds away and can be stored neatly. Reflectors are available from 12in (30cm) up to sizes of 47in (120cm) or more. The larger the size, the greater the area of reflected light; therefore a small reflector is only suited to shooting small objects.

By using a reflector, it is possible to alter the intensity and, therefore, the quality of light. You can easily adjust the intensity of the reflected light by moving it closer or further away from the subject. However, avoid placing it too near, or you risk giving the image an artificial feel. It is normal to handhold a reflector in position to achieve just the type of illumination that the subject requires, although reflector brackets and clamps are available to buy. For portrait photographers, reflectors are an essential tool. For example, sunlight can cast ugly shadows, particularly under the chin and neck. A reflector, held at waist height, angled upward, will even up the lighting, producing a more flattering result.

Using a reflector naturally adds light to the subject you are photographing, which in turn affects exposure. Therefore, remember to meter with the reflected light in place. Fail to do so and you risk overexposure.

2

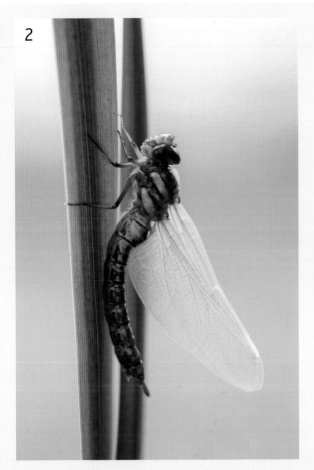

▼ *Reflector*
Whether shooting outdoors or in a studio environment, a reflector is a highly useful and effective tool for manipulating the ambient light and relieving areas of shadow. They are available in different sizes and colours. A gold version will help add warmth to the subject.

4 Flash light

 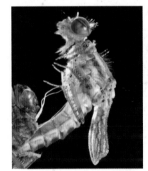

Flash light

Light is crucial to all photographs, so what do you do when the ambient light is insufficient or if the subject is not lit to its best potential? The quantity of light isn't always ideal and rarely perfect, so how do you overcome the limitations and inconsistency of light? The answer is to control light levels by adding your own light source, in the form of flash light.

TTL flash metering

Achieving correctly exposed results using flash is made easier today, thanks to the sophistication and accuracy of TTL flash metering – where the camera and flash 'communicate' to achieve the correct level of illumination. Before this technology, a flash unit would always discharge at full power, leaving the photographer to calculate flash exposure, depending on the aperture and the camera-to-subject distance.

TTL flash metering works by the unit only emitting the correct amount of light for the exposure settings selected and the prevailing shooting conditions. In basic terms, when you take a picture using TTL flash metering, the flash emitted strikes the subject then bounces back to the camera, exposing the image sensor. This light is measured by a sensor in the camera and, once the sensor determines that sufficient light has amassed to form a correct exposure, the flash burst's duration ends. Remarkably, all this occurs within a fraction of a second: at the speed of light.

Thanks to this technology, it is possible to pop-up your camera's integral unit, or attach a dedicated flashgun, and immediately begin shooting acceptably good flash images. However, as with non-flash TTL metering (see page 18), it is designed to render your subject mid-tone and, as previously discussed, this will not always record darker and lighter subjects faithfully. Therefore, while TTL metering is capable of excellent results, it cannot be relied upon in every instance. As with non-flash TTL metering, exposure compensation – or flash bracketing – may well be necessary to achieve the results you desire.

While it is true that, used incorrectly, flash can prove destructive – casting ugly highlights, washing out colour and creating an unnatural look – applied correctly and appropriately, it will hugely benefit your photography.

By enhancing or overriding natural light, a photographer has greater control over the light's quality, quantity and direction. As a result, it is possible to achieve better images than if you had simply accepted and worked within the existing conditions. Flash will allow you to capture shots that wouldn't otherwise be possible. However, the addition of artificial (flash) light presents photographers with a new set of challenges. By introducing flash, some of the basic parameters of exposure are altered. For example, shutter time is largely dictated by the camera's sync speed (see page 131) and the speed of the emitted flash effectively works as the shutter speed. As a result, it is the lens aperture and the flash-to-subject distance that are the overriding controls of flash exposure.

Flash photography can appear quite daunting and complex at first. There are many new terms to become familiar with; for example, fill-in, high- and low-speed sync and front- and rear-curtain flash. Even if you don't own a dedicated flashgun, most consumer DSLRs are designed with a small built-in, pop-up unit that is capable of surprisingly good results. To enable you to use flash correctly and creatively, a good understanding of the 'basics' is important. This chapter is designed to help you get to grips with flash and understand flash exposure.

▶ **Barn owl**

Arguably, the most common exposure problem is a simple lack of light, preventing us from taking the images we want. When natural light is insufficient, flash is the answer. Thanks to the sophistication and accuracy of TTL metering, achieving correctly exposed pictures using flash is easier than ever before.

Nikon D300, 150mm, ISO 200, 1/250sec at f/5.6, SB800 Speedlight, handheld.

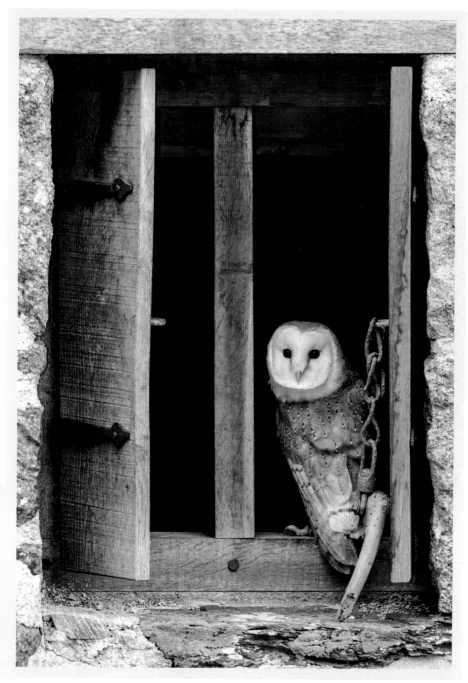

Flash basics

Flash can prove a powerful and essential tool. However, to make the best use of it, it is important to be familiar with the terms associated with using flash. For example, a unit's guide number refers to its maximum operating distance, so to ensure you always stay within its effective working distance, it is important to be aware of this number. Also, the effect of the 'inverse square law', and the unit's recycling time, will dictate its reach and performance.

Guide numbers

The guide number (GN) of a flash unit is given by the manufacturer and indicates its power and operating distance. The number can be used to calculate the relevant aperture or, more commonly, the distance that the flash can effectively travel. The number is usually stated in feet or metres for a sensitivity rating equivalent to the camera's lowest ISO – usually ISO 100 or 200. The guide number can be used in two equations:

f-stop = GN/distance
distance = GN/f-stop

For example, if the guide number of a pop-up flash is 18 (ISO m/ISO 200), the effective operating distance for that unit can be calculated by dividing the number by the f-stop selected. Therefore, if an aperture of f/4 is set, the effective range of the flash will be:

distance = 18/4 = 4.5m

The power of an external flashgun will exceed that of a pop-up unit, so it has a larger guide number. When buying a flash, invest in a unit with the largest guide number you can afford, as this will provide the longest operating distance.

▼ *External flashgun*
This flashgun is typical of today's breed of sophisticated flashguns. With a high guide number of 40, it boasts an impressive operating range. It also has a fast recycling time, and offers high-speed flash sync of up to 1/4000sec.

Flash recycle time

This is the length of time it takes for a flash unit to recharge its capacitors and be ready for use after being fired. Typically, this will only be a matter of seconds, but recycling time will be lengthened when the flash is fired at full capacity or when batteries are becoming exhausted. A quick recycling time is important when you need to shoot a number of frames in quick succession. The recycling time of some external flashguns can be shortened by attaching compatible power packs that hold extra batteries and are designed to speed up recycling time by as much as half between bursts.

Exposure tip

A guide number is exactly that – a guide. It is not a power output value. Each manufacturer has a different interpretation of what constitutes acceptable exposure for the operating range. Some are more optimistic than others, so do your own tests to check the unit's effectiveness over varying distances.

▶ *Large red damselfly*
Due to flash fall-off – a result of the 'inverse square law' – a subject that is lit by flash can have an artificially dark, or even black, background. While this can betray the use of flash, it can also isolate your subject against a simple, non-conflicting black backdrop.

Nikon D300, 150mm, ISO 200, 1/200sec at f/16, Metz 15MS-1, tripod.

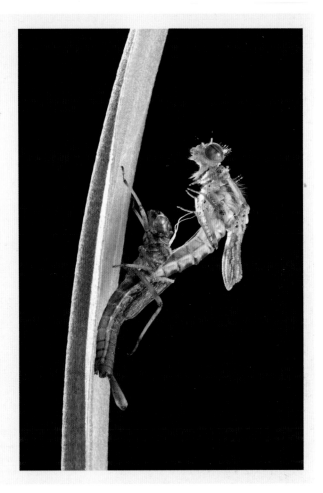

The inverse square law

When using flash it is useful to keep in mind the limitations imposed by the 'inverse square law'. This is a mathematical law, describing light fall-off owing to distance travelled. Simply put, it means that at a constant output the illuminating power of the flash will be the inverse square of the distance. Therefore, if you double the distance from a light source, the illumination is quartered, not halved as you might first think. For example, if you had two objects, one of which is 6½ft (2m) from a light source and the other 13ft (4m) from it, the object 13ft (4m) away will receive only a quarter of the light received by the nearer object. An object 26ft (8m) away would receive only a sixteenth as much light. This rate of fall-off is due to the way light spreads as it travels progressively further from its source.

All light sources follow this rule and it is the reason why foreground objects are much more brightly illuminated by a camera-mounted flash unit than distant objects. A modern flash unit is highly sophisticated and will try to compensate for fall-off, but its power (guide number) may limit the extent to which it can do so.

Built-in flash

Practically all digital compacts are designed with a flash, while many SLRs have a built-in, pop-up flash unit. They are designed to provide illumination in situations where there isn't sufficient ambient light to correctly expose your subject. If the camera is used in an automatic mode, the unit will pop up and fire if the metering system deems the ambient light levels too low to achieve a correctly exposed result. This is usually when the shutter speed drops below a safe speed to handhold the camera without the risk of shake – for example 1/30sec. However, your integral unit can be useful in a wide variety of situations: to fill-in ugly shadows or to add a catch-light to your subject's eyes, for instance. Therefore, it is often only when you override the automatic settings that you will enjoy your built-in unit's full creative and corrective potential.

It is easy to overlook a camera's small, pop-up flash. However, it can prove a useful and convenient lighting accessory. Although not as powerful or flexible as an external flashgun, an integral unit will typically boast a GN of between 10 and 18 – powerful enough for illuminating most nearby subjects. It can be used when ambient light is inadequate; or as fill flash when backlighting is excessive and you wish to relieve ugly, dark shadows. It is capable of producing excellent results, particularly when used in conjunction with flash exposure compensation (see page 136). However, to make the most of your camera's pop-up unit, and to ensure you use it appropriately, it is important to be aware of its limitations.

Compared to an external flashgun, which will often boast a GN of 30 or more, a built-in flash lacks power. Therefore, there is little point trying to use

one to illuminate distant objects as the flash will 'fall off' before reaching the subject. Depending on the ISO you employ, they are normally best used with subjects within a 13ft (4m) range. Also, their position is fixed, so the flash burst can't be directed away from the subject in order to bounce the light off a ceiling or wall to soften its effect. Lastly, a built-in flash can exaggerate the effect of red-eye (see page 143). This is because the flash is near to the optical axis of the camera and, as a result, the light strikes the subject's eyes at a similar angle to which the reflected light is entering the camera.

If you are on a budget or rarely use flash, your camera's built-in unit will prove capable in many shooting situations. However, due to the limitations stated, if you intend working with flash regularly, it is worth investing in a dedicated flashgun. One of the advantages of an integral flash is that it can be quickly activated whenever required, without the need to attach a separate unit or adding extra weight to your kit bag. Usually, it is possible to pop up the flash via a small button near the pentaprism – indicated by a lightning flash symbol. Lifting the flash will activate the unit and it will quickly charge and fire the next time the shutter is released. The unit is designed to work seamlessly with the camera's exposure metering, focusing and zoom systems, so the results are often accurate and pleasing.

Most cameras have a range of flash modes, typically: front-curtain sync (see page 140), red-eye reduction (see page 143) and slow sync (see page 139). Exposure compensation can also be applied, adding to the pop-up unit's versatility. Integral units are also very useful for adding a small reflection of light to a subject's eyes. This is commonly known as a 'catchlight' and adds life and depth to portraits of people and animals. While catchlights will often appear naturally, when necessary, they can be created artificially using flash. When using a pop-up flash to create a catchlight, reduce the flash unit's power output by 2 or 3 stops to ensure subtle, natural-looking results.

In your camera's fully automatic mode, the integral flash will pop up whenever the exposure meter deems there is insufficient light. A camera cannot recognize situations where a flash isn't required; when shooting a sunset, for instance. In situations like this, flash is obviously redundant, so switch to a different exposure mode or switch the flash off.

▶ Built-in flash

Most consumer DSLR cameras boast a built-in pop-up flash, which can prove effective and useful in a wide range of shooting situations.

▼ Hedgehog

A camera's integral flash unit (presuming it has one) can prove useful in a wide variety of shooting situations. In this instance, I used a reduced burst of flash from my camera's pop-up unit to simply add catchlights to the eyes of this hedgehog. They give the image more life and depth.

Nikon D300, 150mm, ISO 200, 1/100sec at f/5, pop-up flash, handheld.

External flash

An external flashgun offers far more versatility and power than the camera's built-in unit, so it is a worthwhile investment for regular users of flash. There is a wide choice, varying in design, strength, sophistication and cost. The majority are auto-electronic systems, which operate by exchanging information with the camera via a proprietary digital data line. They are designed to operate in synchronization with the camera's internal metering – producing correctly exposed flash images with minimum effort.

There are many advantages to using external flash instead of an integral unit. They are designed with a higher GN, enabling photographers to illuminate subjects from further away. Many flashguns boast a flash head that can swivel from side-to-side and be raised and lowered to offer more control over the flash's direction, enabling photographers to 'bounce' flash (see page 142). Some have a zoom head, which is designed to expand the flash beam when there is a wide angle of view, and narrow it at longer focal lengths in order to extend its useful range while maintaining coverage. Often they are designed

with an integral diffuser panel that can be pulled down in front of the flash head to diffuse the light emitted – particularly useful when shooting nearby subjects. Their flash recycle time is faster, and using an external flash limits the effect of red-eye (see page 143), as the light source is farther away from the subject's eyes. The majority of flashguns also feature an LCD panel, where settings are displayed and can be easily altered, and they boast an AF assist illuminator, which is activated in low light to project a patterned beam to aid the camera's auto-focusing and accurately lock onto the subject.

External flash units connect to the camera via the hotshoe mount, although they can be used off-camera – in order to simulate a more natural angle of light, for example – via a connecting cable or as a slave unit triggered remotely. Although you can set flash output manually, the camera's automatic and TTL modes tend to be extremely reliable, ending the flash burst when the correct level of exposure has been reached. However, no form of metering is infallible. Flash output is affected by the reflectivity and tonal value of your scene or subject, so, just as with normal metering, your camera will attempt to record the subject as an average tone. So, when photographing very light or dark subjects you may need to dial in positive or negative flash compensation (see page 136) to achieve a correct exposure.

◀ *Camera-mounted flash*
There is a wide choice of external units available to buy – ranging in strength, versatility, sophistication and cost. Dedicated units are best, so try to buy a flashgun produced by the manufacturer of your camera.

▶ *LCD display*
External units offer far greater versatility and control. Settings can be quickly altered via the unit's control panel, and the present settings are displayed in the flashgun's LCD.

Flash sync speed

The duration of a flash burst is a matter of milliseconds, so timing is crucial. The burst must occur when the shutter is fully open. If the flash is triggered whilst the shutter is in the process of opening or closing, then the resulting image will only be partly exposed. This is due to the design of a shutter mechanism. The shutters typically incorporated in DSLR cameras are equipped with a pair of moving curtains. They move vertically across the image area, as opposed to horizontally, as there is less distance to travel. At fast shutter speeds the opening is actually a slit between the two curtains, travelling the height of the image area. However, this presents a problem when using flash: if only a narrow slit is exposed at the moment the flash fires it is not possible to illuminate the entire image area. An electronic flash burst is always much briefer than the camera's fastest shutter speed. Therefore, full synchronization – where the flash burst exposes the entire image area of the sensor – is only possible within a limited shutter speed range. You will be overridden by the camera if you try to select a shutter speed that exceeds this range. The maximum synchronization speed is commonly known as the 'flash sync' or 'X-sync'. Some cameras are faster than others, but typically the flash sync speed is in the region of 1/200sec.

▼ *Make a wish*

A dedicated flashgun is not only more powerful than a camera's pop-up unit, but offers flash photographers more control, options, and is generally very versatile. Flashguns can even be positioned off-camera and employed to light your subject creatively. They can prove useful for illuminating your subject in low-light, freezing subject movement, or even just to add a subtle 'kiss' of light to fill shadow areas.

Nikon D300, 24–70mm (at 50mm), ISO 200, 1/200sec at f/8, SB800 Speedlight, handheld.

Macro flash

When the ambient light is insufficient to illuminate close-up subjects – indoors or out – flash is the answer. Flash provides illumination when light levels are low, preventing the blurring effects of subject or camera movement. It also allows a smaller aperture to be employed, creating a larger depth of field than would otherwise have been possible – crucial if you want your subject to be recorded sharp throughout. Applied well, it will highlight fine detail and help create sharper-looking results. It can be used to fill ugly, dark shadows, highlight the subject's shape and form, or to produce more vibrant colours.

However, illuminating small subjects using artificial light can prove challenging, due to the short working distances involved. For example, a camera's built-in, pop-up unit is designed to cover subjects in the region of 5–15ft (1.5–4.6m) away. Your subject will be much closer than this, so the usefulness of your camera's integral flash is fairly limited. Also, the (relatively) high, fixed position of a hotshoe-mounted flashgun means that the flash burst emitted may miss or only partly illuminate nearby subjects and, unless it is heavily diffused, light can prove quite harsh. Instead, the best way for close-up enthusiasts to artificially illuminate miniature subjects is to attach a dedicated macro flash. There are two main types of macro flash: ring/macro flash or twin flash.

Ring/macro flash

Unlike a conventional flashgun, a ring/macro flash is circular, attaching directly to the front of the lens via an adapter, while the control unit sits on the camera's hotshoe. This design enables the flash to effectively illuminate nearby subjects from all directions at once, providing even, shadowless light. While this might sound ideal for close-ups, in practice the resulting light can look unnaturally flat. To help overcome this, the majority of modern

▼ *Twin flash*

For advanced macro photography, a twin flash system is best. This unique wireless system kit is designed with two SB-R200 remote units. All exposure and triggering communication is carried out using infrared wireless communication. By using two separate flash heads, it is possible to direct light precisely onto miniature subjects.

▼ *Macro flash*

Ring/macro flashes are designed to produce even, shadowless light to illuminate close-up subjects. They are ideally suited to macro enthusiasts; however, being a specialized piece of kit, they can prove quite costly.

Ring/macro flashes can also be used for portrait and fashion photography. Not only do they help remove shadows, which otherwise can be unflattering and emphasize wrinkles, but the unique way that ring/macro flashes render light can give models a 'glowing' appearance.

ring/macro flash units boast more than one flash tube, which can then be controlled independently. This allows photographers to vary the output ratio between them in order to create shadows and more natural, three-dimensional-looking results. For example, employ one flash tube as the main light source and the other for fill light by reducing its power output by 2 or 3 stops. If you are using a unit without this level of control, improvise by using black tape to mask parts of the ring to vary the flash output.

Twin flash

These units work using a similar principle to a ring/macro flash. Instead of a ring, twin flash units consist of two individual flash heads that are mounted on an adaptor ring attached to the front of the lens. The flash output can be varied between the heads to solve the problem of the flat, even light that is commonly associated with macro flash. However, they also have the added flexibility of being able to be moved and positioned independently. They can even be removed from the mounting ring altogether and be handheld or attached to, for

example, a tripod leg. The heads can be fired together or individually, providing even greater flexibility and creative possibilities. They're relatively lightweight and compact and are arguably the most versatile form of flash available. However, they produce twin catchlights, which can look unnatural. Due to the fact that macro flashes are intended to illuminate close-up subjects, they normally have a small GN and are most effective within a range of 3ft (1m).

Adaptors

You can also buy ringflash adaptors that are designed to convert an ordinary flashgun into a makeshift ringflash by redirecting the flash burst, using a system of internal prisms and reflectors, to a circular unit that fits around the lens. Another option today for close-up photographers is LED lighting units.

Whatever close-up subject you are shooting, don't be afraid to use artificial light if it will benefit your shots. However, your goal should be to create results that look as natural and authentic as possible; unless you intentionally want to do otherwise.

▶ *Common darter*
Light is often severely restricted when shooting in such close proximity to the subject – particularly when photographing natural history. Macro flash units are specifically designed to illuminate small subjects. By varying the output of a twin-flash unit, natural-looking results are possible.

Nikon D200, 150mm,
ISO 100, 1/250sec
at f/4, SB R1C1, tripod.

133

Fill-in flash

Although it is easy to presume that flash is only useful in low light conditions, in reality it is an essential tool in a wide range of photographic situations. Flash doesn't have to be the primary light source for exposure. 'Fill-in' or 'fill' flash is a technique where a flash burst is used to supplement the existing light, typically to brighten (or relieve) deep areas of shadow outdoors on sunny days.

Arguably, fill-in flash is the most important flash technique to be familiar with, supplementing ambient light in order to give images more life, yet retaining a natural feel. Fill flash works in a similar way to employing reflected light (see page 120), shining a little extra light into certain regions of the subject. Fill flash is particularly popular with portrait photographers working in daylight when the sun's position can cast distracting shadows under the model's nose, lips and eye sockets. However, it is useful in any situation where shadow is obscuring subject detail or when the background is significantly brighter than the foreground. To give you an example, if photographing a portrait of someone wearing a hat outside – at a wedding, say – the rim is likely to create a distracting shadow directly across the subject's eyes. Fill flash will relieve this area of shade, creating a more even exposure across the subject's face.

Before modern electronics existed, calculating fill flash manually could prove complex, requiring the photographer to balance the flash and existing light to give a daylight-to-flash ratio of approximately 1:4. Today, it is straightforward, with the camera and dedicated flashgun communicating with one another in order to adjust flash output to achieve a natural balance between the main subject and the background. Essentially, using fill flash doesn't alter exposure settings – its role is to relieve areas of shadow that would otherwise appear too dark in the final image. The aperture and shutter speed are set to correctly expose the background, while the flash is fired to illuminate the foreground subject. Therefore, meter as you would normally, with exposure time being dictated by the amount of light already present within the scene.

To help you decide whether fill flash is appropriate or not, ask yourself the following questions: is my subject (or part of it) in shade, or, is there more light behind the main subject than in front of it? If the answer to either of these is yes, then you need to consider whether you are near enough to the subject for the flash burst to be effective. Presuming that you are, attach a dedicated external flashgun or pop up your camera's built-in unit. The majority of flashguns have a specific fill-in mode, designed to emit just enough flash light to relieve the shadows. However, monitor the results carefully, as you may want to alter the camera's automatic settings to ensure the best results. Fill-in flash often looks most natural when the output is approximately a stop darker than the ambient light. If the flash-to-daylight ratio is too even, or if the flash begins to overpower the existing light, the overall balance looks false and betrays the use of flash. By using the camera's flash compensation function – or by dialling in positive or negative compensation on the flashgun itself – it is possible to increase or decrease the burst emitted to create just the result you desire. By adjusting the output of the flash unit in this way, you are effectively altering the flash-to-daylight ratio. Generally speaking, photographs taken in bright light require more fill-flash to relieve the shadow areas than images taken in shade or on an overcast day.

Exposure tip

Fill-in flash isn't just useful for portraits. Close-up and flower photographers will often employ a small burst of flash to open up shadow detail and it can even prove useful for images of architectural detail.

▼ *Fill-in flash*

Fill-in flash is useful to relieve harsh shadows, particularly when shooting portraits on sunny days, when overhead sunlight can create distracting shadows underneath facial features. Here, the first image was taken without flash, while for the subsequent frame a burst of fill-in flash was used.

Nikon D300, 24–85mm (28mm), ISO 100, 1/250sec at f/7.1, SB800 Speedlight, handheld.

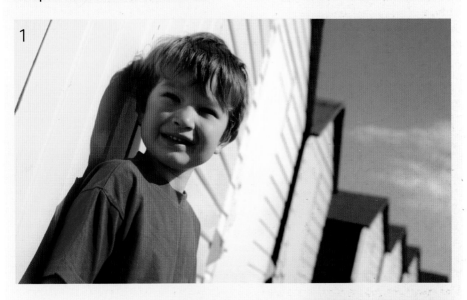

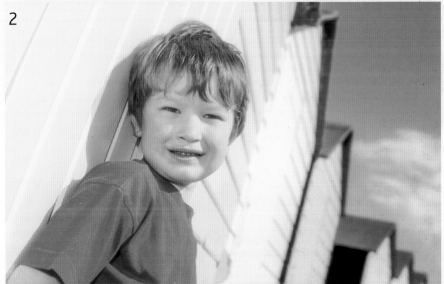

Flash exposure compensation

Although TTL flash metering is reliable in the majority of shooting situations, it can still be deceived. As with normal TTL metering (see page 18), your camera attempts to record subjects as mid-tone. Therefore, if you are using automatic TTL flash, the camera will effectively underexpose light subjects and overexpose dark subjects in order to render them with average tonality. The simplest way to correct this is to apply flash exposure compensation.

Flash exposure compensation is similar in principle to exposure compensation (see page 58). It is a common feature on DSLRs and should be applied if the flash level automatically set by your camera proves incorrect. When flash exposure compensation is applied, no changes are made to aperture, shutter speed or ISO – only the level of flash emitted is altered. Positive compensation (+) increases the burst, making the subject appear brighter, while negative compensation (-) reduces flash output, making the subject darker and also reducing highlights and reflections.

Because of the way cameras attempt to render subjects as mid-tone – typically underexposing light subjects and overexposing dark ones – you often need to apply positive compensation when photographing light or white subjects, and a negative amount when shooting subjects darker in tone. For example, if you are photographing a white flower, or a bride in her wedding dress against a light-coloured backdrop, you would actually need to increase the flash burst, contrary to what your initial instincts might tell you. Naturally, the amount of compensation you need to apply will depend on the tonality of the scene or subject. Most DSLRs will allow you to set a flash compensation value of between -3EV (darker) and +1EV (lighter) in increments of 1/3EV. Experience will help you identify just how much compensation is required in any given situation, but at first you may need to experiment or even 'bracket' flash output to achieve the correct level of exposure.

Flash exposure compensation allows you to control the balance between flash and ambient light. Therefore, it is a function that can be used creatively as well as for corrective purposes. Using flash compensation you can exert more creative influence on your images. The more the flash burst dominates the ambient light, the more artificial the effect is.

▼ - 2EV

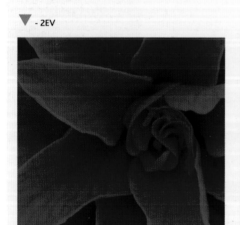

▼ - 1EV

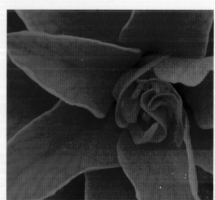

Flash bracketing

This technique is recommended in tricky lighting situations, where it is difficult to set exposure confidently and there is not time to scrutinize results on the camera's LCD and adjust the settings accordingly. It works in a similar way to exposure bracketing (see page 59); however, just the flash output is altered with each subsequent frame, as opposed to the exposure value. The majority of DSLRs are designed with a specific flash bracketing facility, where you can select the number of shots in the sequence and also the flash exposure

increment. Some cameras will allow you to shoot a sequence of up to nine frames, automatically adjusting flash intensity after each shot. However, in most situations a series of three images – one taken with negative compensation, another with no compensation applied and a third with a positive amount – will suffice.

Bracketing is particularly useful if you are a beginner to flash photography, helping you find the most pleasing combination of ambient and flash light.

Therefore, for subtle results, employ negative compensation, and for more dramatic effects apply a positive amount. As you use flash more, and grow familiar with its effects, you will begin to intuitively recognize just when positive or negative compensation is required.

▼ *Positive or negative compensation*
You can increase or reduce the light emitted by your flashgun by setting either positive or negative compensation. It can be worthwhile bracketing flash output to ensure you achieve just the effect you desire.

Nikon D300, 150mm, ISO 100, 1/180sec at f/16, Nikon SB800 Speedlight, tripod.

▼ 0EV

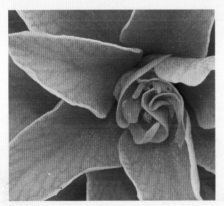

▼ +1EV

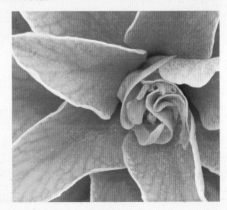

Flash modes

Digital cameras offer a choice of flash modes, designed to suit different subjects and shooting situations. They enable photographers to capture more creative and imaginative results than may have been possible by simply relying on standard auto-flash mode.

High-speed sync

Focal-plane (FP) or high-speed synchronization flash is when the flashgun's output is pulsed at an extremely high rate to simulate a continuous burst. In this mode,

it is possible to synchronize flash exposure with shutter speeds faster than the normal limits of the camera's flash-sync. Although not all DSLRs offer this function, this mode is useful in a variety of situations – for example, if you want to employ a burst of fill-in flash to relieve harsh shadows, but also want to select a large aperture to create a shallow depth-of-field. The wide aperture lets in more light, but increasing shutter speed to allow for this will often exceed the camera's flash-sync speed. High-speed sync is the answer. The drawback of using this type of pulsed light is that the effective range of the flashgun is reduced (by as much as a third). Also, despite its name, the continuous nature of pulsing light isn't able to freeze movement in the way a single, powerful burst can.

▼ *Flower*
Focal-plane flash is ideally suited to situations where you wish to employ a faster shutter speed than the camera's flash will allow. In this instance, I wanted to select a large aperture to create a narrow depth of field, but as a result of setting an f-number of f/4, the shutter speed exceeded the

flash sync. However, by using high-speed flash sync, I was able to employ a small 'kiss' of flash, which I needed to relieve the shadows.

Nikon D200, 150mm, ISO 100, 1/400sec at f/4, Nikon SB800 Speedlight, tripod.

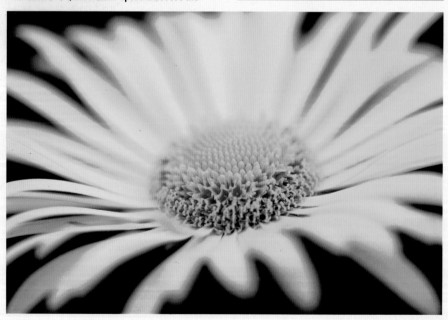

The trick when using any mode of flash is to ensure that the artificial burst doesn't overpower your subject. For this reason it is often worth applying a small degree of negative exposure compensation, in the region of 2/3 of a stop.

Exposure tip

Slow-sync

Slow sync is a technique where the flash is fired in combination with a slow exposure. It is most commonly used at night. The flash burst correctly illuminates the foreground subject, while the long shutter speed enables the sensor to record ambient light and detail in the background. Also known as 'dragging the shutter', this form of mixing flash and existing light can create some stunning results – particularly if there is subject movement, which will create light trails and ghosting – while still retaining the mood of the setting. You should meter for the scene as you would normally, selecting your camera's slow-sync mode, or 'night portrait' pre-programmed exposure mode if it has one, to expose the foreground subject correctly. As this technique relies on using a shutter speed of several seconds or longer, the use of a tripod is essential to keep the camera still during the exposure. It is also a good idea to use a remote release or your camera's self-timer function to ensure you don't move the camera when releasing the shutter.

▼ *Illuminated statue*
Slow-sync flash is ideal in situations where you wish to record the ambient light but need a burst of flash to expose a foreground subject. Here I employed slow-sync flash to illuminate a statue, while the long exposure correctly exposed the background and captured the trails of passing cars.

Nikon D300, 12–24mm (at 12mm), ISO 100, 20sec at f/20, Nikon SB800 Speedlight, tripod.

Front- and rear-curtain sync flash

The majority of DSLR cameras have a focal-plane shutter, designed with two curtains: a front and a rear. The front curtain opens to begin exposure, while the rear curtain slides shut to end it. Front- and rear-curtain sync, also known as first- and second-curtain synchronization, allow you to select whether the flash is fired at the beginning or end of the exposure.

The moment the flash triggers during exposure can have a big impact on the look of the final image. If it fires at the beginning of the exposure (front-curtain sync) any subsequent motion will appear to be in front of the subject; while if it fires just before the shutter closes (rear-curtain sync) the motion will appear to trail the subject. Therefore, before you begin taking pictures, you need to decide which flash effect will suit your subject or scene best.

In front-curtain sync mode, the flash is triggered the instant the shutter is fully open, freezing any subject motion at the beginning of the exposure. This is suitable in most situations and is often the camera's default setting. However, during longer exposures of moving subjects, a light trail will be recorded in front of your flash-illuminated subject, creating the impression that the subject is moving backwards, which can look artificial. Therefore, in situations like this, it is better to select rear-curtain sync. This mode fires the flash at the end of exposure, just before the shutter closes. As a result, any light trails appear to follow the moving, flash-exposed subject, creating more natural-looking images.

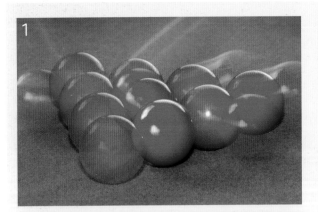

◀ *Snooker balls*
When using front-curtain flash (the default setting) to photograph moving subjects, the motion trail appears to be in front of the subject (1), which can look strange. By selecting rear-curtain sync, the light trail, or ghosting, will appear to follow the subject (2) and appear more natural.

Nikon D70, 105mm, 1sec at f/18, ISO 200, SB800 speedlight, tripod.

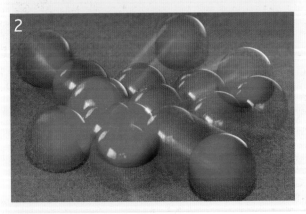

▶ *Bumblebee*
Different flash modes are suited to different subjects and lighting situations. Again, by using high-speed sync here, I was able to generate just enough flash light to relieve contrast in the image.

Nikon D300, 150mm, ISO 100, 1/800sec at f/4, SB800 Speedlight, handheld.

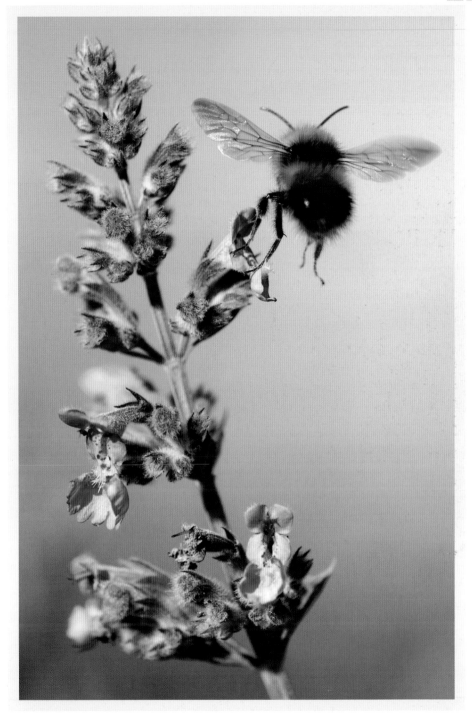

Bounce flash

Direct flash, where the flash head is aimed directly at the subject, can create quite harsh, unflattering light. Flash is a relatively small light source, so it creates quite hard-edged shadows that draw attention to the use of flash light. One way to soften the light of on-camera flash is to spread it over a larger area. The most effective and simple way to do this is to 'bounce' the light.

Bounce flash is a technique where the flash head is intentionally positioned to provide indirect light onto the subject. It is best to 'bounce' the light off a large white surface, such as a wall, ceiling or large portable reflector, otherwise the bounced light will adopt the colour characteristics of the surface it strikes. Not only is bounced light more diffused and flattering, but it reduces distracting hotspots and, if you are shooting portraits, eliminates the risk of red-eye as the flash light is not directed on the subject-to-lens axis.

▼ *Bounced flash*
More natural results are possible by bouncing the flash off a nearby white wall or ceiling. You will diffuse the flash light and soften the hard shadow. Here, (1) was shot using direct flash, while (2) was taken by bouncing the burst off the ceiling.

Nikon D300, 150mm, ISO 200, 1/125sec at f/11, SB800 Speedlight, tripod.

To bounce flash, you need an external flashgun designed with a head that tilts and swivels – your integral unit won't work as its position is fixed. Naturally, the direction in which you bounce the light will have a bearing on the end result, and will be dictated by the position of the nearest, most convenient surface.

Bouncing flash off a ceiling

Tilt the flash head towards the ceiling at a 75–90-degree angle. It will act like a giant reflector, bouncing light downward to evenly expose your subject. However, the disadvantage of this method is that if you are shooting portraits, you may notice some shadow beneath the eyes, nose and lips due to the way the subject is effectively lit from above.

Reverse bouncing

This method involves directing the flash head at a 45–75-degree angle backwards over your shoulder, to bounce light off both the ceiling and wall behind you. This will give you a greater level of diffusion and the light reflecting off the wall will relieve any shadow that may be caused by the light reflected downward from the ceiling. However, a lot of light is lost when doing this.

Bouncing flash off a wall

This form of side bouncing involves swivelling the flash head 90 degrees sideways towards the nearest wall. The wall acts like a large softbox. This form of bounced light appears more directional, creating areas of shadow and light, so gives images more depth.

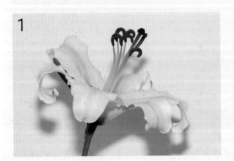
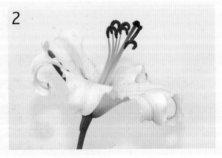

Exposure

The drawback of bouncing flash is that a certain amount of light is scattered or absorbed – typically, around 2 stops. Also, the light has to travel farther in order to reach the subject, reducing the effective range of your flashgun. For the best results, you need to be within just a few metres of the surface you intend bouncing from. However, unless you are using your flash manually, there is no need to worry about compensating exposure time. The camera is measuring the light entering through the lens, so accounts for the extra distance the flash has to travel and also for the light lost. Therefore, in auto or TTL mode, dedicated units will automatically adjust flash output – presuming that you stay within the flashgun's effective range, with an appropriate ISO and aperture selection.

Red-eye

Most snappers are familiar with the effect of red-eye, when a person's eyes appear red in photographs where flash is the principal light source. This is caused by the artificial burst reflecting off blood vessels at the back of the subject's retina. The effect of red-eye also affects certain animals, and, while it can be corrected post capture, it is best to avoid it in the first place.

There are various ways to limit its effect. Placing the flash away from the camera's optical axis will ensure that the artificial burst strikes the eye at an oblique angle. Therefore, if possible, avoid using your camera's integral flash and instead use an external flashgun. Also, bounce the flash if possible, so that only diffused light enters the eye. To help minimize the risk of red-eye, most digital cameras – compact and DSLR – have a built-in red-eye reduction facility. Normally, this works by emitting a series of short, low-power pre-flashes in order to contract the iris. Failing this, some cameras have the facility to correct red-eye in-camera, although, generally speaking, this isn't as reliable as using the red-eye removal function built in to many photo editing programs.

◀ *Harvest mouse*

Bounce flash is a useful technique when taking photos indoors; for example, when photographing family portraits or still life images. In this instance, I used bounced flash to create even, shadowless light when photographing this captive harvest mouse indoors. Doing so softened the flash burst, helping disguise the use of an artificial light.

Nikon D4, 150mm, ISO 200, 1/200sec at f/5.6, SB900 Speedlight.

There are a number of flash accessories available that are specifically designed to bounce or diffuse the typically harsh lighting of direct flash (see page 144).

Exposure tip

Flash accessories

As previously mentioned in this chapter, one of the drawbacks of using flash light is that, applied poorly, it can look artificial, casting hard shadows and drawing attention to its use. While it may be possible to bounce or diffuse light, doing so isn't always an option. Thankfully, there is a wide range of useful flash accessories available to buy that are designed to help your flash exposures look more natural and intended to help you realize the full creative potential of your flashgun.

Diffusers

Although many modern flashguns are designed with an integral, flip-down diffuser panel, it is still worthwhile investing in a dedicated diffuser or softbox. They greatly help to reduce the flash bursts' intensity, softening shadows, reducing the risk of red-eye and creating more natural-looking results overall. They are available in a wide range of designs, but each is intended to do the same job: fitting over the flash head to broaden the light's output and make it appear less intense. The most popular type is a push-on diffuser. This is a hard plastic diffuser that is available to fit different flashguns. You can even buy a version that is compatible with a DSLR's pop-up unit.

Another popular type of diffuser is a mini-softbox design. Again, it fits directly to the flash head, attaching with a hook and loop strap or Velcro, but the larger design gives a wider, softer, more even diffusion.

▼ *Diffuser*
A diffuser is an essential flash accessory that works by softening the intensity and harshness of the flash burst. They are available in a wide variety of designs; it is even possible to buy versions that are compatible with your camera's pop-up unit.

▼ *Softbox diffuser*
Mini-softbox-type diffusers are designed for hotshoe-mounted flashguns. They help eliminate red-eye and soften harsh light. They are quick and easy to use and require no additional adaptor or bracket.

It is possible to buy coloured 'gels' that attach to the flash head and alter the colour of the light emitted. They can be used for colour correction or to create dramatic colouring effects for creative purposes.

Exposure tip

The drawback of using any type of diffuser is that, because of how they absorb light, they reduce the effective range of the flash. As a result, they are best used when shooting relatively close to the subject; for example, indoors or in a studio environment.

Extenders

Flash extenders are designed to increase a flash's range. They concentrate the burst of artificial light via a precision fresnel lens (a concept designed originally for lighthouses), effectively gaining 2 or 3 stops of light. They attach directly to a flash head and are best combined with longer focal lengths, of 300mm and upwards. Therefore, they are most popular with sports and wildlife photographers

▼ Custom bracket

Compared to having your flash camera-mounted, flash brackets and arms provide far greater lighting flexibility. They allow you to be more creative in the way you position and direct your burst of artificial light.

who have to shoot subjects from further away. Presuming you are using TTL metering, there is no need to adjust your exposure settings when using an extender as the camera will do this automatically. However, always ensure that there is a clear, visual path between the flash and the subject you are photographing, as anything in between is likely to appear grossly overexposed – receiving too much light – due to the inverse square law (see page 127).

Flash brackets and arms

Although flash can provide very natural-looking lighting, particularly when it is diffused in some way, it can also create harsh-looking light if directed poorly. One way to rectify this is to alter the position and angle of the flash. Hotshoe-mounted flash can prove severely limited when you require this type of creative control over the light's direction and effect. Often, better results are achieved by positioning the flash off-camera; for example, to one side of the lens so shadows are cast in one direction to create more depth and life. It is possible to mount your flash off-camera using a dedicated flash arm or bracket. There is a wide range of designs available, with different makes and models offering different levels of functionality.

Wireless flash triggers

The ability to fire your flashgun off-camera generates a whole new creative perspective: for example, you can transform a portrait by moving the light's direction to one side; add light to the shadow areas of a still life; or add impact to action. While flash can be used off-camera using off-camera shoe cords, an easier option is using wireless flash triggers. Although more costly, they replace a tangle of leads and wires, and are far more convenient to use. Hahnel, Phottix and PocketWizard are among the leading brands of wireless devices, providing radio triggering for one or more flashguns over a large range (some work up to a range of 550 yards or 500m) using a choice of channels. Most designs support the camera's maximum flash-sync speed.

5 Filters

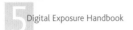

Filters

While it is true that digital capture has replaced the need for some traditional, in-camera filters, some filter types remain an essential creative and corrective tool for photographers today. A camera's white balance function may be a far more convenient method of correcting the light's colour temperature than attaching a colour-balancing filter (as was once necessary), but the role and necessity of many other filter types remains unaltered. For example, the effect of a polarizer (see page 160) or extreme neutral-density filter (see page 154) is impossible to mimic post capture. Filters can have a huge effect on exposure and light, so their relevance to digital exposure is significant. Although there is a wide range of filter types available to buy, this chapter only deals with the filters most relevant and useful to photography today.

Filters can benefit a wide range of subjects, but they are most suited to landscape photography (see page 74). Although some filter effects can be replicated using imaging software such as Photoshop, there are benefits to filtering the light at the time of exposure, which is why in-camera filtration is more popular today than ever before. The corrective and creative effects of filtration are easier to apply and manage today thanks to digital tools such as image playback and histograms. A word of warning, though: it is important not to get in the habit of using filters just for the sake of it. Only attach filters when they will genuinely benefit your images. Attaching a filter in the wrong situation, or when it isn't really required, will have the opposite effect to what you intended: degrading rather then enhancing a photo. Filters will not miraculously transform a bad image into a good one. However, applied appropriately they will enhance your photography and help you achieve results that would have been impossible otherwise.

Filter factor

Due to their design, many filter types reduce the amount of light reaching the sensor. This is known as the 'filter factor' – a measurement indicating the degree of light that is absorbed. The higher the 'filter factor' the greater the light loss and if the exposure settings are not adjusted accordingly, the resulting photograph will be underexposed (see page 58). TTL metering measures the actual light entering the lens. Therefore it will compensate for the filter's 'factor' automatically. However, it is still important to be aware of the effect filters have on exposure.

The 'filter factor' should be stated either on the filter, its mount or packaging. The table below lists the amount of light that a handful of the most popular filter types absorb.

Filter:	Filter factor:	Exposure increase:
Polarizer	4x	2 stops
ND 0.1	1.3x	1/3 stop
ND 0.3	2x	1 stop
ND 0.6	4x	2 stops
ND 0.9	8x	3 stops
ND 1.8	64x	6 stops
ND 3.0	1000x	10 stops
ND grads	1x	None
Skylight/UV	1x	None
Close-up	1x	None

▶ The effect of filtration

Digital capture may have negated the need for some filter types, but filters remain an important creative tool. The following images help illustrate how they can be used to enhance a scene: for the first image (1), no filters were attached; for the second shot (2), a 3-stop ND grad and 10-stop ND were used.

Nikon D800, 17–35mm (at 17mm), ISO 100, 90sec at f/11, 3-stop ND grad, 10-stop ND, tripod (2 only).

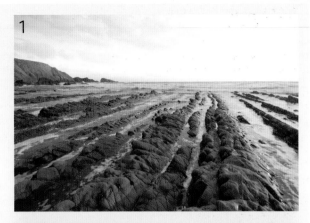

Vignetting

This can be a common and frustrating filter-related problem. It occurs when the light is obstructed from reaching the edges of the frame during exposure. The result is a photograph with visible darkening at the corners. Often, vignetting is caused by stacking two or more screw-in type filters, or using a filter holder (see page 150) in combination with a screw-in filter, while using a wide-angle lens. However, it can also occur if a filter holder is positioned at an angle, instead of straight. Super wide-angle lenses are particularly prone to this problem and vignetting will almost certainly occur when combining filters at focal lengths below 18mm. You might think that the effect would be obvious when you look through the viewfinder. However, it can easily go undetected, due to the fact that many DSLR viewfinders only display around 91–97% of the actual image area. Switch to Live View for 100% viewfinder coverage.

▼ Mountain lake

Darkening of the corners of the frame is a common problem when using ultra wide-angle lenses in combination with filters and filter holders.

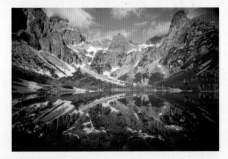

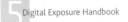
Screw-in or slot-in filters?

Filters are available in two distinct types: screw- or slot-in. Screw-in filters are circular in design and attach directly to the front of the lens via its filter thread. Slot-in filters are square or rectangular pieces of glass, or optical resin, that attach to the lens via a dedicated filter holder. Filter users often employ a hybrid system, investing in certain screw-in-type filters and also a modular slot-in system.

thread size, this isn't economical or practical, proving costly and adding weight to your bag. Instead, step-rings offer a simple solution. They are designed to adapt a filter to a lens, when the two have differing diameters. For instance, if you had a 67mm screw-in filter but wanted to attach it to a 58mm lens, the appropriate step-down ring would allow you to do this. Step-down rings are a cost-effective way to expand the compatibility of larger filters. Step-up rings, allowing smaller filters to be attached to larger

Screw-in filters

Circular screw-in filters are produced in specific filter threads; for example, 52mm, 58mm, 67mm and 77mm are all popular sizes. Therefore, it is important to buy filters that fit the thread size of the lens you intend using it with. Many photographers have a variety of lenses in their system, all typically boasting a different filter thread size. As a result, filter compatibility between different optics can be an issue. While you could buy a set of filters for each

▼ *The Rumps*

Different filters perform different roles; therefore, it can be necessary to employ a combination of screw-in and slot-in filter types. In this instance, I combined a circular polarizer with a solid neutral-density, slot-in-type filter. The polarizing filter helped to enhance the sky, while the ND lengthened the shutter time to intentionally render the sea a milky blur.

Nikon D200, 10–20mm (at 10mm), ISO 200, 30sec at f/18, polarizer, 3-stop ND, tripod.

Exposure tip

UV or skylight filters are clear filters designed to absorb UV light. While the effects of using them are fairly minimal, they provide a cheap method of protecting the lens's delicate front element from getting scratched or damaged.

diameter lenses, are also available. However, they are usually best avoided, as they increase the likelihood of vignetting (see page 149).

If you decide to invest in a system of circular filters and step-rings, remember you will need to buy a set of filters that fit the largest diameter lens in your current system. This could be up to 77mm or 82mm in size. Not only will the initial outlay prove costly, but also filters of this diameter will prove bulky in your camera bag. Instead, many rely on the versatility of using a slot-in system, and only buy essential screw-in type filters such as a polarizer (see page 160).

Slot-in filters

The advantage of using a slot-in system is that you can use the same filters and holder on all the lenses in your set-up. This is possible via adaptor rings, which are inexpensive and available to fit different thread sizes. The adaptor rings attach directly to the holder, but can be removed quickly should you need to swap the holder and filters from one lens to another. Also, due to the holder's design, it is possible to employ two or three filters together without

increasing the risk of vignetting. Holders are usually designed with three filter slots, making it possible to combine technical and creative filters together to achieve different results.

Without doubt, a slot-in system is the most cost-effective, compatible and versatile method to apply in-camera filtration. Simply speaking, it is the best long-term investment for regular filter users. Not only is a slot-in system expandable, but filters can be slid into position and removed quickly – vital if the light, or conditions, are quickly changing. There is a variety of systems on the market, with popular filter brands being Cokin, Lee Filters and Hitech. Typically, they are available in three progressive sizes – 67mm, 84/85mm and 100mm – designed to cater for different budgets and capabilities. A large 150mm system is also available, designed to cater for wide-angles with a protruding front element.

It is best to opt for the largest filter system that you can justify buying, as smaller holders will not be compatible with larger diameter lenses and the risk of vignetting is greatly increased when using wide focal lengths. A 100mm system is the best long-term investment for landscape photographers.

▼ Filter system

At the hub of a slot-in system, is the holder or filter bracket. Normally it will be designed with two or three slots, allowing you to combine filter types. The Lee Filters holder is customizable, and can be constructed with one, two, three or even four slots.

▼ Adaptor rings

Adaptor rings are required to attach filter holders to the lens's filter thread. They are available in various sizes to suit different diameter lenses.

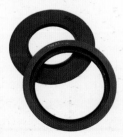

▼ Screw-in filters

Screw-in filters are available in a variety of sizes and types. One of the most useful screw-in types are UV or skylight filters.

Neutral-density (ND) filters

One of the most popular and regularly used filter types, the neutral-density (ND) filter is designed to absorb light entering the camera and reaching the sensor. By doing so, the filter can be employed to artificially lengthen exposure time. Although solid ND filters can be useful in situations when there is too much light and you wish to employ a larger aperture than the light or camera capabilities will allow, they are more commonly used to lengthen shutter speeds to creatively blur subject motion.

ND filters have a neutral grey coating, designed to absorb all the colours in the visible spectrum in equal amounts. This coating prevents them from creating a colour cast; altering only the brightness of light, not its colour. They are produced in a range of densities, to suit different conditions and purposes and in both slot- and screw-in types. Their strength is printed on the filter, or mount – the darker their shade of grey,

the greater their absorption of light. A density of 0.1 represents a light loss of 1/3 stop and the most popular strengths are 0.3 (1 stop), 0.6 (2 stops) and 0.9 (3 stops). Extreme versions, with a density equivalent of up to 10 stops, are also available (see page 154).

If required, two or more solid ND filters can be combined to generate an even greater light loss. However, a 0.9 ND, which is equivalent to a 3-stop reduction in light, is usually adequate in most shooting situations where you wish to artificially lengthen exposure. For instance, using one will lengthen a (unfiltered) shutter speed of 1/8sec to 1sec; or permit

▼ *Godrevy Lighthouse*

In order to generate a shutter speed long enough to render the rising tide as an ethereal-looking blur, I attached a solid 3-stop ND filter to absorb the ambient light. While the effect is subjective, personally I love the impression of motion ND filters create.

Nikon D700, 24–70mm (at 56mm), ISO 200, 1min at f/11, 2-stop ND grad, 3-stop ND, tripod.

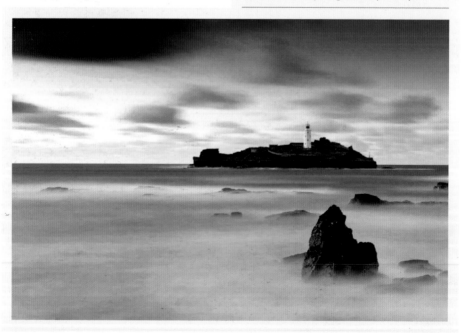

the use of an f-stop 3 stops wider. This represents a significant shift in exposure, which has the potential to vastly alter the appearance of the final shot.

Intentionally emphasizing movement is a powerful aesthetic tool (see page 54). Traditionally, solid ND filters are most popularly used to create lengthy exposures to blur the movement of running water, for example a waterfall or rising tide. This is a favourite technique among many outdoor photographers, as the water adopts a milky white blur, which can help produce atmospheric-looking results. However, ND filters can also be used to creatively blur, among other things, the movement of people, flowers or wildlife.

No other filter type has a greater effect on exposure than solid NDs. However, presuming you are using your camera's internal TTL meter, you will not usually need to make any manual adjustments for the filter's 'factor'. Unless you are using an extreme

ND, simply meter with the filter in place and the camera will automatically compensate for its density. If you are using a non-TTL meter, then remember to adjust the reading by the strength of the filter in use.

▼ Capturing motion

By artificially lengthening exposure time, ND filters are capable of dramatically altering the appearance of motion. It is possible to alter the look, feel and mood of a shot by using solid NDs to intentionally blur the movement of cloud, water, foliage, flowers, crops and even people. Here, image 1 was taken without an ND filter, while for image 2 filtration was used.

Nikon D300, 12–24mm (at 15mm), ISO 200, 25sec at f/22, 3-stop ND, tripod (1 only).

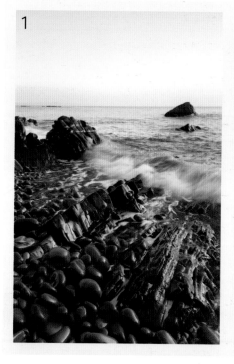

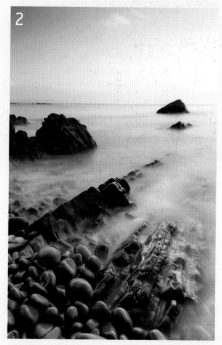

Extreme neutral-density filters

These filters have quickly become a 'must have' for landscape photography. With a filter factor of up to 10 stops (or 1000x), they enable photographers to slow down exposure to the extreme – even in bright light you can employ lengthy shutter speeds of 30sec or longer. Their key characteristic is the effect they have on motion, creating eye-catching results.

Although 1.8 (6 stops) and 2.4 (8 stops) densities are available, 3.0 (10 stops) ND filters are the most popular versions on the market – with Lee Filters, Big Stopper a favourite. Even in good light, where you would naturally use an exposure of a fraction of a second, a 10-stop ND allows photographers to employ artificially long exposures. For example, an unfiltered shutter speed of 1/15sec will be lengthened to 1min with the filter attached. During an exposure of this length, a lot can alter: drifting cloud will be transformed into brushstrokes, moving water is recorded smooth and glass-like, and passing people or traffic can 'disappear' altogether. This is a highly creative filter type and it will give your images atmosphere.

The density of extreme ND filters is so great that you can see little, if anything, through them. Therefore, composition, focusing and any other filtration required, needs to done before attaching the filter. Alternatively, Live View can prove a great aid when using extreme ND filters, often giving a clear enough image on the monitor to allow photographers to tweak composition and align ND grads without having to remove the filter; however, on some models, Live View isn't sensitive enough to be of any help.

Extreme ND filters are particularly effective when used in constant, overcast light for photographing subjects with strong, bold shapes; for example, a pier, lighthouse, groyne or windmill. Even in grey weather, the length of exposure will transform a textured sky, helping create an arty masterpiece that suits conversion to monochrome (see page 176).

Calculating exposure

With a huge filter factor of 1000x, calculating exposure and achieving correct results using a 10-stop ND filter isn't always easy. Because of the filter's density, a camera's TTL metering will normally fail to select a correct exposure. Often the length of exposure will exceed the camera's slowest shutter speed anyway – this is typically 30sec. Therefore, photographers often have to do a little basic arithmetic when using extreme NDs, and they will also often have to employ their camera's bulb (see page 50) setting in order to keep the shutter open manually.

So how do you calculate correct exposure? One option is to take a meter reading without the filter attached and then increase exposure time by 10 stops. For example, if the unfiltered meter reading is 1/15sec, with a 10-stop ND filter attached it will be 1min – 1 stop is 1/8sec; 2 stops is 1/4sec; 3 stops is 1/2sec, and so on. However, rather than working this out manually, photocopy the chart below and keep it in your camera bag. Alternatively, use the calculator on your mobile phone, multiplying the original exposure by 1000x. If you own a smart phone, you can even download applications that do all the hard work for you – calculating exposure depending on the strength of the ND filter you are using; NDCalc is one of the most popular Apps. Extreme NDs are rarely exactly 10 stops in density, so review the histogram of extreme exposures and be prepared to lengthen or shorten exposure time if necessary.

Unfiltered exposure	Exposure with 10-stop ND
1/500sec	2sec
1/250sec	4sec
1/125sec	8sec
1/60sec	15sec
1/30sec	30sec
1/15sec	1min
1/8sec	2min
1/4sec	4min
1/2sec	8min
1sec	16min

During such long exposures, light leakage can prove a problem, resulting in ugly flare, or strips of light on the final image. To minimize the risk, always place extreme NDs in the filter slot closest to the lens and also keep the camera's eyepiece covered during exposure.

Exposure tip

▼ Filter types

Due to the popularity of extreme ND filters, there is a good choice among filter brands. The most practical type is a slot-in version. Lee Filters 'Big Stopper' is a favourite among professionals. While ND filters of this density are rarely truly 'neutral', the Lee version only displays a slight cast – typically a cool, blue hue that is easily corrected in-camera using WB or it can be neutralized post capture. Hitech's 'Pro Stopper' is another good option. Among the circular, screw-in types available, the B+W ND-110 is very good, but the cast is stronger, adding a warm, orange–brown hue to images. Again, it can be corrected relatively easily and the cast is irrelevant if you intend to later convert to black and white. Not all extreme ND filters have a density of 10 stops; 6-, 8- and even 13-stop versions are also available. Singh Ray are among the brands that produce a vari-ND filter. You can alter the filter's density from 2 to 8 stops by simply twisting the front section of the mount.

▶ Extreme exposures

10-stop ND filters have the ability to transform otherwise quite ordinary looking scenes, or light, into atmospheric, visually striking photographs. During lengthy exposures, cloud movement is rendered as brushstrokes and even choppy water appears smooth and reflective.

Nikon D300, 10–24mm (20mm), ISO 100, 3min at f/22, 3-stop ND grad, 10-stop ND, tripod.

Graduated neutral-density (ND) filters

The sky tends to be lighter than the landscape below it. The difference in brightness between land and sky can be equivalent to several stops, and the level of contrast will often exceed the sensor's dynamic range (see page 28). As a result, if you expose correctly for the sky, the foreground will be too dark; but if you meter for the land, the sky will be overexposed and the highlights washed out. This is a common exposure problem for scenic photographers. The only in-camera method to balance the light in unevenly lit scenes is using graduated neutral density filters.

These filters are half-clear and half-coated, with a transitional zone where they meet. They work in a similar way to a solid neutral-density filter. However, a graduated ND filter is designed to only block light from one area of the image, as opposed to all of it.

They are brilliantly simple to use. With your filter holder attached (see page 150), slide the ND grad in from the top and then – while looking through the camera viewfinder or using Live View – align the filter's transitional area with the horizon. By using an ND grad of an appropriate density, you are able to balance the contrast in light and bring the whole scene within the sensor's dynamic range, ensuring detail is retained in both the shadows and highlights. They are typically available in 0.3 (1 stop), 0.6 (2 stops) and 0.9 (3 stops) strengths. Which density ND grad you require will depend on the lighting and the effect you wish to achieve.

▼ Without ND grad

▼ 1-stop ND grad

While coloured grads are also available – including blue, grey, tobacco and coral – their effect can look very unnatural. If you wish to add a colour hue to bland-looking skies, it is best done post capture in Photoshop when the effect is reversible and can be applied with far more precision.

Exposure tip

The most precise way to work out which density grad to apply is to take spot meter readings (see page 22) from the land and sky then calculate the difference between the two. For example, if the reading from the sky is 1/250sec and the one for the land is 1/8sec, the difference would be about 5 stops. Remember, a 'stop' is a halving or doubling of an exposure value. This is a fairly typical level of contrast. However, our eyes naturally perceive the sky to be lighter than the land, so don't attempt to balance the light evenly. For example, in the instance above, I would suggest using a 3-stop ND grad in order to leave a natural-looking 2-stop contrast between the sky and land – combining two grads to generate 5-stops-worth of graduation would create an unnatural, ugly result. Remember, the key to filtration is to create authentic-looking results.

▼ *Graduated ND comparison*

The land is typically darker than the sky. The most popular method for balancing the contrast in a scene is to employ graduated ND filters. They are available in 1-stop, 2-stop and 3-stop strengths and with either a hard or soft transition (see below) in order to suit different scenes and lighting conditions. Their effect can be better understood by looking at this picture sequence. In this instance, the result using a 2-stop ND grad produces the correct result.

Nikon D700, 17–35mm (at 18mm), ISO 100, 10sec at f/16, tripod.

▼ 2-stop ND grad

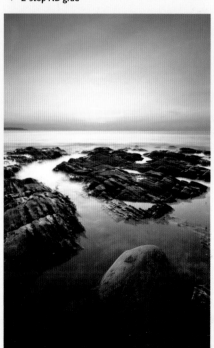

▼ 3-stop ND grad

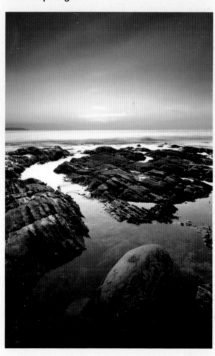

Types of graduated neutral-density (ND) filters

Most landscape photographers rely on ND grads to achieve perfect exposures in-camera. The alternative to using grads is taking two exposures of the same image – one correctly exposed for the sky, and another for the land – then later blend them together, to create a correctly exposed result overall, using photo editing software (see page 178). There are advantages to this technique, but the process involves spending more time in front of a computer, which won't suit every photographer. For those who prefer to get things right in-camera, ND grads are the best option.

Like solid ND filters, grads are available as both screw-in and slot-in types. Circular versions are not recommended, though, as once attached to the lens, the position of their transitional zone is effectively 'fixed', dictating where you place the horizon in your photo and limiting your choice of composition. Slot-in versions are rectangular in design and can be slid up and down in the holder so that the photographer can position the graduated zone precisely, depending on where the horizon is positioned in your photo. Accurate placement of the grad is important, particularly if you are using one with a hard transition. If you inadvertently push the filter too far down in the holder – so that the coated area overlaps the foreground – the landscape will also be filtered and look artificially dark. Equally, if you don't slide the filter down far enough, you will create a noticeable bright 'band' close to the horizon where the sky isn't filtered. However, positioning the filter correctly is normally straightforward and, with just a little practice, very easy to do.

Soft- or hard-edged?

Graduated neutral-density filters are available in two types: hard- and soft-edged. 'Soft' ND filters are designed with a feathered edge, providing a gentle transition from the coated portion of the filter to the clear zone, while a 'hard' ND is designed with a more sudden transition. Both types are useful, depending on the scene.

Soft grads are better suited to shooting landscapes with broken horizons, as they don't noticeably or abruptly darken objects breaking the skyline, such as buildings, mountains or trees. However, on the downside, only around a third of the filter is coated with its full density before it begins to fade to transparent.

This can be a problem, as usually the brightest part of the sky will be just above the horizon where a soft grad is at its weakest. As a result, to avoid this strip of horizon from overexposing, it may be necessary to align the filter lower in the holder so that it begins to overlap the ground, which isn't ideal.

In contrast, 'hard' grads are designed so the full strength of their specified density is spread over a greater proportion of the coated area. They can be aligned with far more precision and allow photographers to reduce the brightness of the sky with greater accuracy than a soft grad. On the downside, they are far less forgiving should you position the filter incorrectly, so they require careful use.

▼ *Soft-edged* ▼ *Hard-edged*

Exposure tip

ND grads can be combined together to create even higher densities, which is useful when there is extreme contrast between the land and sky. However, although intended to be neutral, you may notice a colour cast (typically magenta) when combing budget ND filters.

▼ Evening glow

ND grads allow photographers to capture detail throughout high-contrast scenes. They are particularly useful during the 'golden hours' at dawn and dusk. 'Hard' grads are well suited to landscapes with a straight, even horizon – like beach scenes.

Nikon D700, 17–35mm (at 20mm) ISO 100, 30sec at f/16, 3-stop ND grad, tripod.

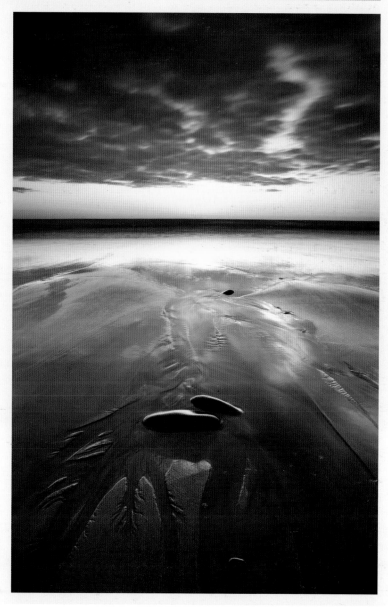

Polarizing filters

If you only have room for one filter in your camera bag, carry a polarizer: no other filter will have a greater impact on your images. They are designed to eliminate glare, reduce reflections and enhance colour saturation – effects that are impossible to replicate post capture. For outdoor photographers, a polarizer is a must-have accessory.

To appreciate how a polarizer works, it is first necessary to have a basic understanding of how light travels. Light is transmitted in waves, the wavelengths of which determine the way we perceive colour. They don't just travel up and down in one plane, the vibrations exist in all possible planes through 360 degrees. When they strike a surface, a percentage of wavelengths are reflected, while others are absorbed. It is these that define the colour of the surface. For example, a blue-coloured object will reflect blue wavelengths of light, while absorbing others. It is for this reason that foliage is green, as it absorbs all wavelengths of light other than those forming the green part of the visible spectrum.

Polarized light is different. It is the result of wavelengths being reflected or scattered and only travels in a single direction. It is these wavelengths that cause glare and reflections, reducing the intensity of a surface's colour. It is prevalent, for example, in light reflected from non-metallic surfaces, such as water, and in light from blue sky at 90 degrees to the sun. A polarizing filter is designed to restore contrast and natural colour saturation by blocking polarized light from entering the lens and reaching the image sensor.

A polarizing filter is constructed from a thin foil of polarizing material, sandwiched between two circular pieces of optical glass. Unlike other filters, the front of its mount can be rotated. Doing so affects the angle of polarization, which alters the degree of polarized light that can pass through the filter. The direction that wavelengths of polarized light travel in is inconsistent, but the point of optimal contrast can soon be determined by simply twisting the filter in its mount while looking through

the camera's viewfinder. As you do so, you will see reflections come and go and the intensity of colours strengthen and fade. The strength of this effect depends on the angle of the camera in relation to the sun. Some surfaces remain unaffected by the polarizing effect; for instance, metallic objects such as polished steel and chrome plate do not reflect polarized light patterns.

A polarizer has a 4x filter factor (see page 148), which is equivalent to 2 stops of light. Therefore, attaching one will affect exposure. Your camera's TTL metering will automatically adjust for this, but remember that the shutter length will be lengthened as a result.

Linear or circular – what is the difference?

Polarizing filters are available in two types: linear and circular. This can prove confusing if you are new to using filters, with photographers being unsure which to buy. Although both types are (typically) physically circular in shape and look identical, the design of the linear type will affect the metering accuracy of auto-focus cameras, as they polarize some light internally. If this light is also polarized by a filter a false meter reading will result. To correct this, circular polarizers are constructed with a wave-retardation plate – one-quarter of a wavelength thick. This allows the wavelengths passing through the filter to rotate and appear un-polarized to the camera's metering system. Therefore, digital photographers need to opt for the circular type to ensure their camera's metering remains accurate.

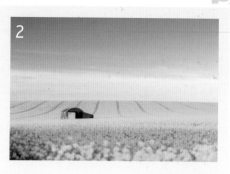

▲ *Polarizing effects*

The difference between a polarized and non-polarized photograph can be dramatic. The filter can bring images to life, cutting through haze and improving clarity and subject definition. In this instance, the photograph without a polarizer (1) is rather dull and nondescript. In contrast, the subsequent shot (2) – taken with polarizer attached – is vibrant, with more saturated colours.

Nikon D700, 70–200mm (at 100mm), ISO 200, 1/80sec at f/4, polarizer, tripod (2 only).

▼ *Oxeye daisies*

If you wish to capture eye-catching images with strong, vibrant colours, attach a polarizer. Subjects captured against a clear, blue sky will stand out. Here, a polarized sky provided the perfect backdrop for a group of oxeye daisies.

Nikon D700, 17–35mm (at 19mm), ISO 400, 1/125sec at f/16, polarizer, handheld.

Using polarizing filters

Polarizers are synonymous with vibrant blue skies. Our atmosphere contains air molecules and tiny suspended particles, smaller than a wavelength of light, both of which scatter light. This scattered light is polarized, which is why polarizing filters work so effectively to intensify the colour of skies. However, the strength of the effect will vary depending on the angle of the camera in relation to the sun. Light from the sun is most highly polarized in the areas that are at 90 degrees to the sun. Therefore, to achieve the most obvious result, position the camera at right angles to the sun – this is known as 'Brewster's angle'. The polarizing effect appears at its most pronounced during morning and evening, when the sun is lower in the sky. However, the filter will have little or no effect on hazy, cloudy skies.

Although many photographers invest in a polarizing filter simply for its ability to deepen blue skies, they have many uses aside. Due to the way they reduce glare reflecting from foliage, they are useful when taking countryside images, restoring colour and contrast. They are also useful when shooting floral close-ups, revealing their true colour. The polarizing effect is particularly noticeable if foliage is damp, as wet leaves and petals reflect more stray light. A polarizer will cut through this sheen, so attach one next time you shoot foliage after a downpour.

A polarizer can also be employed to reduce, or eliminate, reflections. So, if you wish to photograph a subject underneath the water – fish and coral in a rockpool, for instance – a polarizer will weaken the reflections on the water's surface to

▼ *Water lily*
Polarizers cut through the glare reflecting from foliage, especially when wet. The first frame (1) was shot without filtration, while a polarizer was attached before capturing the second frame (2).

Nikon D200, 100–300mm (at 200mm), ISO 100, 1/8sec at f/9, polarizer, tripod (2 only).

Polarizing problems

As useful as polarizing filters are, a few problems can occur when using them. Thankfully, once you are aware of the problems, they are relatively easy to avoid. The most common polarizer-related problem is over-polarization. While a deep blue sky might look seductive, it is possible to overdo the effect. It is important to remember the most flattering effect isn't necessarily achieved at full polarization and at the optimal point the effect can be too strong. This can render skies unnaturally dark, or even black. Over-polarization is most likely when photographing a blue sky overhead at high altitudes. Often the effect will be obvious through the viewfinder, but review images via playback. Another relatively common problem is uneven polarization.

This is when the polarizing effect is uneven across the sky. Short focal lengths below 24mm are most prone to this, as they capture such a broad expanse of sky. As a result, when taking pictures at certain angles to the sun, you may find the colour of the sky will be irregular, being dark in some areas, but lighter in others. Either employ a longer focal length, or adjust your shooting position, to correct the problem.

Finally, the risk of vignetting (see page 149) is enhanced when using a polarizer. This is because, being constructed with two pieces of glass, the mount can be quite deep. Thankfully, many filter brands now market ultra-slim polarizers to minimize the occurrence of vignetting.

reveal what is below. Equally, they can be used to diminish distracting reflections from glass, making polarizers well suited to photographing modern buildings and urban landscapes. However, it should be emphasized that eliminating reflections is not always desirable. While some reflections can prove ugly and distracting, others enhance a photograph; for example, a mountain range reflected in a still loch. In situations like this, the reflections form an integral part of the composition. This isn't to say you shouldn't still attach a polarizer. Removing the sheen on the water's surface can actually intensify reflections. Regulate the effect by slowly rotating the filter until you get the result you want.

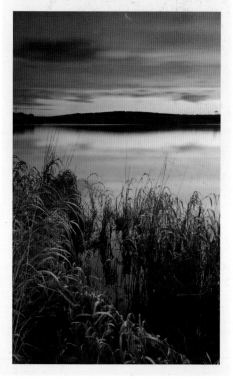

 Lake view

With this shot, I attached a polarizer and, while peering through the viewfinder, slowly rotated it until the sheen on the water's surface was removed. As a result, the colourful early morning reflections were intensified, enhancing the impact of this shot.

Nikon D300, 12–24mm (at 16mm), ISO 200, 1min at f/16, 3-stop ND grad, polarizer, tripod.

6 Exposure in the digital darkroom

Exposure in the digital darkroom

Triggering the shutter and capturing a photo is just the beginning – an image still needs processing before it is ready to be shared, printed or published. Presuming exposure was correct at the time of capture, images shot in Jpeg should require very little further work. However, if, as recommended, you shoot in Raw (see page 68), your photographs are effectively unprocessed data. Just like a film negative, you need to carefully process Raw files if you want your images to fulfil their full potential.

While you don't need to be a Photoshop whiz in order to bring your Raw files to life, it is important to be familiar with at least a handful of essential post processing tools. Post processing can have a huge bearing on exposure; in practice, the two go hand-in-hand. In the digital darkroom, you can alter exposure, make images lighter or darker, and also make fine adjustments to shadow and highlight areas. It is possible to blend exposures in order to mimic the effect of graduated ND filters (see page 156), or even combine multiple exposures to create

a High Dynamic Range (HDR) image (see page 180) – a technique designed to overcome the dynamic range limitations of a digital chip. You can also add contrast and saturation to your shots, or convert them into moody black and white photos. All this is possible using relatively basic software and modest post processing skills.

Naturally, post processing is a huge topic, to which entire books are dedicated. Although it is impossible to go into processing techniques in any great depth in a single chapter, the following pages are dedicated to digital darkroom techniques and topics that are particularly relevant to exposure, complementing subjects covered in previous chapters.

Software

Using appropriate image editing software to edit and process your files is important. Although digital cameras are usually bundled with a dedicated software package, most enthusiasts prefer using third-party programs. Although this is an extra cost, their power and range of capabilities are unrivalled. Adobe Photoshop is widely recognized as the industry standard, but just so you are aware of the options available, I have briefly outlined a handful of the most useful and popular software packages available.

▶ *Processing*
Raw files in particular need at least some degree of processing applied to them in order to reveal their true impact and potential. For example, the first image is an unprocessed file, without any adjustments made to exposure, colour balance, contrast or saturation. The second image is the same as the first, but after a few simple 'tweaks' had been made using Lightroom. The difference is significant. The final image resembles the scene I remember photographing far more closely.

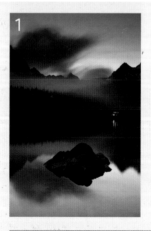

Nikon D800, 17–35mm (at 35mm), ISO 200, 2min at f/16sec, 3-stop ND grad, tripod.

Popular software packages

Adobe Photoshop Creative Suite	Photoshop CS is the most popular and widely used imaging program. Quite simply, it is the ultimate image-manipulation package, providing one application for managing, adjusting and presenting large volumes of digital files. However, many photographers will never require, or fully utilize, its full capabilities, so a limited version can prove more practical and economical.
Adobe Photoshop Elements	This is a stripped-down version of the full Photoshop CS package. It is a fraction of the cost, yet still possesses the key editing tools and enough features to satisfy the vast majority of photographers. It is a digital photographer's essential toolbox.
Adobe Photoshop Lightroom	This is a popular and sophisticated workflow and Raw editing package designed to help photographers process, organize and archive large numbers of images. Aimed at professionals and enthusiasts alike, it allows you to fine-tune your photographs with precise, easy-to-use tools. For many photographers, it offers all the processing options they will ever need.
Phase One Capture One	This Raw workflow software is the perfect choice for high-volume photography, as it is designed to handle many images at a time. Renowned for its excellent image quality, Capture One offers unlimited batch capability, multiple output files from each conversion, and IPTC/EXIF (meta data) support among many other essential features. It is available in full or limited edition (LE) versions.
Apple Aperture	This innovative package offers next-generation Raw processing for producing images of the highest quality. It provides a quick preview mode for rapid-fire photo browsing, as well as image adjustment controls such as Recovery, Definition, Vibrancy and Soft-edged Retouch brush for removing unwanted elements from photographs. It also has iPhoto library facilities. It is only available for Apple Macintosh computers.
Corel Paintshop Pro	PaintShop Pro is an inexpensive alternative to Photoshop. It provides a depth of functionality, allowing photographers to download, view, sort and quickly process their digital photographs. This is easy-to-use, powerful and affordable software.

Why shoot Raw?

Jpegs require less post production and effort, so why shoot in Raw? The answer is simple. When you capture a Jpeg (or Tiff) in-camera, all the shooting parameters – white balance, sharpening, and so on – are already applied to the image to produce a processed 'finished article'. Although this might be the simplest, most convenient option, you are effectively allowing the camera to make a series of important, interpretive decisions on your behalf.

Jpegs (see page 68) are also a compressed file type, meaning important picture information is discarded. In contrast, by shooting in Raw, you are effectively capturing a 'digital negative' containing untouched, 'raw' pixel information. Raw files contain more information, a wider level of tones, have a greater dynamic range and are generally more tolerant of error. They are the best option for maximizing image quality and allow you more control over the look of the final converted image.

Digital photographers naturally wish to capture photos with the highest image quality. The range of tones and colours captured are of particular importance. The majority of DSLRs capture either 12 or 14 bits of data in order to do this. 12-bit sensors can record 4,096 tonal levels, while a 14-bit chip can capture 16,384 different brightness levels. However, a photograph captured in Jpeg is converted in-camera to 8-bit mode, reducing the levels of brightness to just 256 levels. By retaining the sensor's full bit depth, Raw capture enables photographers to extract, among other things, shadow and highlight detail during conversion that may otherwise have been lost. Higher bit depth also reduces an image's susceptibility to posterization – an effect where abrupt changes from one tone to another are obvious.

For most types of photography, the argument to shoot in Raw format is hard to ignore. However, a Raw file's latitude for error is no excuse for laziness or complacency. The need to achieve good exposures in-camera is as important as always.

Raw conversion software

A Raw file is effectively unprocessed digital data until it is converted. Therefore, unlike a Jpeg, it cannot be opened and viewed without using appropriate software. Raw formats differ between camera manufacturers, so dedicated software has to be used. Digital cameras are bundled with proprietary programs, but their capabilities vary tremendously – some being highly sophisticated, while others are relatively basic. As a result, many photographers prefer to convert their Raw images using third-party software. Adobe, Apple, Phase One, DxO and even Google market Raw conversion software that allows you to download, browse, correct and process your Raw files with the minimum of fuss.

Most digital SLRs allow photographers to capture RAW and Jpeg simultaneously – ideal if you want to shoot Raw yet still require Jpegs for quick reference.

Exposure tip

▼ Downloading and backup

It is easy to download images onto your hard drive and open them in your chosen software. Using a card reader is more convenient than connecting your DSLR to the computer. Hardware can fail, so always backup your images on an external hard drive, or use remote storage, before formatting the card ready for reuse.

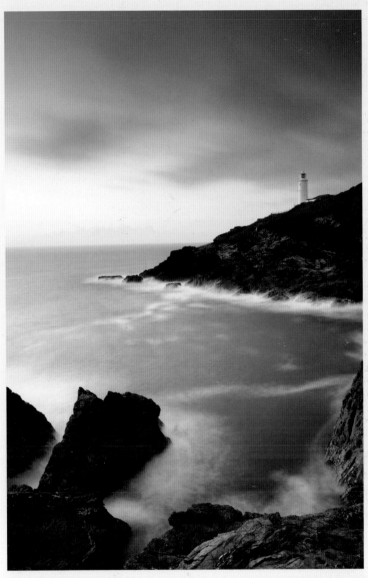

▲ *Cornish lighthouse*

Having downloaded your images, look through them and select the photos you wish to process. Most programs have a useful 'star rating' system to classify your shots. Having read this handbook, hopefully you will have achieved the exposure you desire in-camera. However, Raw files will still need a number of adjustments made to them – particularly if you practise 'exposing to the right' (see page 34) – so be prepared to invest a little time and effort in your shots to achieve the best result.

Nikon D300, 12–24mm (at 18mm), ISO 200, 30sec at f/16, 2-stop ND grad, 3-stop ND, tripod.

Raw workflow

To get the most from your Raw images, you need to be able to process them appropriately. Raw software is very advanced and sophisticated today, so when you have decided which package you wish to use, buy a detailed manual for that program; it will provide a much fuller, more detailed description of the tools available to you than is possible here. However, whatever package you opt for, the basic tools – and therefore workflow – will be very similar. Below is a brief overview of a number of key tools. They don't need to be applied in any particular order; you will soon develop your own personal workflow.

Setting the black and white points

This is a logical first step that helps to ensure the tones in the image are spread across the full range of the histogram. If there are gaps between the right and left limits of the horizontal axis, the image is not using the full range of tones and may lack contrast as a result, although this may be desirable for some images.

The black and white points are typically set using the Levels control. The histogram will be displayed alongside the image when it is opened in your Raw converter. Beneath the histogram are normally three sliders: the pointer on the far right represents pure white (255); the pointer to the far left, pure black (0); and the middle pointer represents the mid-tone (128). To set the black point, move the black point slider to the right, to the point just in front of the first line of the histogram. The image will grow darker. To set the white point, drag the white point slider to the left, to the point just after the end of the histogram. The image will become lighter. Be careful not to increase contrast too much, though. A slight clipping of the shadows is acceptable, but clipped highlights rarely look right. Now use the middle slider to adjust the mid-tones – pushing it to the left will brighten the image overall, and moving it to the right will darken it. The black and white points remain unaffected.

Every image, and its corresponding histogram, is unique, requiring individual treatment. However, the basic object remains the same: to obtain a full range of tones across the histogram.

Colour temperature

Before making any further adjustments, it is best to adjust the global colour of the image using the white balance or colour temperature control – you make further adjustments to it again later if required. Most Raw converters will present you with the usual choice of white balance presets, such as 'daylight' and 'cloudy'. If your choice of white balance was incorrect at the time of capture, you can quickly and easily correct colour temperature – or even adjust it creatively. For even greater precision, you can manually adjust colour temperature (to give a warmer or cooler look) and tint (the amount of green or magenta). There is also normally an Eyedropper tool – simply click on an area of neutral colour to set the white balance accordingly. However, bear in mind that the 'technically' correct white balance setting won't always produce the most pleasing result. Therefore, always set colour temperature to taste.

▼ *Spreading the tones*
Setting the black and white points spreads the image's tones across the full range of the histogram, increasing contrast.

Many Raw converters have an 'exposure' slider. You can effectively alter exposure by dragging the slider left (to darken the image) or right (to make the image lighter), as you wish.

Exposure tip

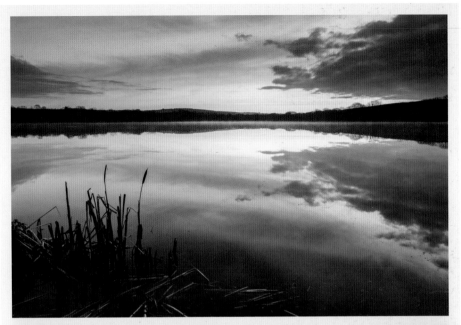

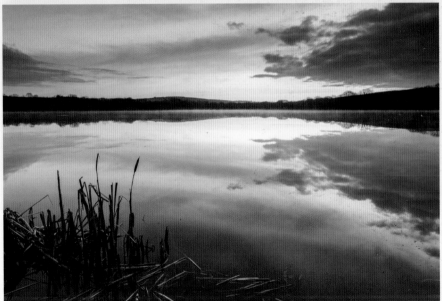

▲ *Colour temperature*
It is quick and easy to adjust a Raw file's colour temperature for corrective or creative purposes, **either by selecting from a number of standard presets, or by manually adjusting colour temperature or tint.**

Curves

Even after setting the black and white points, you may still need to make further adjustments to the image contrast. Most Raw converters have a simple Contrast slider, to allow users to quickly increase or reduce contrast levels. However, for greater control, use the Curves control.

The Curves box shows a graph with a straight diagonal line, cutting diagonally at a 45-degree angle. The bottom left corner represents pure black (0); the top right corner white (255); and mid-point mid-tones (128). The horizontal axis of the graph represents the original brightness values of the pixels (Input levels); the vertical axis represents the new brightness levels (Output levels). By clicking and dragging the line into different positions you can 're-map' the image's tonal range and alter overall contrast.

If you wish to increase contrast, add an S-shaped curve. This is done by pulling down the 'quarter tones' slightly and pushing up the 'three-quarter tones'. You can also create anchor points by clicking on any point along the line. Then, by either dragging them up or down, you can create your customized 'curve'. By moving a point on the grid up, pixels of that tone within the image will become lighter; drag them down and they will become darker. Curves is a powerful and flexible tool for stretching and compressing tones.

Cropping

This is an important compositional tool that can radically alter a photograph's appearance and balance. It also allows you to remove distracting features from the edge of the frame, or effectively magnify the subject – useful if you were unable to obtain the desired composition in-camera. You can also change the aspect ratio of the image if your subject doesn't

▼ *Using the Curves control*
Creating an 'S' curve will increase the overall contrast in your images.

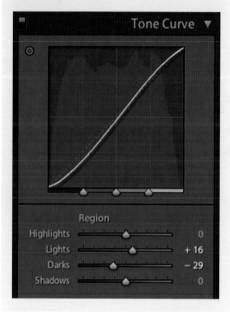

suit the standard 3:2 ratio of most DSLRs, or crop your picture to a square or panoramic format. Most Raw converters allow you to 'lock' a particular aspect ratio or create your own custom ratio. Alternatively, you can unlock the aspect ratio and crop images to the shape you think best suits that particular shot.

Having clicked on the crop tool, use the selection handles to highlight the area you want to maintain. To perform the crop, click on the selection or press Enter. The area outside your selection will be discarded.

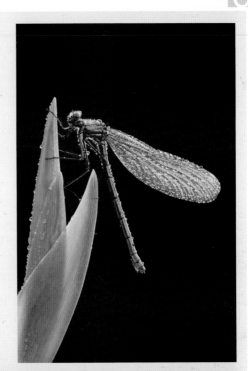

▶ *Aspect ratio*
**Due to the standard 3:2 aspect ratio offered by
most digital cameras, it is not always possible
to frame your subject just as you would wish
in-camera. Thankfully, in post processing, you
can alter the image's aspect ratio, or crop to
taste, to enhance the look of your photos.**

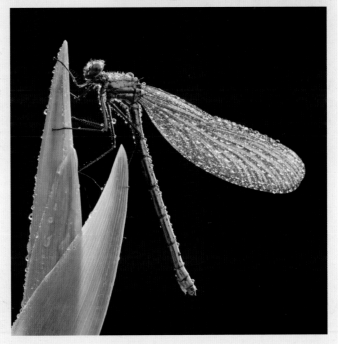

Colour saturation

The colours in an unprocessed Raw file – particularly in an 'exposed-to-the-right' image – often look weak. A good degree of natural colour saturation will be restored once the black and white points have been set and contrast adjusted. However, colours may still require a little extra 'boost'. All Raw converters have Saturation control; some also offer a useful Vibrance slider. The difference between the two is straightforward. Saturation is linear, boosting all colours equally. Vibrance is non-linear and is designed to boost the colours in the image that are less saturated. It also protects skin tones, useful for portrait and people photography. The Vibrance control typically produces more subtle, natural-looking results. There is no magic formula for adjusting Saturation or Vibrance. Simply drag the slider – to increase or decrease colour saturation – to taste. However, do be cautious: it is very easy to be seduced by the results of colour saturation and overdo the effect. Try to keep images looking natural and faithful to the original scene.

Many Raw converters allow you to fine-tune the hue, saturation and lightness (HSL) of individual colours using a colour wheel, colour picker, or a targeted adjustment tool for maximum colour control.

▼ *Feathers*

While happy with this close-up of a pheasant's feathers, the colours of the Raw image looked a little subdued (1). To enrich them, I increased saturation by +8 in Lightroom. The result retains a natural look and has more impact than the unaltered original (2).

Nikon D200, 150mm, ISO 100, 1/80sec at f/14, tripod.

Noise reduction

One of the final things to do before exporting your processed image is to look for noise (see page 43) and, if needed, apply a degree of noise reduction. All digital images contain a certain amount of noise. Exposing well – by pushing exposure to the right – will help keep noise to a minimum. However, a small degree of noise reduction at the conversion stage is often beneficial. Noise reduction software – typically built-in to RAW packages – is very sophisticated. However, it is effectively obscuring and destroying fine detail, so do not be too aggressive with it; only apply the minimum amount required. A certain degree of luminance noise, resembling film grain, is generally acceptable to the eye, but colour noise is ugly. The amount of noise reduction you need to apply will depend on the individual image.

Dust spotting

Even the latest DSLRs, with automatic sensor cleaning systems, are prone to dust and dirt settling on the sensor, causing unattractive telltale dust spots. Any marks on the sensor grow more defined and obvious when employing small f/stops. To remove marks and dust spots from images, photo-editing software incorporates a Clone tool. This allows you to 'clone' pixels from a neighbouring area to remove any marks. The size and opacity of the brush can be adjusted as required. Some programs also have a Healing Brush tool. This works in a similar way, but also matches the texture, lighting, transparency, and shading of the sampled pixels to the pixels being healed. As a result, the repaired pixels appear to blend seamlessly into the rest of the image. Dust spotting tools in some Raw converters can be quite fiddly to apply. Using equivalent tools in Photoshop can prove quicker and easier.

▼ Checking for dust spots

Before exporting your images, view photographs at 100% and check for any dust spots. Marks can be quickly removed using the Clone tool or Healing Brush tool. It is important to 'tidy up' an image before sharing or printing.

Conversion for output

With your processing complete, you can convert the image to your chosen file format. When archiving images, Tiff is generally considered best, particularly if you intend to do further work to the image in Photoshop. However, if you are sure that you won't, and conserving storage space is a priority, convert your file to Jpeg, saving it at its highest quality setting. During the conversion process, you will be given various options. Save your TIFFs at the 16-bit setting

in order to preserve image quality when making additional adjustments. If you have finished working on the file, it is fine to archive images as 8-bit Tiffs, as the file size is more manageable. Export images at 300 pixels per inch, as this is the resolution required if you are submitting images for publication. You will also be prompted to select the image's colour space. There are generally three options: sRGB, Adobe RGB and ProPhoto RGB. sRGB is the smallest colour space and generally best avoided, except for web use. ProPhoto RGB is the largest and (theoretically) the best one to use if you intend to do any further editing or are preparing images to print using your own inkjet – although many of the colours will be out of the printer's gamut. However, if you are sending files for publication, use Adobe RGB, which is the industry standard. Name your file as you wish, to suit your naming system. Personally, I give my images a custom name followed by the original file number. This helps me quickly locate the original Raw file should I need to do so. Finally, click Export.

▼ Exporting photos

Having carefully processed your Raw file, making adjustments to exposure, contrast, colour temperature and saturation, your last action is to convert your file. Tiff is the best file format for archiving images. Name files with a custom name for easy identification and finally click export.

Black and white conversion

The appeal and drama of black and white photography is endearing and, thanks to digital, this powerful medium has never been more popular or accessible. Converting colour images into mono is a relatively quick and simple process – although for the very best results, it is worthwhile investing a little more time and effort.

Black and white photography has certainly passed the test of time and, combined with a suitable scene or subject, can convey more drama and mood than its colour equivalent. Removing colour helps place emphasis on the subject's shape and form and also on an image's composition and light.

Although digital cameras allow photographers to capture greyscale images in-camera, or convert captured files in-camera via a Retouch menu, more tonal information is recorded in colour. Therefore, to maximize image quality, continue shooting in colour and convert in the digital darkroom. Another advantage of shooting in colour is that, while you can convert a colour image to black and white; you can't convert a black and white image to colour. Quite simply, shooting in colour originally gives you more options.

You can convert an image to monochrome either at the Raw processing stage or, having saved your file as a Tiff, in Photoshop. The latter gives you more options and a greater degree of control. There are a number of different ways to convert images to black and white in Photoshop. The simplest is Image > Adjustments > Desaturate, but this offers no control over the result. One of the most popular methods is to use the Channel Mixer (Image > Adjustments > Channel Mixer). This allows you to mix the three colour channels – red, green and blue – to simulate the effects of colour filters in order to adjust the image's tonal range and contrast. When using this method, try to keep the combined total of the three mixer settings to 100%.

However, photographers are given even more control over the look of their black and white images in the latest versions of Photoshop, with the Image > Adjustments > Black and White dialog.

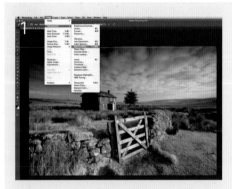

Step 1

Having selected an image suited to conversion to monochrome, click Image > Adjustments > Black and White. There are various options in the dialog box. You can click on Auto and let Photoshop make all the decisions for you. There are also a number of useful presets. However, it is better to adjust the colour channels yourself.

Step 2

The colour sliders are designed to mimic traditional back and white filters – used to adjust and control contrast and tone. Using the sliders, it is possible to lighten or darken specific tones by increasing or decreasing selected colours. Doing this can help a subject stand out from its surroundings, rather than merge into them.

Step 3

Every image will need individual treatment – adjust the sliders until you achieve the desired result. In this instance, upping the green and yellow sliders created a far more striking, contrasty result. If necessary, make any final adjustments to contrast by clicking Image > Adjustments > Curves. Finally, save and export your black and white – using a different file name to the original.

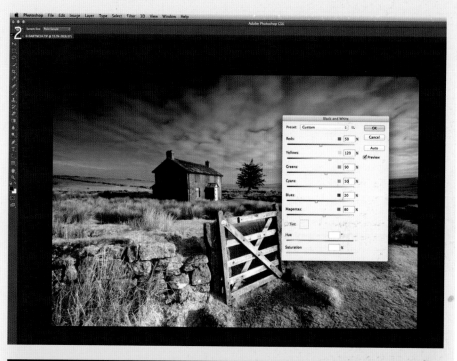

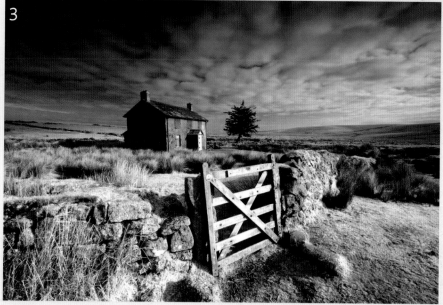

Exposure blending

An alterative to using grads is to blend two different shots: one correctly exposed for the sky; the other for the land. By doing so, it is possible to achieve a result that is correctly exposed throughout. Graduated ND filters (see page 156) are popular tools among landscape photographers for helping lower the contrast between the land and sky. However, it can be argued that placing a piece of glass or resin in front of the lens will degrade image quality to some small degree.

There are also certain situations where using a grad just isn't practical, such as when there is a broken horizon, or the contrast range is so great that filtration isn't a viable option. There is also cost to consider: buying sets of grads can prove expensive.

There are a number of different methods to do this. However, for this example, I will demonstrate one of the simplest, but also one of the most popular and effective ways to blend two exposures.

Step 1

When I photographed this early morning moorland view, I captured two identically composed images – one correctly exposed for the land and the other for the sky – to ensure I had both shadow and highlight detail. Using Lightroom, I converted both images to TIFF format and then opened them in Photoshop. I named the images LAND and SKY for easy identification.

▼ Land

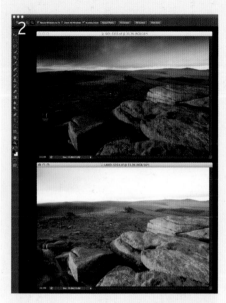

Step 2

With both images open in Photoshop, click on the lighter of the two shots. Select the Move tool from the Tools palette. Drag the lighter picture (LAND) over the darker one (SKY), dropping it onto the darker frame. The lighter image is added as a new layer in the Layers palette, on top of the darker photo. Hold down the Shift key while dragging to ensure that the two images precisely align.

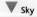
▼ Sky

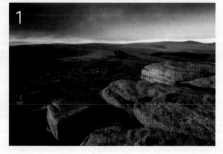

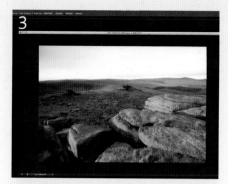

Step 3

Click on the Magnetic Lasso Tool in the Tools palette and, using it, carefully select the sky. In this example, I feathered the selection by around 100 pixels so that there would be a smooth blend between the two layers in the next step. A radius of between 100 and 200 pixels typically works well.

Step 4

Now, select the Eraser tool from the Tools palette, opting for a large brush size of medium hardness. Using the brush, erase the top (lighter) layer in order to reveal the darker (correctly exposed) sky beneath. Continue to selectively erase the top layer until you are satisfied with the result. Finally, flatten the layers (Layer > Flatten Image).

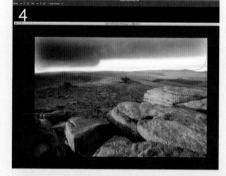

Step 5

Having finished blending your image, you may wish to make a few final adjustments to the image as a whole by adjusting contrast (Image > Adjustments > Curves) or saturation (Image > Adjustments > Hue/Saturation). The final blended image looks natural and perfectly exposed.

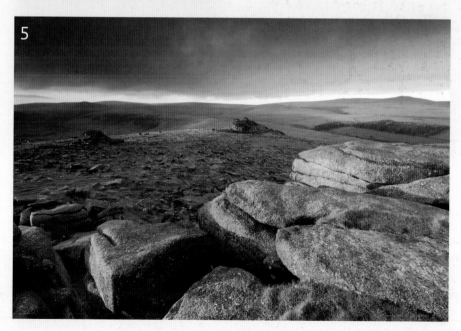

High dynamic range photography

High dynamic range, or HDR, photography is a software technique where a series of bracketed exposures is merged together to overcome the dynamic range limitations of traditional single-shot photography. The final result displays remarkable detail and tonality throughout the image, boasting far more shadow and highlight detail than would be possible from a single frame.

It is similar in principal to exposure blending (see page 178), but it takes the process a step further. Some DSLRs have an HDR mode, where the camera captures a bracketed series and merges them in-camera. However, producing an HDR image post capture using dedicated software offers far more versatility and options.

Although HDR can be employed to extend dynamic range to create natural-looking results, more commonly it is applied creatively, in order to produce wonderfully artistic, surreal and artificial-looking images of high-contrast subjects. Responses to HDR are very subjective – you either love or hate the look of HDR images. However, when combined with a suitable subject, there is no denying that HDR images can prove truly striking, recording the full range of colour and contrast that our eyes can typically see but which a sensor can't normally capture in a single exposure. Architecture, derelict buildings and cityscapes at night are just a small example of the types of subject that suit the HDR treatment.

When you capture your HDR sequence, take enough photos to cover the subject's full dynamic range. A series of at least five is usually required for

1 To create your HDR image in Photoshop, click File > Automate > Merge to HDR pro. Select the images you wish to merge and load all the photographs in your sequence. Check the Attempt to Automatically Align All Source Images box, to help precise alignment. The process is quite memory intensive, so, depending on your computer, it may take several minutes for the images to load.

2 A Merge to HDR Pro dialog box displays thumbnails of the source image and also a preview of the merged result. To the upper right of the preview, select bit depth. Choose 32-bit to store the entire dynamic range of the HDR file. However, opting for a 16- or 8-bit depth image allows you to access Photoshop's HDR Pro tone-mapping methods. Select Local Adaption. This offers greater control compared to the other options: Equalize Histogram Exposure and Gamma and Highlight Compression.

the best results. However, depending on the scene, you may need to shoot a larger sequence. Many digital cameras have an Auto Bracketing sequence to help you capture your HDR sequence. Using this feature, you can program the camera to vary the level of exposure with each subsequent frame. For example, you could capture a series of five images at -2, -1, 0, +1, +2. Alternatively, instead of using the Auto Bracketing feature, capture the series manually by adjusting the shutter speed for each image – f/stop and ISO should remain consistent throughout.

All images need to be identically composed to aid alignment, so use a tripod and trigger the shutter remotely using a remote device.

To create your HDR image, you need to merge your bracketed sequence using appropriate HDR software. Independent programs such as Photomatix are popular. HDR is a fairly in-depth technique, impossible to do justice to in a couple of pages, and you will find no shortage of information on it online. However, to get you started, below is a basic tutorial using the built-in HDR facility in Photoshop.

3 **Check the Remove Ghosts box to create a smoother image and alter the image's HDR tonality by adjusting local brightness regions throughout the image using the following tools:**
Edge Glow **Radius specifies the size of the local brightness regions. Strength specifies how far apart two pixels' tonal values must be before they are no longer part of the same brightness region.**
Tone and Detail **Dynamic range is maximized at a Gamma setting of 1.0; lower settings work on mid-tones, while higher settings emphasize highlights and shadows. Exposure values reflect f-stops. Drag the Detail slider to adjust sharpness and the Shadow and Highlight sliders to brighten or darken these regions.**
Color Vibrance **Adjusts the intensity of subtle colours while minimizing clipping of highly saturated colours. Saturation adjusts the intensity of all colours from −100 (monochrome) to +100 (double saturation).**

Toning Curve **Displays an adjustable curve over a histogram showing luminance values in the original, 32-bit HDR image. The red tick marks along the horizontal axis are in one EV (approximately one f-stop) increments. Once you have finished making adjustments to the image, click OK to create your HDR image.**

4 **Finally, if required, make further adjustments to the image's contrast by clicking Image > Adjustments > Curves. The result should be an eye-catching image that would have been impossible to achieve in a single frame in-camera.**

3

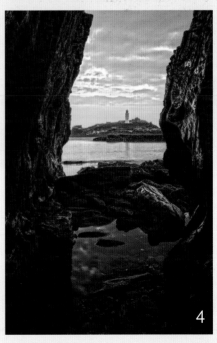

4

6

Calibration

Having captured a correctly exposed image, and processed it appropriately, you need to know that your final, printed image will look the same on paper as on your computer screen. Cameras, monitors and printers all 'see' colour slightly differently, which is why calibration is important.

In order to edit and process your images confidently, and produce faithful, high-quality prints, you need to do two things: calibrate your monitor and also your photo printer – or, more accurately, create profiles for the papers you use with your printer. Only by calibrating your monitor can you be sure that what you see on screen is how the image really looks. Typically, the majority of monitors display a colour cast of some type out of the box. While this may only be a slight colour shift, it still means that the colours in your photographs will not look authentic. By printing a test target, and then using hardware to read the target and software in order to compare the output against known values, ICC (International Color Consortium) profiles can be generated for specific printer-paper combinations. An ICC profile describes the colour characteristics of a device, such as a monitor or printer, and communicates that information to other hardware, enabling it to reproduce colours accurately.

How to calibrate your monitor

You can calibrate your monitor by sight, using simple programs such as Adobe Gamma in Photoshop or, if you use an Apple Mac, the Display Calibrator Assistant. While this will usually be an improvement on an uncalibrated monitor, it won't produce critically accurate results. The second, far more accurate, method, is to use a hardware calibration device known as a colorimeter. Monitor calibration involves placing the colorimeter on the screen then running software that compares the colours your monitor displays against known values. Then software creates a profile that adjusts the monitor's colours accordingly.

Before you start the calibration process, ensure you are working in a suitable environment. Lighting should be dim but not completely dark, and there shouldn't be any lights shining directly onto the monitor. Set your computer desktop to display a solid mid-grey background. The calibration software will guide you through the process step by step. Some monitors allow you to make manual adjustment to brightness, contrast, white point and RGB settings. If your monitor does not allow this, the software may provide a fully automatic calibration. You may also be asked to define target settings for the parameters listed below. There are no absolute rules about which settings to choose, as they can be affected by factors such as the brightness of your working environment, but the following settings are widely recommended:

▶ *Calibration device*
There are various colorimeters available, but three of the principal manufacturers are Datacolor, Pantone and X-rite. Not all devices will calibrate both the monitor and printer. Some are designed solely for monitor calibration, others for printer profiling, while more advanced devices will do both. The Datacolor Spyder is a popular, easy-to-use device, that is designed to calibrate LCD, LED, OLED, CRT, DLP and other displays.

Try to calibrate your monitor at least once a month, as profiles can 'drift' over time, particularly luminance settings. Most calibration software can be set to remind you when you need to recalibrate.

Brightness: in the region 110 cdm2–140 cdm2
Contrast: around 50% (the calibration software may help you arrive at a suitable level)
Gamma: 2.2 (for both Macs and PCs)
White point: 6500K, D65

Some LCD monitors may give a better result if the white point is set to a value known as the native white point. This will give you the maximum possible colour range for your monitor, and any other value may introduce banding on some monitors. In the majority of cases, the native white point will be close to 6500K. It is often worth experimenting with different settings to see which one works best.

Printer and paper profiles

In many respects, creating paper profiles is very similar to calibrating a monitor: you print a test target, measure it with a hardware device and let the software create a profile. The equipment needed is generally more expensive than that needed for monitor profiling, so many photographers have profiles made for them by colour management specialists. If you have several profiles made at the same time, for different papers, this can be relatively costly, but is normally a one-off expense.

It is important to remember that when you print the test target, you must turn off all colour management in your editing software and printer drivers. How you do this will vary depending on your operating system and printer model. If carrying out your own profiling, the software will guide you; if a specialist is making profiles for you, ask their advice.

▼ *Lake reflection*
To ensure the colours you view on screen look authentic and reproduce faithfully when printed, calibrate your monitor and printer.

Nikon D800, 17–35mm (at 25mm), ISO 100, 1sec at f/11, tripod

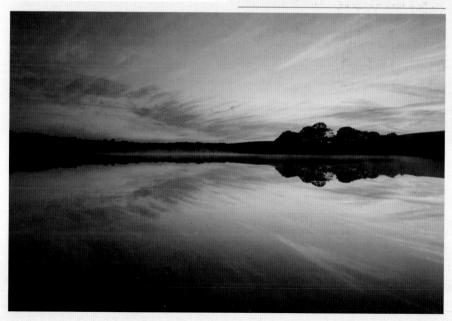

Printing

It would be a waste to keep your favourite images hidden away on your computer's hard drive. Great digital 'exposures' should be shared and enjoyed and the majority of photographers take photos with the intention of ultimately printing their best – either to frame, exhibit or to enter into photo competitions.

Thanks to the sophistication of home printers, it is possible to produce prints of outstanding photo quality without the need, or added cost, of getting them printed at a professional lab. Even budget photo printers are capable of excellent results, despite their relatively low price tag. However, if you intend on making a large number of prints it is worthwhile investing in the best quality printer you can justify, and opting for a version that prints up to A3 size, or larger. This will give you greater flexibility with the range of sizes you can print. After all, with the resolution of digital cameras growing ever higher, it is possible to produce large prints without making any compromises in print quality.

Only a few years ago there were concerns regarding the longevity of digital prints. However, the latest inks are far more stable than older ink sets and accelerated testing suggests that digital prints have a long projected life. Although ink is relatively expensive, generally speaking it is best to opt for the printer's own inks, rather than a cheaper, compatible, third-party brand. There is a wide range of papers available, in a variety of finishes, produced by the likes of Epson, Fotospeed, Ilford and Hahnemuhle. The finish you prefer is a matter of taste – try a selection of paper types and do your own comparisons.

Entire books are dedicated to the art of printing, so this section is simply designed to help get you started – there is insufficient space here to go into any great detail. Most photographers prefer to print using Photoshop. The basic workflow for printing an image can be summarized as follows:

- Open the image in Photoshop (or a similar program)
- Resize the image accordingly
- Soft proof the image (simulate the appearance of the print on your computer screen)
- Make any adjustments necessary based on the soft proof
- Sharpen for output
- Select the paper type and paper profile in the printer driver
- Select the output resolution
- Print

Dpi (dots per inch)

Dots per inch, or dpi, refers to a printer measurement and shouldn't be confused with pixels per inch (ppi). Simply, a printer prints dots and a monitor displays pixels. The dpi measurement of a printer often needs to be considerably higher than the ppi of a monitor in order to produce similar-quality output. This is because of the limited range of colours for each dot typically available on a printer.

Remember that dpi is not the resolution of the image or the monitor; it is the measurement of how many dots of ink the printer can place within an inch. In theory, a printer with a higher dpi will produce a higher-quality print. Today, even so-called budget printers are capable of excellent results, typically boasting a high dpi upwards of 1440. Inkjet is the most widely used type of home printer, working by squirting tiny droplets of ink onto the paper.

▶ *Photo paper*
There is a wide range of different photo papers available to buy from the likes of Epson, Fotospeed, Ilford, Hahnemühle, Permajet and Tetenal.

▼ **Printer**
There are now many high-quality, affordable photo printers available to buy, offering flexibility, long-lasting images and high-speed operation.

Resizing

When possible, print at the file's native size – as long as the resolution falls between 180 and 480ppi. If you need to upsample or downsample the image, do so by clicking Image > Image size.

Soft proofing

Soft proofing allows you to preview the way the print will look in your chosen medium. A lot of people are initially discouraged from soft proofing, because when you first click on the Preview button, the appearance of the image can change dramatically, depending on the options you have selected. It is, however, a useful tool; it gives you the opportunity to adjust your settings to squeeze the maximum image quality out of the print and prevents disappointment when you see the final result.

To set up soft proofing in Photoshop, go to View > Proof Setup > Custom. In the dialog box, from Device to Simulate, choose the profile for the paper you want to print on then select your rendering intent. The rendering intent 'translates' the colour gamut from the colour space of the image to the colour space of the printer. Typically, there will be some 'out-of-gamut' colours that the printer cannot reproduce precisely. From the choice presented in the dialog box, Perceptual and Relative Colorimetric are the two most useful.

Perceptual compresses the range of colours to match the gamut of the printer, while trying to maintain the perceptual relationship between the colours – it therefore adjusts all the colours in the image. Relative Colorimetric, on the other hand, simply removes the colours that can't be printed and doesn't change any of the colours that are within gamut. So which one should you choose? Well, the only way to know is to try them both, while soft proofing, and choose the one that works best with that particular image.

The next step is to click on Simulate Paper Colour. Clicking on this button soft proofs the contrast range of the paper. As this will always be much lower than your monitor's contrast range, this is when you will see the major changes in the image. Monitors have much deeper blacks and much brighter whites than can be reproduced on paper, so typically the image will look darker and 'muddier'

when soft proofed. At this stage, it's worth double-checking that you are happy with the rendering intent you've chosen.

You now need to make adjustments to the image so that the print will resemble the on-screen image more closely. One way to do this is to open two copies of the image, soft proofing one of them then tweaking it to match the original version as closely as possible. Typically, you will need to make changes to the image Curve to add a little extra 'punch' to the blacks and lighten the mid- and three-quarter tones, and the hue and saturation of individual colours. Having done this, you can feel confident that your print will be closely matched to the screen image.

Sharpening

Sharpening is a much broader topic than most people realize, so this is only a brief introduction here. As well as capture sharpening, digital images need additional sharpening before output. How much output sharpening an image needs depends on the size of the print and the paper type you are using. It will also vary slightly from image to image. In Photoshop, Unsharp Mask is recommended – Click Filter > Sharpen > Unsharp Mask. View images on screen at 50% or 25%, as this will give you a much better idea of how the effect will look in print than viewing the image at 100%. Set a small radius – often one between 0.3 and 0.7 pixels works well – and push the Amount slider up until you just start to see a very slight 'halo' around the edges.

Some media, such as heavily textured fine art paper, will need more sharpening than others, but you can experiment with this when you have identified your favourite papers.

The print

You are now ready to print your image. In Photoshop, go to File > Print. In the dialog box, select Photoshop Manages Colors and choose the appropriate printer profile and rendering intent. Select the paper type. The layout of the printing options dialog box may vary depending on your operating system and printer model, but all these settings should be selectable.

When you have printed your image, give it half an hour or so to settle before you view it, and always try to view it in neutral light.

▼ *Afterglow*

Your best images should be enjoyed and shared with others. Your print is the last stage of taking a great 'digital exposure'.

Glossary

Aberration: An imperfection in an image caused by the optics of a lens.

Autoexposure lock (AE-L): A camera control that locks in the exposure value, allowing an image to be recomposed.

Angle of view: The area of a scene that a lens takes in, measured in degrees.

Aperture: The opening in a camera lens through which light passes to expose the image sensor. The relative size of the aperture is denoted by f-numbers.

Autofocus (AF): A through-the-lens focusing system allowing accurate focus without the user manually focusing the lens.

Bracketing: Taking a series of identical compositions, changing only the exposure value, usually in ½ or 1 f-stop (+/–) increments.

Camera shake: Movement of the camera during exposure that, particularly at slow shutter speeds, can lead to blurred images.

Charged-coupled device (CCD): A common type of image sensor used in digital cameras.

Centre-weighted metering: A way of determining the exposure of a photograph, placing emphasis on the lightmeter reading from the centre of the frame.

Complementary oxide semi-conductor (CMOS): A microchip consisting of a grid of millions of light-sensitive cells – the more sensors, the greater the number of pixels and the higher the resolution of the final image.

Colour temperature: The colour of a light source expressed in degrees Kelvin (K).

Compression: The process by which digital files are reduced in size.

Contrast: The range between the highlight and shadow areas of an image, or a marked difference in illumination between colours or adjacent areas.

Depth of field (DOF): The amount of an image that appears acceptably sharp. This is controlled by the aperture – the smaller the aperture, the greater the depth of field.

Distortion: Typically, when straight lines are not rendered perfectly straight in a photograph. Barrel and pin-cushion distortion are examples of types of lens distortion.

dots per inch (dpi): Measure of the resolution of a printer or a scanner. The more dots per inch, the higher the resolution.

Dynamic range: The ability of the camera's sensor to capture a full range of shadows and highlights.

Evaluative metering: A metering system whereby light reflected from several subject areas is calculated based on algorithms.

Exposure: The amount of light allowed to strike and expose the image sensor, controlled by aperture, shutter speed and ISO sensitivity. Also the result of taking a photograph, as in 'making an exposure'.

Exposure compensation: A control that allows intentional over- or underexposure.

Fill-in flash: Flash combined with daylight in an exposure. Used with naturally backlit or harshly side-lit or top-lit subjects to prevent silhouettes forming, or to add extra light to the shadow areas of a well-lit scene.

Filter: A piece of coloured, or coated, glass or plastic placed in front of the lens for creative or corrective use.

F-stop/number: Number assigned to a particular lens aperture. Wide apertures are denoted by small numbers such as f/2.8, and small apertures by large numbers such as f/22.

Focal length: The distance, usually in millimetres, from the optical centre point of a lens element to its focal point, which signifies its power.

Guide number (GN): Used to determine a flashgun's output. GN = subject distance x aperture.

Highlights: The brightest areas of an image.

Histogram: A graph used to represent the distribution of tones in an image.

Hotshoe: An accessory shoe with electrical contacts that allows synchronization between the camera and a flashgun.

Incident-light reading: Meter reading based on the light falling on the subject.

International Standards Organization (ISO): The sensitivity of the image sensor measured in terms equivalent to the ISO rating of a film.

Joint Photographic Experts Group (Jpeg): A popular image file type that is compressed to reduce file size.

Lens: The 'eye' of the camera. The lens projects the image it sees onto the camera's imaging sensor. The size of the lens is measured and indicated as focal length.

Liquid crystal display (LCD): The flat screen on the back of a digital camera that allows the user to play back and review digital images and shooting information.

Macro: A term used to describe close-up photography and the close-focusing ability of a lens.

Manual focus: This is when focusing is achieved by manual rotation of the lens's focusing ring.

Megapixel: One million pixels equals one megapixel.

Memory card: A removable storage device for digital cameras.

Metering: Using a camera or handheld light meter to determine the amount of light coming from a scene and calculate the required exposure.

Metering pattern: The system used by the camera to calculate the exposure.

Mirror lock-up: Allows the reflex mirror of an SLR to be raised and held in the 'up' position, before the exposure is made.

Monochrome: Image comprising only of grey tones, from black to white.

Multiplication factor: The amount the focal length of a lens will be magnified when attached to a camera with a cropped-type sensor – smaller than 35mm.

Noise: Coloured image interference caused by stray electrical signals.

Overexposure: A condition when too much light reaches the sensor. Detail is lost in the highlights.

Perspective: In context of visual perception, it is the way in which the subject appears to the eye depending on its spatial attributes, or its dimensions and the position of the eye relative to it.

Photoshop: A photo-editing program developed and published by Adobe Systems Incorporated. It is considered the industry standard for editing and processing photographs.

Pixel: Abbreviation of 'picture element'. Pixels are the smallest bits of information that combine to form a digital image.

Post processing: The use of software to make adjustments to a digital file on a computer.

Prime: A fixed focal length – a lens that isn't a zoom.

Raw: A versatile and widely used digital file format where the shooting parameters are attached to the file, not applied.

Resolution: The number of pixels used to either capture an image or display it, usually expressed in ppi. The higher the resolution, the finer the detail.

Red, green, blue (RGB): Computers and other digital devices understand colour information as shades of red, green and blue.

Saturation: The intensity of the colours in an image.

Shadow areas: The darkest areas of the exposure.

Shutter: The mechanism that controls the amount of light reaching the sensor by opening and closing when the shutter release is activated.

Shutter speed: The shutter speed determines the duration of exposure.

Single lens reflex (SLR): A camera type that allows the user to view the scene through the lens, using a reflex mirror.

Spot metering: A metering system that places importance on the intensity of light reflected by a very small percentage of the frame.

Telephoto lens: A lens with a large focal length and a narrow angle of view.

Tagged-Image File Format (TIFF): A universal file format supported by virtually all image editing applications. TIFFs are uncompressed digital files.

Through the lens (TTL) metering: A metering system built into the camera that measures light passing through the lens at the time of shooting.

Underexposure: A condition in which too little light reaches the sensor. There is too much detail lost in the shadow areas of the exposure.

Viewfinder: An optical system used for composing and sometimes focusing the subject.

Vignetting: Darkening of the corners of an image, due to an obstruction – usually caused by a filter(s) or hood.

White balance: A function that allows the correct colour balance to be recorded for any given lighting situation.

Wide-angle lens: A lens with a short focal length.

Zoom: A lens with a focal length that can be adjusted to any length within its focal range.

Useful websites

Calibration

Datacolor: www.datacolor.com
Xrite: www.xrite.com

Depth-of-field Calculator

DOF Master: www.dofmaster.com

Outdoor equipment

Paramo: www.paramo.co.uk

Photographers

Ross Hoddinott: www.rosshoddinott.co.uk

Photographic equipment

Canon: www.canon.com
Cokin: www.cokin.com
F-Stop Gear: http://fstopgear.com
Gitzo: www.gitzo.com
Lastolite: www.lastolite.com
Lee Filters: www.leefilters.com
Lexar: www.lexar.com
Lumiquest: www.lumiquest.com
Manfrotto: www.manfrotto.com
Nikon: www.nikon.com
Novoflex: www.novoflex.com
Olympus: www.olympus.com
Pentax: www.pentaximaging.com
Sekonic: www.sekonic.com
Sigma: www.sigmaphoto.com
Sony: www.sony.com
Sto-fen: www.stofen.com
Tamron: www.tamron.com
Wimberley: www.tripodhead.com

Photography workshops

Dawn 2 Dusk Photography:
www.dawn2duskphotography.co.uk

Printing

Epson: www.epson.com
Hahnemuehle: www.hahnemuehle.de
Harman: www.harman-inkjet.com
HP: www.hp.com
Permajet: www.permajet.com
Tetenal: www.tetenal.com

Sunrise and sunset direction

The Photographer's Ephemeris:
www.photoephemeris.com

Software

Adobe: www.adobe.com
Apple: www.apple.com/aperture
Corel: www.corel.com
DxO: www.dxo.com
Phase One: www.phaseone.com
Photomatix Pro: www.hdrsoft.com

Further reading

Digital Photography Review: www.dpreview.com
Digital SLR photography magazine:
www.digitalslrphoto.com
Ephotozine: www.ephotozine.com

Acknowledgements

Writing any book is a time-consuming – and often stressful! – project. Although it is my name on the cover, this book wouldn't be possible without the hard work of everyone at Ammonite Press.
A big thank you to Gerrie Purcell, Jonathan Bailey, Virginia Brehaut, Dominique Page, Rob Yarham and Chloë Alexander. Thank you to Canon, Datacolor, Cokin, Epson, Hoya, Lastolite, Lee Filters, Lumiquest, Nikon, Sekonic and Wimberley for supplying product images, and to Ollie Blayney and Tom Collier.

The biggest thank you is reserved for my wonderful family. Their love, support and encouragement is unfailing. I'm fortunate that my mum and dad aren't just great parents, but wonderful friends, too. Thank you for everything you do. My wife, Fliss, is simply the most wonderful person I've ever met. She is so understanding of the demands of my profession. She is my best friend and the most wonderful mother to our beautiful children, Evie, Maya and Jude. Thank you Fliss... I love you.

Index

To place an order, or request a catalogue, contact:

Ammonite Press
AE Publications, 166 High Street, Lewes, East Sussex, BN7 1XU, United Kingdom
Tel: +44 (0)1273 488006 **www.ammonitepress.com**